The Complete Guide to
Airbrushing
Techniques and Materials

The Complete Guide to
Airbrushing
Techniques and Materials

Judy Martin

Foreword by
Michael English

Thames and Hudson

A QUILL BOOK

First published in Great Britain in 1983 by
Thames and Hudson Ltd, London
Reprinted 1983, 1984

This book was designed and produced by
Quill Publishing Limited
32 Kingly Court
London W1

Project director · Nigel Osborne
Art director · James Marks
Editorial director · Jeremy Harwood
Senior editor · Liz Wilhide
Editor · Joanna Rait
Designer · Paul Cooper
Illustrators · Steve Braund David Weeks
Photographer · Clive Boden

Filmset in Great Britain by Text Filmsetters Ltd, Orpington, Kent
Origination by Rodney Howe Ltd, West Norwood, London
Printed by Leefung-Asco Printers Ltd, Hong Kong

Consultants · Peter Owen Ken Warner

Quill would like to extend special thanks to:
The Airbrush Company; Faculty of Art and Design, Cornwall Technical College;
Gordon Cramp Studios; Jerry Daniels, Royal Sovereign Graphics;
Diagram Visual Information Ltd; Mike Drew, DeVilbiss;
Fisher Fine Art Ltd; Ian Fleming and Associates; Folio;
Grandfield, Rork and Collins; Hipgnosis; Jantzen Inc; London Transport;
Richard Manning; Ken Medwell, Conopois; NTA Studios; Pictures;
Graham Poulter and Associates; Mrs Irene Sneddon; Richard Williams;
World Wide Posters.

CONTENTS

TBWA (1981), Michael English; acrylic on canvas

FOREWORD

In April 1969, my life went through a traumatic transformation: my work changed abruptly, I turned my back on my old ideas and worn-out techniques. I was beginning a new journey. In my right hand I held a Super 63A Aerograph; at my feet stood a DeVilbiss ACA1 compressor (no.25274).

I quickly discovered that my new companions would not yield easily to friendship. They were difficult, capricious and downright stubborn. It would be many years before I could rely on them with confidence.

The airbrush is not a magic wand that conjures instant visions on empty canvases, neither is it a passport to paradise for those lacking in creativity, as some art critics would have us believe. It is a brush that does not stroke, which projects its paint like rays of light. This marvellous ability to create images without touching a surface is ironically what the airbrush's critics seize upon, insisting that the spray somehow impersonalizes the work, disqualifying it as true art.

All art, however, reflects society, and today we live in a world of impersonal, productively efficient systems, smooth and well fitting. However much this horrifies me, I am drawn irresistibly to its aesthetic and all of my work reflects this inherent confrontation between the technical efficiency of the airbrush and my fears for the culture it represents.

The airbrush was originally designed for the technical illustrator and photoretoucher, and later found a major role in the production of advertising images. It is smooth and soft, and at the same time hard and cold. I revel in these qualities and yet I conspire to destroy the images they produce. In my own paintings, in the precise images of the products of our society, there lie the seeds of disorder.

No one was more surprised than I to discover that these images with their inherent decay were seized upon voraciously and displayed on a massive scale all over the world – by the very industry they were directed against. Confused, I sought refuge in paintings of nature, where my use of the airbrush was restricted to representing mere flickers of light shining from wet leaves, or the glint of pieces of glass swallowed up in the undergrowth.

It was in this quiet period of the mid-1970s that a real friendship and mutual understanding arose between myself and my airbrush. I used it sparingly and it no longer dominated the proceedings. I had freed myself from its style.

Now the spray is once again spreading across my work, but in a new form. In my new paintings of machines and graffiti, I use the larger DeVilbiss Type MP spray gun to cover bigger areas. A small paintbrush does the rest. My machine does precisely what I want it to do. It is an extension of my thoughts – a real brush. And, dare I say, a real magic wand.

When I began, I had no guide to assist me, no text to inform me. This book is long overdue. It has accumulated the knowledge of many artists, illustrators and technicians, and passes on this information in precise detail. It cannot fail to increase an understanding of the airbrush by the art world, the world of advertising and especially by those students who want to take up the journey that I began all those years ago.

Michael English

INTRODUCTION

The airbrush has played a crucial role in the development of the popular art of the twentieth century. The images it has produced for posters, advertisements, books, magazines, record covers and animated cartoons are all part of everyday life, even though they are often not recognized as airbrush work.

Invented in 1893 by Charles Burdick, a watercolour artist who wanted a quicker, more efficient way of applying paint to a surface, the airbrush is a delicate instrument with carefully designed capabilities. It is aptly named: the airbrush physically resembles a fountain pen more than an ordinary brush, but its flow of medium has the fluidity and covering power of a painting tool. Properly handled, it can also produce a line as fine as that of a sharp pencil. Effective use depends only on the mastery of basic control and simple methods of masking. With these skills, the airbrush artist can proceed to use the technique in a variety of ways, from the simple to the extremely sophisticated.

The first major use of the airbrush, in the early years of this century, was for photographic retouching. Here, the prime target of the work is invisibility. Retouching cleans and sharpens a photographic image, but is not meant to be obtrusive in itself. Early airbrush artists learned their technical and perceptual skills by long apprenticeship; photographic studios also provided many graphic artists with an introduction to the unique capabilities of the tool.

The airbrush's central role, however, is now firmly in the context of graphic art. For designers and illustrators, it is an indispensable part of their studio equipment, an instrument which greatly widens the scope of their creativity. It is used in its own right for fully airbrushed illustrations while it also offers the capability to combine images coherently, and to make subtle adjustments to photographic or hand-drawn work. It adds a certain style and character to an image which could otherwise only be achieved by laborious manipulation of conventional artists' tools and no other technique can imitate its shimmering, soft-focus effect. The airbrush uniquely provides the means to create particular effects of colour, tone and texture, effects now taken for granted in the repertoire of design and illustration.

Arising out of its use in graphic art, the airbrush has also exerted both a direct and indirect influence on the fine art of this century. On the most basic level, some fine artists have incorporated airbrushing in their work because the technique particularly answers a problem of style or expression. Here, the airbrush is used simply as an instrument capable of achieving certain effects, or of making a certain kind of mark. On a further level, however, the graphic styles which rely on airbrushing have been assimilated and developed by fine artists, whether or not they use the instrument to achieve their ends. In this context, the influence of the airbrush is particularly interesting, because of the way in which it illustrates the persistent division between the world of graphics and the world of traditional fine art.

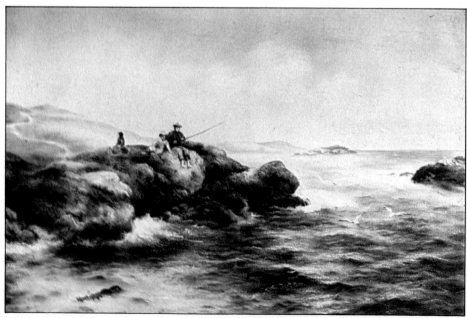

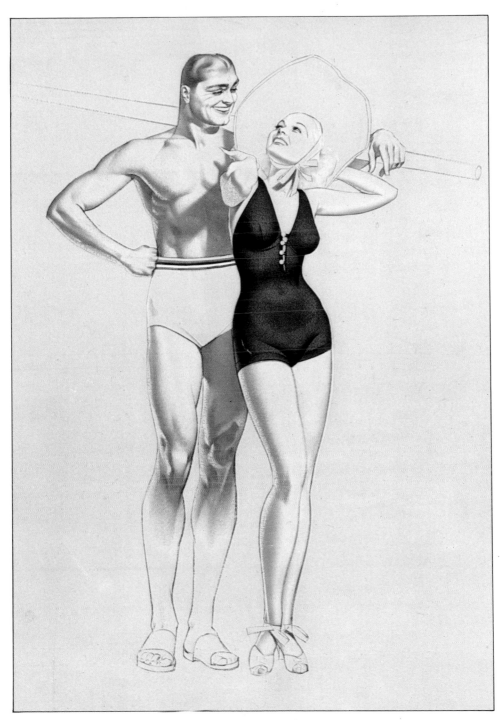

LEFT One of the first to take advantage of the new airbrush was Sydney Winney. In 1904 he used the technique to create this naturalistic, romantic scene in the same way as artists had previously used ordinary brushes, and with similar results.

The streaked, shadowy effect in sepia watercolour is well suited to the movement in the water.
ABOVE George Petty was one of the best-known American illustrators of the 1930s and 1940s. He developed the popular pin-up image while working for *Esquire* magazine and later in advertising. The slick, graphic representation of figures in this Jantzen swimwear ad was achieved with a combination of techniques. First, the descriptive outlines were drawn, then modelling hand-painted in watercolour, with some use of crayon. Airbrushing gives the even finish to the forms, smoothly describing muscle contours without any brushmarks.

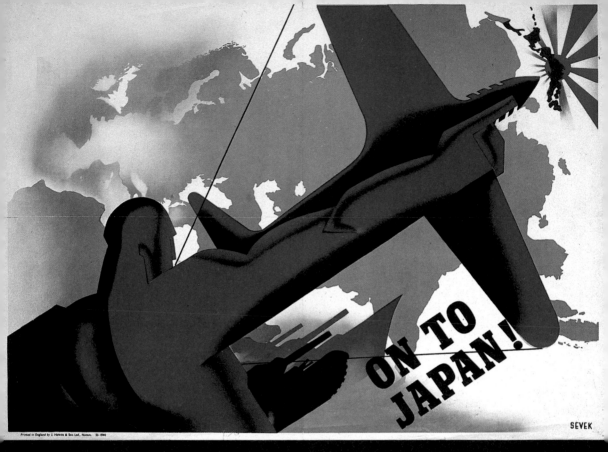

Printed in England by J. Howitt & Son Ltd., Nottm. SS-1944

ON TO JAPAN!

SEVEK

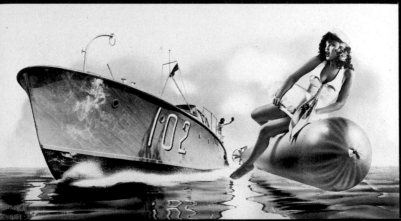

TOP This powerful graphic image by the French propagandist Sevek, was produced by a combination of loose and hard masking. The land masses and the sea were masked with Frisket or tracing paper gummed to the surface and sprayed alternately, then an overall blue vignette

added. A flat gouache was laid over the precise shapes of the figure and the aeroplane, and shadows worked.
ABOVE A fine example of photo-retouching, this image was created by Richard Manning for a record sleeve. Four sections of black and white photographs were

montaged and the ship's bow wave airbrushed before a sepia-toned copy print was made. Using photographic water-based dyes, the colours were both airbrushed and hand-tinted. The clouds were masked with cotton wool to give the effect of softness.

RIGHT *Abierto*, Ben Johnson. Airbrushing is used here in the context of fine art. Hard masking, in the curtains and the window frame, has been combined with softer effects, and brushwork added for the tiny details. The static composition creates a tranquil scene.

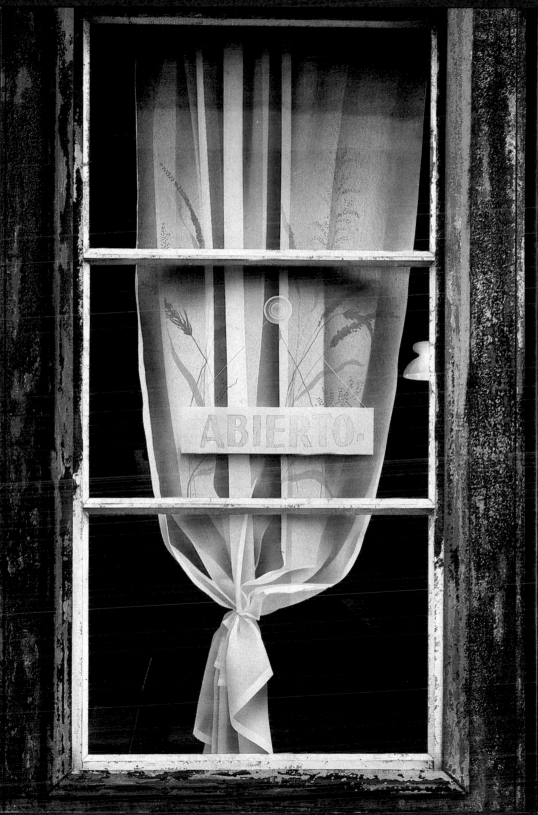

Art and the airbrush
The sprayed image

The airbrush is, without question, the most sophisticated and versatile of all spraying tools. Sprayed colour has always had a powerful appeal, both because of its appearance and its method of application.

The sprayed image is as old as painting itself. In the cave paintings at Lascaux in France, the outline of a human hand recurs, created by pigment dispersed over and around the hand. The pigment was probably blown through a hollow stick or bone and the technique represents the first use of masking and spraying, exactly the same in principle as work done now with far more sophisticated equipment. The precise techniques of the cave painters are still a matter of speculation, but it would seem that broad areas of colour were sprayed in this way, applied into black and brown outlines sketched in with primitive brushes made of moss or hair.

The usual assumption about the purpose of these cave paintings is that they formed part of the magical hunting rituals of early peoples, a way of making magic to bring creatures under the hunters' control. Deer, horses and bison are shown tumbling across the cave walls, and the layering of the images suggests that they were constantly reworked, perhaps seasonally. The power and vitality of the creatures are vividly represented, but it is interesting to note that where human figures occur they are minimal and symbolic in form compared with the fluid naturalism of the animals. The outlined hands suggest a different purpose, perhaps providing a simple way of testing the spraying technique which was then exploited more fully in the large compositions. Many of these paintings are vast, the animals well over life-size. On a practical note, it appears that spray painting was appreciated as a device for speedy and efficient rendering of a planned image, a function it still serves.

A more recent use of spray painting has been the widespead appearance of spraycan graffiti in large towns and cities. Much of it has little romance or style and here the aerosol can, originally sold for retouching car bodies or painting household objects, is merely a device for drawing or writing quickly on a large scale. The thoughts expressed in the graffiti may be blunt, witless or unoriginal but even in these cases the soft power of the aerosol spray has an arresting

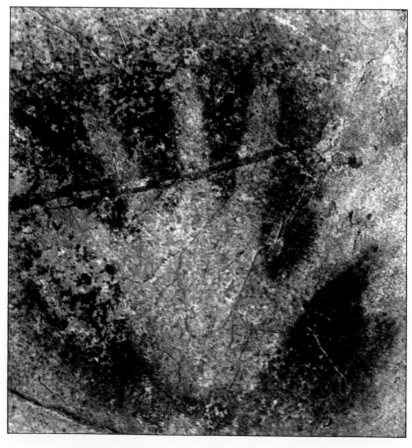

quality – it draws the eye. In a further development, occurring in the New York subways during the early 1970s, sprayed lettering and designs spread across whole walls and over the subway trains themselves, in an explosion of colour and texture rivalling the products of more professional artists. Whether it is a protest or a celebration of urban life, the aesthetics are instinctive and are enhanced by the shimmering edges between bands of colour. These have a luminosity lacking in the solidity of brushed paint.

The graphic influence

The distinction between fine art and the graphic arts is not a matter of a simple clear definition. Neither is it clear why this division often implies a judgement of relative values. The airbrush is often regarded as a designer's or illustrator's tool; its mechanical nature still offends many traditional artists and those who hold traditional views about painting. An illustrator can work in oil paint, a painter with an airbrush, but this type of crossover remains relatively uncommon. Despite obvious differences between graphics and fine art, with respect to function, scale, display and dissemination of

works, there is no firm reason why such a split should persist.

Two major movements in twentieth-century art have confronted this division of artistic disciplines directly, however, and have achieved some fusion of ideas in terms of principle, technique or image-making. The Bauhaus, a German school of art and design, was a major influence on European arts in the 1920s and subsequently in the United States, when many of the Bauhaus teachers left Germany under the threat of the Nazi regime in the 1930s. Pop Art is a style which arose independently in Britain and the United States in the early 1960s, when a number of young artists realized that their traditional pictorial conventions had lost touch with the changing world around them. It introduced as subject matter the numerous, everyday incidental items which are so much a part of life that hardly anyone cares to remember who designed them, or when, or why. These two movements had quite different intentions and are certainly represented by very different results, but both challenged accepted standards of the role of fine art in a fast-moving atmosphere of social and technological change.

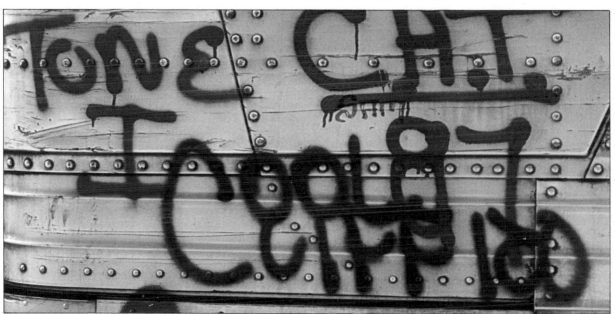

LEFT Dating from 15,000 B.C., this hand outline on a cave wall at Puente Viesgo in Spain must be one of the earliest examples of spray painting. The shape of the hand is still quite clearly visible. Using the hand itself as a mask, pigment was probably blown on and around it through a hollow bone or stick. The purpose of such a mark is also uncertain; the cave painters may have been testing the technique before venturing on a larger project or the mark may have been intended as a kind of signature. ABOVE Urban graffiti could be seen as an art form inasmuch as ideas are expressed in a distinctive and compelling way. Applied using a can of spray paint, the graffiti in this photograph was sprayed onto the side of a New York bus. Here, the subway stations and trains are renowned for their graffiti; it only takes a few hours for a new train to be almost completely covered. Spray paint is an ideal medium for this type of immediate expression.

THE BAUHAUS The work of the Bauhaus was geared towards combining the best efforts of designers, artists and technicians to create an indissoluble link between the functional, technological and aesthetic properties of work in the arts. The areas of concern included graphics, textile and furniture design, ceramics, theatre, architecture and stained glass, as well as painting and sculpture.

The Bauhaus teachers, while having special skills of their own, conducted experiments and analyses with their students in a number of different disciplines. Under the leadership of Walter Gropius (1883-1969) a comprehensive study curriculum was developed to give the students practical experience of all the available techniques and to equip them with a proper understanding of visual principles and conventions. Gropius himself was responsible for ideas which became fundamental in contemporary architecture; Joseph Albers (1888-1976) developed the colour studies which formed the basis of his later work *The Interaction of Colours* (1963); Paul Klee (1879-1940) and Wassily Kandinsky (1866-1944), teaching drawing and painting, promoted an understanding of abstract form and its relationship to three-dimensional construction; László Moholy-Nagy (1895-1946), Lionel Feininger (1871-1956) and Johannes Itten (1888-1967) were among others on the staff. The Bauhaus was an extraordinary and exciting combination of great talents in one establishment, dedicated to generating its own principles of art and design, in theory and in practice.

The Bauhaus had two different phases, one at Weimar, 1919-25, and the other at Dessau, 1925-28. The school survived the departure of Gropius in 1928 and ran until 1933 when it was closed by the Nazis. A major figure in the Dessau Bauhaus was Herbert Bayer (b. 1900). He had studied with Kandinsky in 1921, having already trained in architecture, and then, after a period spent in travel and painting, Bayer rejoined the Bauhaus as a member of staff, teaching advertising, layout and typography.

Bayer was an inventive force in the area of graphic design, constantly questioning the conventions of visualization and even of written language itself. His poster designs and layouts demonstrate his belief that graphic art should be simple and direct, commanding attention immediately, communicating its message and remaining in the viewer's memory. He made good use of tone and colour contrasts and of two-dimensional representation of spatial structure. The latter was expressed through dynamic line and carefully arranged differences in the suggested scale of various pictorial elements. This interest in relative size he also applied to figurative imagery, using a stylized face on a grand scale in a hoarding advertisement, for example, or including a tiny figure in a geometric design suggestive of vast space.

The emphasis on technical possibilities which was such a feature of Bauhaus teaching is clearly apparent in Bayer's work. He included airbrushing with collage,

photography and montage, typography and a full command of conventional drawing and painting techniques. Airbrush painting suited the huge, echoing spaces invoked in some of his designs, and the surface texture of his peculiar, mask-like renderings of human faces. His inventiveness was displayed not only in the coursework of the Bauhaus and formal commissions for graphic work, but also in the lighthearted side of school life – posters for parties and festivals and personal tokens such as the screen designed as a birthday gift for Gropius. This included kisses, the imprint of the lips of each student, and typography carefully arranged to give the birthday message.

The airbrush was no more celebrated at the Bauhaus than any other available technique, but it was used without hesitation or prejudice, and formed an important strand in the visual vocabulary of artists and designers. Working closely with Bayer, Moholy-Nagy was responsible for building up the photographic facilities in the school, and

encouraging the students to experiment with the potential of the medium. The work here included montage and retouching, in which the airbrush was a vital tool. Moholy-Nagy well understood the power of the photographic image and was equally aware of the artist or photographer's ability to manipulate the camera's capabilities.

Such was the influence of the Bauhaus that much of the teaching in art and design to this day still functions along guidelines similar to those it originated, whether or not the current participants are aware of these influences. Products made in the Bauhaus workshops and by Bauhaus teachers set standards for modern design which are now taken for granted. When the school finally closed, the artists left for other countries and jobs, and the principles of the Bauhaus spread rapidly, especially in the United States where Albers, Bayer, Gropius and Moholy-Nagy all went to work, live and teach. Bayer settled in the United States in 1938, after a period as art director of German

ABOVE *Random Illusion No. 4*, Peter Phillips. In this large painting, Phillips has borrowed some components of graphic art and transformed them into a still life. The cubes and cylinders are simply but effectively represented and juxtaposed with other clear images, for example the naturalistic birds. Phillips uses the airbrush because it is a convenient and practical way of laying in even colour, and it reinforces the impersonal style he often employs.

Vogue magazine. He continued his own work as a designer and also became a design consultant to several large companies, perpetuating his influence on the living art of the twentieth century.

POP ART is a product of the era in which graphic design discovered the breadth of its influence. The term "Pop" refers to a desire to confront and reinterpret the ubiquitous manifestations of consumer culture. Few movements in art have a coherent, communal identity in the manner of the Bauhaus. It is more common that the same, or a similar, idea strikes a number of artists within a brief period of time and their work gradually dictates a trend.

The many artists who can be categorized under the Pop Art label had different reasons for choosing that form, and also carried out their ideas by different techniques. Pop Art was not simply engaged in borrowing the images and products of a consumer society. What emerged was a common acceptance of the accoutrements of a society bent on instant gratification. Consumer products and the means of their promotion, advertising, were recognized as parts of contemporary life and therefore as appropriate subject matter for artists.

Pop Art was witty, celebratory and very much in tune with the times. For this reason some of it has dated, obtaining the curiosity value which contemporary ephemera eventually acquires. The major artists of the Pop period, however, fully understood their fascination with the fast and fashionable world they lived in and their work retains its capacity to surprise and entertain. Painters know only too well that there is a difference between making a graphic image and making a painting of one. The work comments as much on the conventions of painting as it does on the appearance of the world outside.

Although Pop Art borrows the forms of commercial design it less commonly makes use of the techniques by which the originals were made. One reason for this is the emphasis on scale in fine art – its relevance to the human scale of the artist and the usual size of the subjects portrayed. Much Pop Art is on a grand scale, epitomized by Claes Oldenburg's grandiose projects for public monuments in the shapes of such items as lipsticks, electric plugs and even the ballcock of a lavatory cistern (this to be floated on the River Thames). Few of these projects have been realized or sited, but the principle of a fundamental change of scale which releases the imagery from its normal context is a widespread feature of Pop Art.

A painter whose style derives directly from experience as a commercial artist is James Rosenquist (b. 1933). While he was working on abstract paintings, Rosenquist was also earning a living as a billboard painter on the streets of New York. Such work is by nature representational, but Rosenquist realized that the vast scale of the work gave each section of the image a totally abstract quality by divorcing it from its normal associations. He used this idea in his own work, producing paintings with jumbled, fragmented images of different types of objects. His painting *F-111* (1965) is 10 by 86 feet (3 by 26 m), divided vertically into panels. The subjects change every few feet, although they are linked by the streamlined jet hurtling through the whole image. A painting of a bomber plane may seem unextraordinary at this scale, but at the righthand end of the painting the viewer is confronted by a 10-foot (3 m) wall of spaghetti. *Above the Square* (1963) speaks directly of his time as a billboard painter. It is a section showing part of a pair of silky smooth legs, no different from those seen every day in advertisements for stockings and tights, but these legs are seven feet (2 m) tall, and this only from knee to ankle.

Such images – silky legs, moist spaghetti, aluminium and chrome machines – are all common photographic images or airbrush illustrations in magazines and advertisements. When a painting is reproduced on the page of a magazine it takes on much the same appearance as graphic work: scale and texture are almost obliterated. The graphic techniques used for such images may be inappropriate to the artist's concerns in a huge painting. A large part of the importance of Pop Art was that it reassessed the graphic images through traditional painterly concerns. Rosenquist remains a brush painter, as he was when working as a commercial artist.

By contrast, the British artist Peter Phillips has embraced both the style and technique of the graphic image. His work also consists of a careful structuring of interconnected images but its flavour is quite different from that of Rosenquist's paintings. British Pop Art arose independently from the American version and had a more whimsical, Surrealist tone. It is often concerned with jokes about the nature of the arts and the style of mass-media imagery. This is reflected in Phillips' work by series of paintings running under titles such as *Art-O-Matic* or *Custom Painting*. His subjects include glossy machinery, car advertising, and the sleek forms of animals, paralleled by those of female advertis-

ing models. In the paintings these are represented in composite images, some in vivid colours with a high-shine, illustrative finish, others more fully representational.

Phillips' early work was loose and gestural but he gradually absorbed a more graphic style of presentation. The paintings were worked out in studies on paper, then transferred to canvas on full scale. For this work he began to use an airbrush, partly as a convenient tool for laying in colour quickly,

but also to enhance his imitation of the advertisers' high-gloss style. He is quoted as having said, "I don't want to be a machine like Warhol, but I love the idea of using one." This suggests a fascination with the depersonalizing effect of the airbrush, the supposed property of the tool which caused the initially suspicious response to it among fine artists. Unlike Warhol, who has a studio called The Factory in which technicians execute his ideas using mass-production techniques,

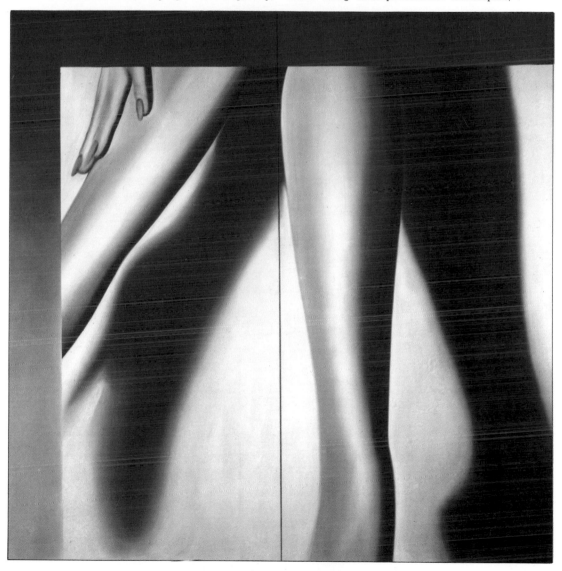

ABOVE *Above the Square* (1963), James Rosenquist. Airbrushing is traditionally suited to the representation of smooth flesh, and Rosenquist being aware of this, decided to exploit the tradition by repeating the image in a different medium. He used a simple graphic structure and attempted to produce an uninterrupted effect in this painting, which is reminiscent of stocking advertisements.

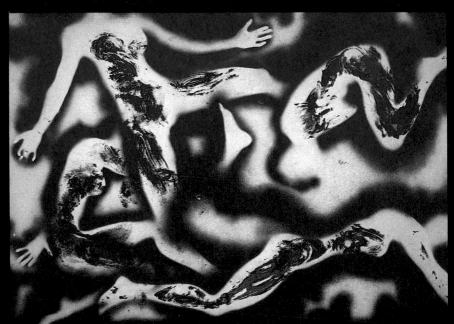

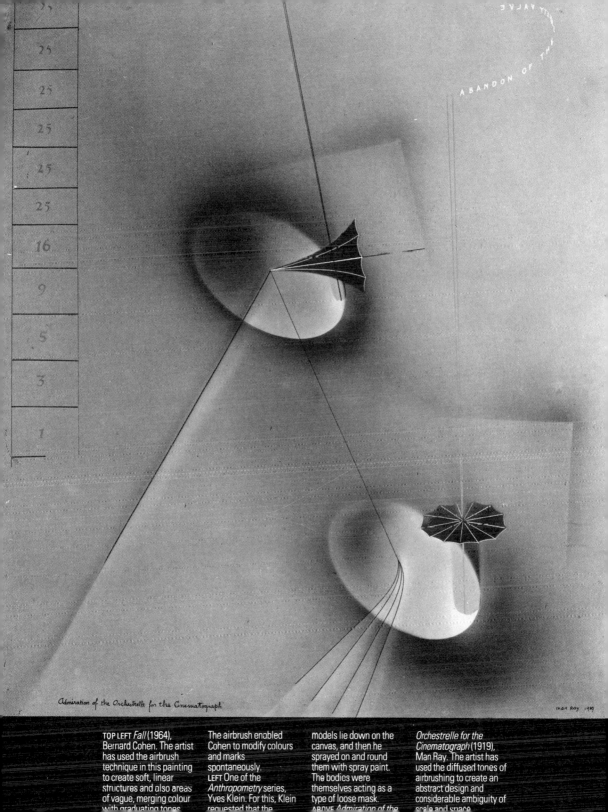

25

25

25

25

25

25

16

9

5

3

1

Admiration of the Orchestrells for the Cinematograph

man Ray 1919

TOP LEFT *Fall* (1964),
Bernard Cohen. The artist
has used the airbrush
technique in this painting
to create soft, linear
structures and also areas
of vague, merging colour
with graduating tones.

The airbrush enabled
Cohen to modify colours
and marks
spontaneously.
LEFT One of the
Anthropometry series,
Yves Klein. For this, Klein
requested that the

models lie down on the
canvas, and then he
sprayed on and round
them with spray paint.
The bodies were
themselves acting as a
type of loose mask.
ABOVE *Admiration of the*

Orchestrelle for the
Cinematograph (1919),
Man Ray. The artist has
used the diffused tones of
airbrushing to create an
abstract design and
considerable ambiguity of
scale and space.

Phillips has retained the personal relationship of artist and medium. However, he has freely incorporated a mechanized tool among his techniques since it is particularly suited to his style of presentation.

Direct applications

It is interesting to discover why some artists do make a deliberate choice to use airbrushing and in what ways it is appropriate to the concepts involved in their work and the required surface appearance of the paintings. Several artists who have incorporated sprayed paint in images have not needed a tool as precise as the airbrush. Aerosol cans of paint, spattering from large decorator's brushes and simple mouth diffuser sprays have all been used and found adequate for certain results. But there are several artists to whom the airbrush is as vital as it is to an airbrush illustrator, and the character of airbrushed paint and of the tool itself forms a significant strand in the conception and execution of the work.

Charles Burdick, the inventor of the airbrush, was himself a watercolour artist; his skill with the airbrush is evident from a very fine freehand portrait, the only remaining example of his airbrush work. Freehand use of the airbrush is more common in painting than in illustration, again mainly because of scale. It is easier to manipulate the spray without masking over a broad area of canvas than it is on a compact illustration board. Another early airbrush painting which shows a fluid, painterly style is a seascape by Sydney G. Winney, which won a competition for airbrush paintings held in Paris in 1904. The existence of this competition suggests that there was considerable interest in airbrush painting, though it was not welcomed in traditional art establishments, either as a skill to be taught or as a technique for exhibition pictures. At that stage the prejudice against mechanized art was strong and widespread.

One major artist who became very interested in the potential of airbrush painting was Man Ray (1890-1977), the American-born painter, photographer and film-maker. Man Ray lived in Paris between the wars and was prominent among Surrealist artists. He wished to shake the conventions of fine art and experimented endlessly with various media. A large part of his work in Paris centred on photography; he invented Rayographs, images made by reaction of light on film but without use of a camera.

Before this Man Ray had experimented with airbrush painting, calling the resulting work aerographs. He enjoyed the similarities with photographic images and felt that his unconventional intentions were enhanced by working with a tool which did not touch the picture surface. Although he found the results very satisfying, he was less impressed by the reaction to his work. The airbrush was again firmly rejected in art circles and his aerographs provoked hostility and accusation. Despite his desire to flout accepted attitudes, Ray was clearly either too discouraged by the response or was too quickly diverted to other work, for he did not continue to promote the technique.

A number of rapid changes took place in painting after World War II. Focus shifted from Europe to the United States, and from figurative to abstract painting. Abstract Expressionism flooded the art audience with huge vistas of colour and texture; the substance of paint gained a more important role and unconventional techniques gradually infiltrated, eventually achieving a general acceptance. Artists began to experiment with different types of paint produced for industrial purposes, and found new ways of applying the material.

A major catalyst of this period was the work of Jackson Pollock (1912-56). In 1936 Pollock joined an experimental workshop set up by the Mexican painter David Siqueiros (1896-1974). Siqueiros had used spraying techniques in his mural paintings and the workshop contained spray gun and airbrush equipment. Pollock tried out these tools, but ultimately developed his characteristic technique of dripping and pouring paint onto large canvases spread on the floor. This formed the basis of all his later work. The paint was thick and applied in a linear tracery – not a style which would be suited by an instrument as delicate as an airbrush – but some control of the medium was necessary. One of the devices which Pollock tried was a large basting syringe, albeit a primitive mechanism compared to the airbrush, but similar in that it preserves some distance between the tool and the surface and maintains a continuous flow of medium.

At a slightly later time, another artist was experimenting with unconventional painting methods. The French artist Yves Klein (1928-62) attacked painting traditions by exhibiting canvases covered all over with a plain, vibrant blue. In other work he reinterpreted the traditions of figure painting by working not from a live model but with the model. He covered nude women with paint and directed them to press their bodies against the canvas, this support being, like Pollock's, spread on the floor. In some of the

paintings in a series called *Anthropometry*, Klein also sprayed round the models as they lay on the canvas, forming ghostly, distorted silhouettes around the marks made by the figures' imprints.

Splashes of publicity accompanying such new developments at first drew public antipathy and some fairly superficial curiosity. But in the wake of these technical innovations and the broader approach to subject matter introduced by Pop Art, painters have largely been left to proceed in any way which seems to them appropriate and convenient.

ABSTRACT PAINTERS The British painter Bernard Cohen (b. 1933) pursues very well-defined intentions in his work. The emphasis is on the process of mark-making and the series of decisions which the artist must make to direct the way the paint surface develops. In paintings made during the early 1960s Cohen developed certain pictorial symbols and painting techniques which he tested in various ways. Although relating to specific themes and images, these paintings gave the viewer no overt clues as to their origins. Some have a geometric form while others seem to have grown organically. The common factor is the attention commanded purely by surface effects – by colour, shape and texture on the canvas.

In 1962 Cohen first sprayed paint onto a canvas to establish a ground for the subsequent linear marks. This paint was applied with a perfume spray, which produced a broad, relatively uncontrollable, hazy line. Spraying became an important aspect of his technique, a means of modifying colour and altering painted marks as well as a way of achieving soft linear effects to contrast with the more definite brushwork. In the following year, he began to use an airbrush. This reproduced the physical character of the earlier sprayed work, but with far more precision and control, increasing his capacity to make decisions about the quality of different elements within the painting.

Throughout the 1960s, Cohen frequently limited himself to working in monochrome. Some of the paintings are a sophisticated development of simple concepts, such as Klee's notion of "taking a line for a walk". Cohen's work is far from random, however, and unlike many other artists, he does not believe in concealment and deceiving the eye. What appears in his paintings is what is meant to appear, since he is under no obligation to create pictorial illusions of any kind. In works using vibrant colour he sometimes developed a tangled web of marks to fill the picture surface completely, while in others only a proportion of the canvas is occupied by evidence of activity.

In a series of later works Cohen again investigated the painting process itself. He sprayed discs of colour at intervals on a clean ground, painted over them in white and sprayed discs again, close to where the original colours had been. Continuing in this way he created "white" paintings in which ghost images of the discs float, literally, in the surface of the paint, represented perhaps by a final mark which is allowed to remain uncovered. The white paintings illustrate Cohen's idea that every mark made on a canvas contributes positively to the final effect, whether or not the mark is subsequently covered. Spray paint from the airbrush is materially different from other types of painted marks; the emphasis on process in Cohen's work requires the fullest technical range he can achieve.

Another British artist who has used the airbrush in purely abstract painting is Peter Sedgley (b. 1930). His work has a wholly different emphasis from that of Cohen. Sedgley has been involved continuously in experiments with colour, light and movement. Lately, he has developed these preoccupations in constructions which emit coloured light, with changing patterns triggered by sound or movement in the immediate environment. In his previous work, he experimented fully with the optical effects of colour in static pieces, through paintings and prints investigating different colour relationships.

In a series of these studies Sedgley chose the format of a target, the radiating figuration of concentric circles. This structural device was also used by Jasper Johns (b. 1930) as a basis for gestural painting in heavily textured paint and by Kenneth Noland (b. 1924) for hard-edged colour abstractions. The target is a symmetrical, wholly self-contained shape, with no interruptions or projections; Sedgley could manipulate bands of colour of varying widths to set up apparent vibrations within the form. Airbrushing allowed him to overlap and melt the colours together, increasing the shimmering effect. These paintings do have a luminous quality which is not easy to obtain with other methods of paint application.

FIGURATIVE PAINTERS "Super Realism" is a style of painting which is based on and imitative of photographic images. A number of major artists have emerged under this label, all making paintings which are breathtaking in their precision and detail, but each

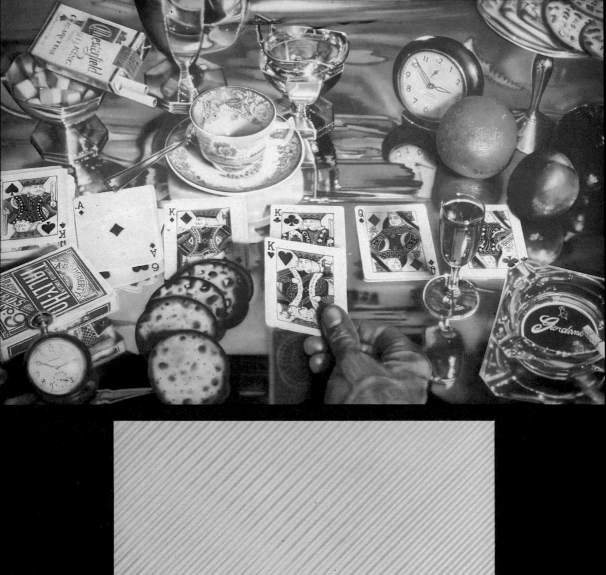

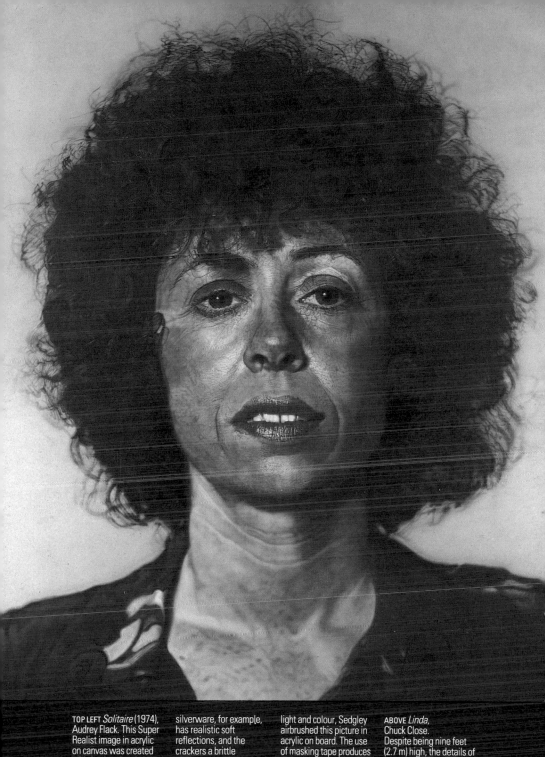

TOP LEFT *Solitaire* (1974), Audrey Flack. This Super Realist image in acrylic on canvas was created with freehand and masked airbrushing and brush painting on top. The textures of the objects are well noted: the silverware, for example, has realistic soft reflections, and the crackers a brittle roughness.

LEFT *Oranges and Lemons*, Peter Sedgley. Experimenting with the optical effects of static light and colour, Sedgley airbrushed this picture in acrylic on board. The use of masking tape produces hard lines and with vignetted colours in between, the result is shimmering, even luminous.

ABOVE *Linda*, Chuck Close. Despite being nine feet (2.7 m) high, the details of this portrait, for example the pores of the skin, are objectively and minutely represented with a photographic effect

preoccupied with a different type of realistic imagery. As in the relationship of Pop Art to its subjects, Super Realism closely recreates the photographs on which the paintings are based, but the techniques applied and the context or form in which the work is displayed demand a new perspective or response from the viewer.

One of the most startling manifestations of this capacity to reinterpret two-dimensional form occurs in the work of the American artist Chuck Close (b. 1940). Close originally worked on abstract paintings; when he moved to figurative work he became interested in the sense of illusion this type of painting demands. He began to use photographs as the basis for paintings, limiting himself entirely to the visual information contained in the photographic image, however minimal or impure. He hit upon the idea of translating the figure to a huge, inhuman scale, treating the subject matter as an abstract problem for interpretation. After an early, inconclusive attempt to deal with a female nude in this way, Close started to work on portrait heads, still on a gigantic scale, blown up from small snapshots of himself and his friends.

At first this work was done in monochrome; and later in colour using a rigid system of separation of colour values, akin to printing techniques. Close has used an airbrush consistently since the late 1960s. The technique gives him a uniformity and control which corresponds to the coherence of a photographic image. Close says the camera "makes no hierarchical decisions" about the relative values, in aesthetic or human terms, of one part of the face over another. He tends to start a painting by working on the eyes, since this area usually has the sharpest focus in the photograph. The illusion is built up over the whole image gradually, sprayed with the airbrush. The form is enlarged by drawing a grid over the photograph and working each section as an abstract pattern area on a larger scale. Some detail is achieved by wiping and scratching at the paint when the overall tones have been laid. When working in colour, Close overlays a series of predetermined tones one on another. The translucency and gradual accumulation of airbrush spray allows him to control the mixture of colours and create subtle flesh tones.

The impact of a head nine feet (2.7 m)

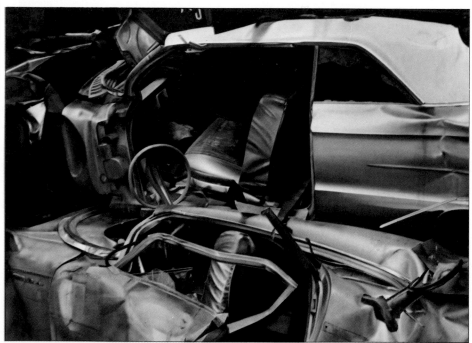

ABOVE *White Roofed Wreck Pile* (1971), John Salt. The airbrushing technique is well suited to the representation of polished metal, as is proved by its traditional use in car advertising. Here, the technique is ironically used in fine art to illustrate wrecked and dulled metal. Texture and volume have been successfully rendered.

RIGHT *Roving Redhead*, Philip Castle. The form of Rita Hayworth, displayed in front of her echoed position on the side of a Flying Fortress, illustrates the finesse possible in controlled freehand airbrushing. The artist used many different techniques to manipulate the gouache medium for the polished, dramatic effect.

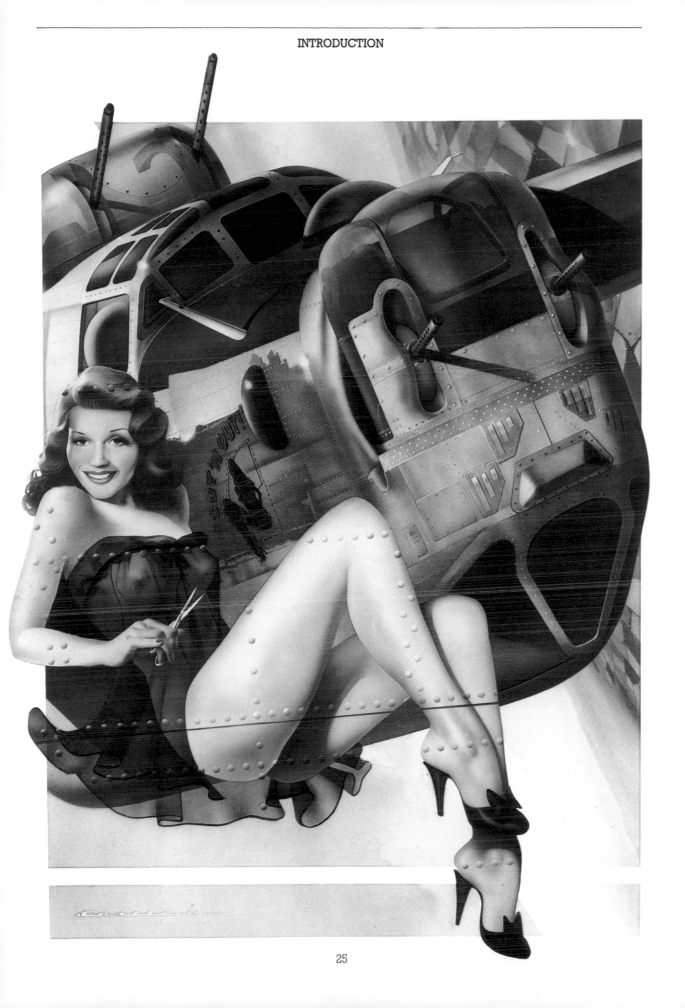

high, reproduced in faithful detail, is both disturbing and intriguing. Because of the scale, tiny details such as beard stubble or eyelashes become huge and crudely shaped in the finished painting. The effect of Close's work is lost when a painting is reproduced in a book or magazine, because the image is immediately translated back to its source – the colossal audacity of the artist's original concept cannot be appreciated in print.

Audrey Flack also works with the airbrush on a fairly large scale, although her imagery is not as stark and aggressive as Close's portraits. Instead, she creates a kind of twentieth-century iconography – demonstrating

a fascination with religious symbols, decorative statues of the Virgin and saints, and making pictures which act as cluttered shrines to contemporary symbols. Her painting *Marilyn* (1977) consists of two soft-focus pictures of Marilyn Monroe surrounded by lush fabrics, jewellery, make-up, glass and china, a lighted red candle and a single red rose. The persistent use of harsh red gives a premonition of violence and tragedy, contrasting with the richness and comfort of the material objects and the optimism of youth portrayed in the photographs. *Solitaire* (1974) is an equally crowded image, but less personal in tone. It shows the paraphernalia of gambling – cards, cigarettes, drinks, a

ABOVE LEFT *American* (1982), Andrew Holmes. This screenprint was created by hand, using a complex series of processes. From an initial line drawing, 15 separate drawings were made in black ink, one for each colour to be printed, on Kodatrace, a translucent plastic film. Each drawing combined lines, flat solid areas and sprayed areas, the latter made with a DeVilbiss air gun with the air pressure reduced to zero. The density of the dots sprayed was varied according to the density of colour to be printed. The film positives so produced were transferred photographically to silkscreen stencils. Ink was then printed through the negative areas on the screen, prepared for each drawing. Colours were proofed for each stencil, until the required effect was achieved.
ABOVE RIGHT *Queen's House, Greenwich* (1978), Ben Johnson. Having made a basic line drawing on gesso-primed canvas, Johnson produced the well-defined lines by masking the edges with tape, and built up the colours in many layers of acrylic paint using DeVilbiss spray guns. He utilized varying air flow pressures to create the different textures.
RIGHT *Mouthmill Stream, North Devon* (1982), Michael English. This remarkable impression of moving water was created using a combination of techniques. The artist made a drawing of the stream, then painted the greenery of moss and leaves onto a support previously covered with black acrylic. He cut the shapes of the reflections out of an acetate sheet mask, and covered the greenery while airbrushing white gouache. The mask was loose so the edges are imprecisely defined. The artist finished the work with a brush.

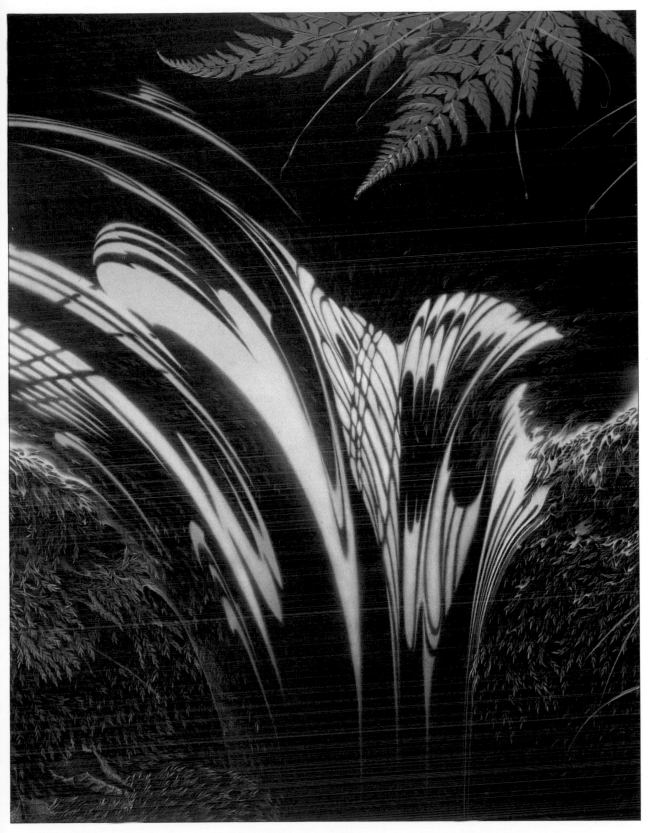

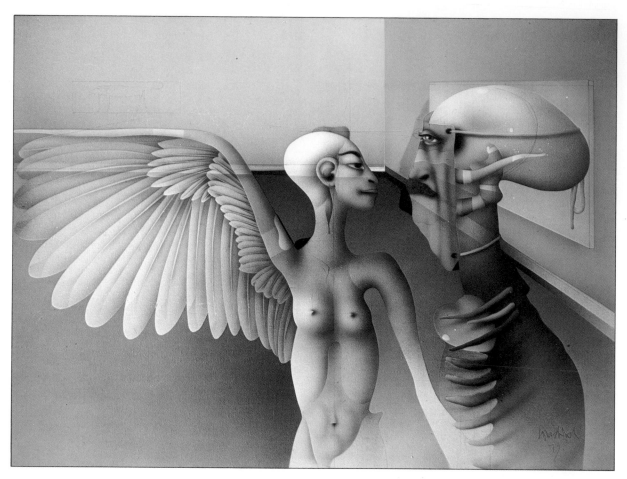

TOP *Sphinx and Death in Studio*, Paul Wunderlich. The fact that this composition is almost 11 feet (3.3 m) long, gives an idea of the delicacy and technical sophistication of the picture. Wunderlich displays an impressive knowledge of the human anatomy in much of his work and employs a wide mythological vocabulary, both of which factors lend his surrealist images a certain reference. However, the sense of ambiguity inherent in his work is enhanced by the smooth vignetting and blocking in, achieved by the airbrush.

ABOVE *Regensburg*, Boyd and Evans. Partly to make pictures less personal and "to point the viewer away from painterly concerns toward the subject matter" these artists use the airbrush in their work. It also provides them with a number of possible textures. The smooth area with spattered detail in the background contrasts with thickly laid paint in the foreground.

coffee cup and sugar bowl – but the evidence of human involvement is represented only by a disembodied hand at the foreground of the painting, which holds the King of Hearts.

Detailed display of lush texture and contrasting surface effects is typical of all Flack's paintings, including the series showing religious statues which the artist observed in European towns and villages. She uses the airbrush in a controlled and systematic way, similar to techniques of illustration but on a far larger scale. Each part of the image is worked to a high degree, sections and particular shapes being masked with large sheets of paper while she concentrates on other areas. Both oil and acrylic paints are used to achieve the highly finished rendering characteristic of her work.

John Salt, a British-born painter living in the United States, has said that he started working from photographs in order to eradicate the influence of other artists on his work. Interestingly, he is prepared to admit that he finds it easier to deal with photographs than with real objects because the form is already reduced to two dimensions. He uses an airbrush for soft-focus effects and smooth tonal transitions. His work portrays cars, usually wrecked or abandoned, and he likes the connection between airbrushing and the surface finish of the cars which themselves have been painted by spray techniques. In common with many of the Super Realist artists, he is dealing with images of contemporary life – but the damaged, isolated condition of the cars gives the paintings a timeless character and the imagery makes a peculiarly ambiguous appeal to the emotions.

It is interesting to note that Robert Cottingham, an American Super Realist whose work deals with reflective surfaces and advertising signs, chooses not to use airbrushing as a painting technique. This is not through unfamiliarity or prejudice, since his background as an artist was in graphic design and advertising. He simply feels the instrument is inappropriate to his current concerns.

Super Realism is largely an American phenomenon, but Ben Johnson is a British artist who also uses airbrushing in the creation of an exact, photographic style of work. Johnson has worked on a variety of subjects, but architecture is a recurring theme – both interior and exterior views. In recent paintings, he focuses on details of particular architectural features – lift gates, windows and doors. There is a rather haunted air about these buildings – there is evidence of human occupation but no figures ever appear. In the window paintings he concentrates on texture – the materials of the window frame, the fabric of curtains – and his painting technique is masterful in its control of subtle variations of tone and colour. Similar themes appear in the work of Brendan Neiland, a painter of urban landscape also working with airbrush and spray gun. Neiland is fascinated by the impersonal qualities of modern architecture and the reflective surfaces which interrupt the symmetrical forms of the buildings.

The work of British artists Boyd and Evans is unusual in several respects. Fionnuala Boyd and Leslie Evans work as a team and do not feel the need to explain who does what in developing the paintings. On the use of photographs and airbrushing they state their aim is "to develop a technique in which our own separate handwriting was not evident and to point the viewer away from painterly concerns toward the subject matter".

The images are composites, traced from slide projections to construct particular events. The rectangular shape of the canvas is not always respected – the canvas may be tipped on one corner or cut through by a diagonal composition. Spray painting is a major part of the technique, though in recent work the artists have also used thick, textured medium to give the paint surface a relief effect. Boyd and Evans deliberately demand the participation of the viewer. The narrative of their work is enigmatic; though it is suggested that there is a story behind the picture, it is no more precisely explained than is the nature of their working relationship. They emphasize that the importance of the work is as a visual, not verbal or literary communication.

Equally disturbing in effect, though quite different in character, are the paintings of the German artist Paul Wunderlich. His compositions are figurative, but he invents spectral, not human, figures which may be a combination of human and animal forms, or figures which draw on cultural myths and literary concepts. The fluidity and smoothness of airbrushing enhances the otherworldliness of the images and Wunderlich employs subtle tonal variations in the background to render ambiguous space which suggests a blank infinity.

Today, airbrushing is more generally accessible – an ever-increasing range of tools and simpler propellant devices are now available. It is as yet not such an integral part of the painter's technique as it is of graphic artists, but this selection of painters represent some of the different styles and concepts in which airbrushing is employed.

THE AIRBRUSH

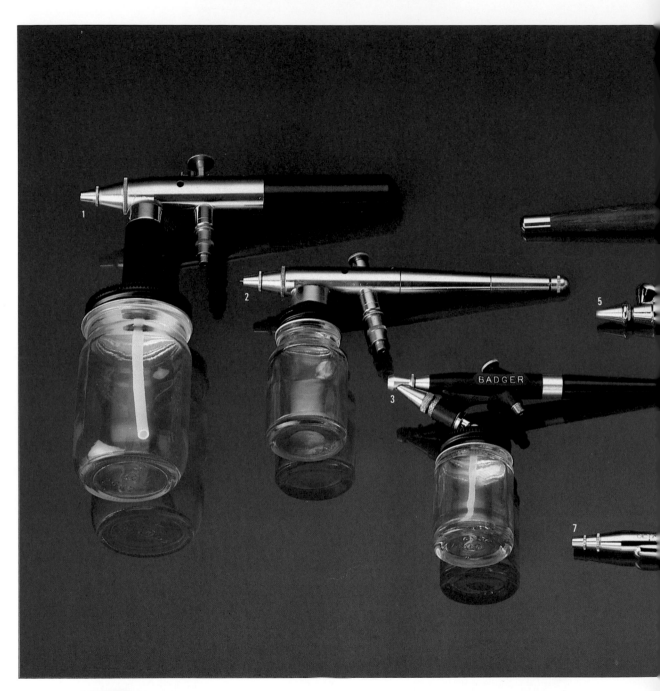

In fundamental design principles the airbrush has changed little since its invention. The shape has become more streamlined, the finish more immaculate and the engineering technology by which it is produced is more sophisticated and efficient. But the vital components of the best airbrushes are the adjustable needle that controls the flow of the medium, the nozzle in which the air and paint supplies are combined, and the lever mechanism which controls this mixture to a fine degree. All these elements were present in the design invented by Charles Burdick in 1893. Unfortunately there is no documentation describing how he arrived at this successful amalgamation of parts, and in common with other inventions of the industrial age, the airbrush was not the inspiration of a sole individual. Burdick, however, is usually credited as having produced the first and most influential product. Others were also

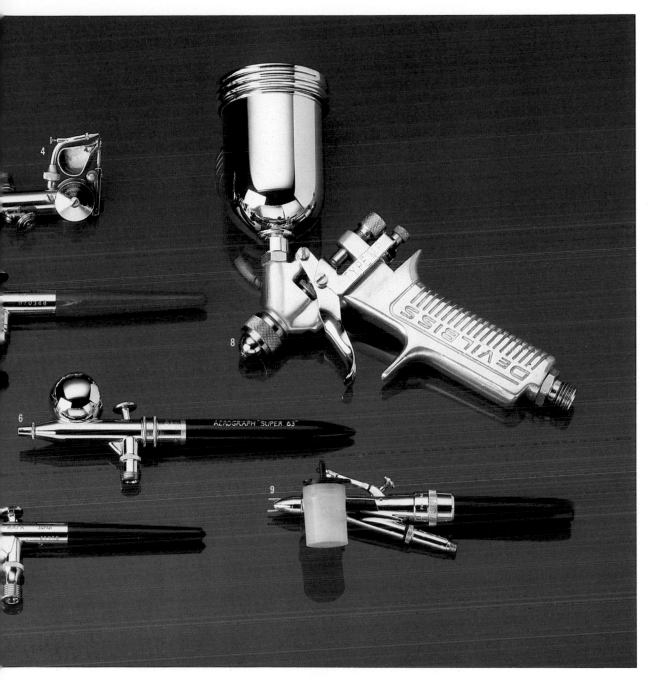

ABOVE Only 20 years ago, there were just two or three manufacturers of airbrushes. Today, a dozen companies worldwide produce over 50 different types of airbrush. The selection varies from rudimentary instruments designed for use in model making to sophisticated precision tools capable of satisfying the technical requirements of any graphic artist. While the DeVilbiss Super 63 is by far the most popular model sold in Britain, American airbrush artists prefer designs which feature a side cup, notably the Thayer and Chandler model A.
1. The Thayer and Chandler model C has the power of a spray gun.
2. Thayer and Chandler model E.
3. Badger 350, a single-action diffuser airbrush.
4. Paasche AB Turbo.
5. Paasche VJR.
6. DeVilbiss Super 63.
7. Olympos HP 100.
8. Aerograph MB, a spray gun for large areas.
9. Conopois F.

experimenting with the same concept at around the same time, most notably Jens A. Paasche, a Norwegian living in the United States. A U.S. patent for an airbrush case exists, dated 1888, suggesting that at least one other model was already in existence, but nothing more is known about it.

Burdick was American and worked originally on his airbrush design in the United States. When he moved to England he patented the device there and set up his first manufacturing company in London in 1893. He was a watercolour artist and it is assumed that the airbrush was a result of his attempts to find a way to apply transparent, even layers of this delicate medium other than with a hair paintbrush, which can pick up previous washes of paint or flood the paper too quickly if overloaded.

Burdick's first venture in manufacturing took the poetic title The Fountain Brush Company. It met with success and in 1900 he also founded The Aerograph Company. Though Aerograph was a tradename, it was subsequently used as a general term for airbrushes for many years. The company also developed industrial spray guns and gradually expanded its business, the industrial side advancing with the development of materials such as cellulose, which does not lend itself to swift application with an ordinary brush. During World War I there was a greater demand for the spray guns and the market grew thereafter. Spraying quickly assumed a vital role in car manufacture as the best method of distributing a quick-drying medium over a large, undulating surface area.

Parallel with the development of Aerograph, the DeVilbiss Company was founded by Dr Allen DeVilbiss, producing atomizers originally designed so that liquid medication could be applied to throat ailments with the least discomfort to the patient. Other spraying devices, for example perfume atomizers, were also developed and marketed. DeVilbiss was an American venture, but the company had an English subsidiary and in 1931 this branch merged with the Aerograph Company when Charles Burdick relinquished control to return to the United States. DeVilbiss is now a worldwide concern, still with manufacturing premises in England, and is recognized as producing one of the best airbrush ranges on the market, though the bulk of their business remains in industrial spraying equipment and techniques. The airbrushes are still marketed in connection with the brand name Aerograph.

Paasche, meanwhile, had set up an airbrush company in Chicago to produce what

was, and is today, a unique airbrush design, the Paasche AB Turbo. This operates on a different principle from that of other airbrushes and gives a fine spray which can emerge more slowly so the artist has a high degree of control. Paasche also market instruments with the more common design, and an air eraser which sprays a very fine pumice powder. More recently a number of other manufacturing companies have been set up in Europe, the United States and Japan, and there is now a large range of airbrushes designed to meet the various demands of both the amateur and professional market.

Airbrush manufacture

DeVilbiss and Paasche are the longest established airbrush companies. For years the demand for airbrushes was small but steady but demand has increased since the 1960s, partly owing to the greater interest in graphic images spread through posters, advertising and record covers, and also because technology has changed to bring the airbrush more within range of non-professionals. This is largely due to new, simpler and less expensive methods of powering the instrument. But whether for the professional or amateur markets, both old and more recently established companies have taken care to develop a range of airbrushes suitable for every purpose. To make the more expensive models, used by artists and designers, a manufacturer must apply precision engineering, careful quality control and a personal approach to the work which cannot yet be replaced by machine technology.

At the DeVilbiss factory, for example, every part is subject to spot checks and the assembled airbrush is hand-tuned and tested for spray quality, to detect air leaks and other possible faults. The prime concern is to produce a fine and consistent spray pattern within the range of each individual airbrush. One of the key factors is the concentricity of the needle tip and nozzle opening. Though the measurements are in thousandths of an inch, the nozzle tip is shown enlarged on a screen to ensure there is no variation.

The measure of the finest line the airbrush can produce is used to assess its quality. It is possible that the artist using the instrument will have no occasion to work so finely, and optimum performance is dependent on the artist's own skill, but this standard nonetheless exists for each model. A card with serial number, date checked and an example of overall tone and fine line spray goes with each airbrush when it is purchased.

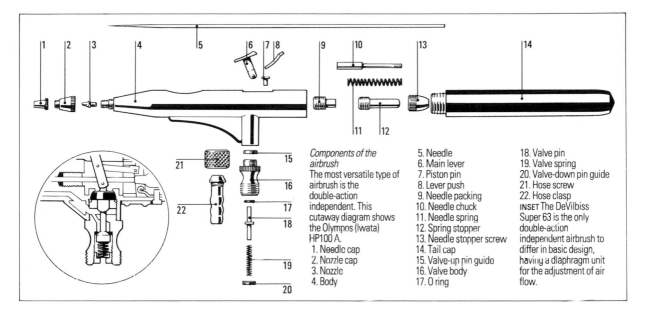

Components of the airbrush
The most versatile type of airbrush is the double-action independent. This cutaway diagram shows the Olympos (Iwata) HP100 A.

1. Needle cap
2. Nozzle cap
3. Nozzle
4. Body
5. Needle
6. Main lever
7. Piston pin
8. Lever push
9. Needle packing
10. Needle chuck
11. Needle spring
12. Spring stopper
13. Needle stopper screw
14. Tail cap
15. Valve-up pin guide
16. Valve body
17. O ring
18. Valve pin
19. Valve spring
20. Valve-down pin guide
21. Hose screw
22. Hose clasp
INSET The DeVilbiss Super 63 is the only double-action independent airbrush to differ in basic design, having a diaphragm unit for the adjustment of air flow.

The balance of the airbrush is another crucial factor. The metal components are brass, finished with chromium, so the operational end of an airbrush is relatively heavy. To counter this a weight is set in the handle. Each airbrush is inspected individually and the balance is also checked by an experienced operator.

Airbrush design

The most important factor to take into account when buying an airbrush is the type of work you expect it to do. There are very simple models on the market which really do no more than colour a surface quickly and apparently evenly. At the other end of the range, a few airbrushes can produce a line as fine as a six-point typeface, although a broader area of spray is also obtained. It is a false economy to buy a cheaper airbrush for detailed graphic work, as it would be an unnecessary expense to use a sophisticated model when spraying a large area of colour or a simple stencil pattern.

There are two main factors which dictate the accuracy and evenness of airbrush spray. One is the principle of internal or external atomization; the other is the single- or double-action of the lever controlling the spray.

External atomization

External atomization is based on the same principle as mouth-diffuser sprays: a stream of air under high pressure causes a pressure drop in its surrounding atmosphere. A mouth-diffuser is simply two hollow tubes hinged together at right-angles. The bottom of the lower, vertical tube is placed in a jar of well-diluted paint. When air is blown through the upper, horizontal tube the rush of high pressure across the top of the vertical tube causes the paint to be drawn in at the bottom where the pressure is lower. It then rises up and mixes with the high pressure airflow, making a spray of paint.

The simplest type of airbrush is really a small spray gun working on this principle, operated by a push-button lever. It has no needle or nozzle to control the flow of paint. What it has in common with the more sophisticated models is the size, the mechanized air supply and an attached paint well, so it is often categorized as an airbrush though being nowhere near the precision instrument used by artists and designers. The Badger 250 is of this type. The spray can be built up quite evenly, though it is not suitable for work in which a light or transparent spray is required. The general uses of this small spray gun might be for painting cardboard or plastic models, spraying through stencils or for making posters for local uses.

Some airbrushes which operate on the diffusion principle do combine the paint and airflow in close alignment within the tip of the brush. These are rather more refined and capable than the spray-gun type, though still short of the full potential of a more sophisticated airbrush. They run on a fixed relationship of paint and air, though they may have different nozzle sets which are interchangeable to vary the width of spray, but they cannot be finely controlled. The Badger 350, Binks Bullows Wren and Paasche H series are in this category.

Internal atomization

In all the airbrushes used for precise and detailed work, except the Paasche Turbo, the paint and air flows are combined in the nozzle to give a reliable, even spray. In these, the centralized fluid needle running through the body of the brush controls the flow of paint through the surrounding nozzle. The air is channelled through the outer layer of the front of the airbrush, converging on the paint supply within the nozzle. This process gives a consistently fine atomized spray which can be further controlled by the artist by means of either a single- or double-action lever. It is vital to internal atomization that the needle tip is absolutely concentric within the nozzle opening and that nothing obstructs the channels of paint and air at any point within the system.

Single- and double-action

In externally atomized sprays, a simple push-button control operates the airflow, which in turn draws out the paint supply. There is nothing which can vary either the speed or texture of the atomized paint. Internal atomizing produces a better consistency of spray, but if a single-action lever is the only control, it is very difficult to alter the spray reliably since the lever again controls only the airflow. A hesitant or uneven action on the lever may cause spattering or interruption in the surface coverage which is undesirable unless required for deliberate effect.

The double-action lever, a feature present in the earliest airbrush models, controls both the paint and air flows. It is usually a flat metal button on top of the brush mounted on a lever passing into the body above the fluid cup. It is pressed down to release air, then pulled back to release the medium. The downward movement opens the air valve. The second action draws back the needle within the nozzle opening to allow the medium to pass into the airstream.

Within the range of double-action airbrushes there are two different types – fixed double-action and independent double-action. Fixed double-action airbrushes are a small group, including the Conopois Model F, Humbrol Studio I and several models produced by Efbe. In these, although the paint and air supplies are both controlled by the lever action, their relationship is fixed and though the spray is reliable and even, the operator has no means of varying its qualities at source. An extra feature provided in the Conopois Model F is a ring which can determine the width of spray, from a hairline to a broad sprayed line.

Independent double-action airbrushes are the most versatile, since the action of the lever controls the proportion of medium to air supplied and the artist can continually regulate the density of the spray. Most airbrushes are of this type and are the most widely sold. For illustration and graphic work, the control afforded by the independent action gives the artist much greater technical facility than a fixed action airbrush, although the latter is easier to use since slight variations in finger pressure will not affect the balance of the spray. Operation of the independent double-action lever requires extremely sensitive finger control and most airbrushes are fitted with a cam ring or adjusting screw which fixes the lever at a chosen point to maintain a constant supply of medium. In effect this converts the brush to fixed action, but the operator has had two choices; firstly in whether to use the device and secondly in the amount of medium to be sprayed.

All DeVilbiss airbrushes have independent double-action and Paasche, Olympos (Iwata), Thayer and Chandler, Badger and Holbein all include several models within their ranges.

The Paasche AB Turbo

The Turbo is worth special mention since its construction is unlike that of any other airbrush. It is designed for absolute precision and can be invaluable for highly detailed work, but it takes time to master full control of its capacities.

The Turbo is an independent action, gravity-feed model. Within the working end of the brush the air flow operates a turbine which runs at 20,000 revolutions per minute, and this in turn moves the fluid needle, giving it a very rapid motion back and forth. Medium is fed onto the needle and clings because of tension caused by the needle's fast action. In another part of the brush the airflow bypasses the turbine and is channelled towards the nozzle section, where it meets and blows out the medium supplied by the needle. Described in words this all sounds a rather laborious process, but in fact by extremely fast repetition of this action a constant and very fine spray is produced. The Turbo is noted for the fineness of its line.

The turbine, which is lubricated by an internal grease cup attachment, has a speed control: a unique feature of the Turbo is that the spray can be slowed without any loss of quality. Another inbuilt feature is an adjustable screw by the nozzle which can be used to convert the spray to a coarse spattering by interrupting the air supply.

One characteristic of the Turbo which will

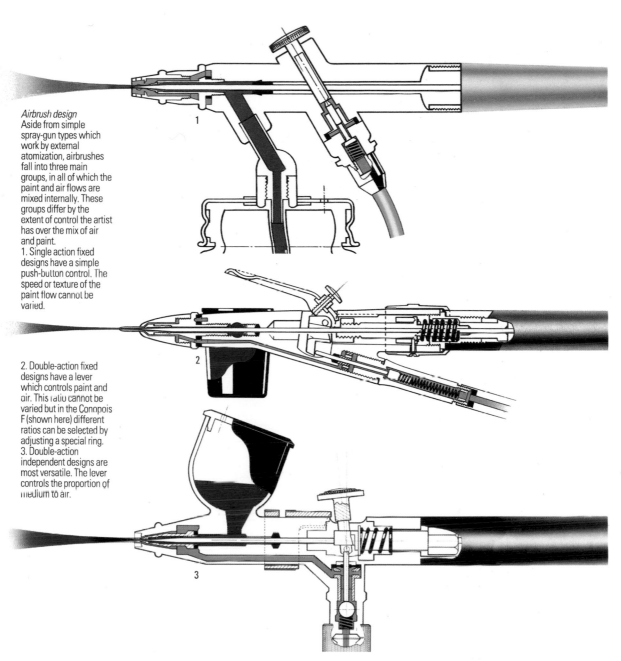

Airbrush design
Aside from simple spray-gun types which work by external atomization, airbrushes fall into three main groups, in all of which the paint and air flows are mixed internally. These groups differ by the extent of control the artist has over the mix of air and paint.
1. Single action fixed designs have a simple push-button control. The speed or texture of the paint flow cannot be varied.

2. Double-action fixed designs have a lever which controls paint and air. This ratio cannot be varied but in the Conopois F (shown here) different ratios can be selected by adjusting a special ring.
3. Double-action independent designs are most versatile. The lever controls the proportion of medium to air.

be unfamiliar even to regular airbrush users is that the air channel literally turns a corner to meet the fluid supply, so the spray emerges to one side of the body of the brush. It is not, therefore, directly in line with the hand and controlling finger, and this must be accounted for in directing the spray.

Supply of the medium

The common feature of all airbrushes is a reservoir which holds the liquid medium. There are two ways in which the medium is fed into the airbrush – suction and gravity feed. Suction-feed models are fitted with a transparent plastic or metal receptacle underneath the fluid channel, below or to one side of the airbrush itself, and the liquid is drawn into the path of the air. This again depends upon the principle described in the diffuser types, where high pressure above forces a drop in pressure below pulling the liquid upwards. Several very good airbrushes are fed by suction, including the DeVilbiss Aerograph Sprite Major and the Paasche VLS. The way the medium is delivered is not crucial in the superior performance of certain models, since this is dependent on nozzle and lever design.

The other method, gravity feed, as its name implies, relies on gravity to encourage the medium downwards. The fluid reservoir sits above the channel, either on top or to one side of the body of the airbrush. External reservoirs are cup-, bowl- or bucket-shaped, but there are several models – the Olympos (Iwata HP100-A), the DeVilbiss Aerograph Super 63A, the Efbe Retoucher, the Holbein Y-1 – which have a colour well recessed into the top of the airbrush itself.

As in suction-feed models the paint jar can be quite large, these airbrushes are suitable for spraying large areas where plenty of medium is required. In close or detailed work where the nozzle must be held close to the surface, this can be a disadvantage since the jar underneath the brush may be obstructive. But the other main advantage of suction feed, apart from fluid capacity, is that the jar is simply screwed or fitted to the main body of the airbrush and colours can be changed quickly simply by swopping jars.

In gravity-feed models, the colour cup or well is smaller and often inseparable from the body of the brush. In general, airbrushes with the colour cup on top are favoured over those with side cups as they are well balanced and easier to manipulate. Where cups are an integral part of the airbrush, they must be cleaned out thoroughly and refilled when the colour is changed. If the colour cup

is not sealed with a lid the artist must take care not to hold it at such an angle that the medium spills. Olympos (Iwata), Holbein and Grafo manufacture airbrushes with fairly large gravity-feed cups, but in general these hold less than suction-feed models.

Propellants

Until quite recently a major drawback for airbrush artists was that the air compressors used to power the brushes were large, expensive, heavy and extremely noisy. The engine in the compressor ran until a tank had been filled with air to a certain pressure. The compressed air passed from the tank into a supply hose and the motor then switched itself off until pressure dropped in the tank, when it started up again. In addition, moisture built up through condensation and had to be drawn off from the tank or it would eventually pass into the air hose and flood the airbrush. A special moisture trap, a small filtering device fitting between the compressor and the airbrush on the lead, could be applied to alleviate this problem.

Because compressors were expensive, and inconvenient to place or handle, regular airbrush work was mainly confined to graphic studios and specialist workshops. But during the 1970s, developments in propellant systems made airbrushing much more accessible and affordable.

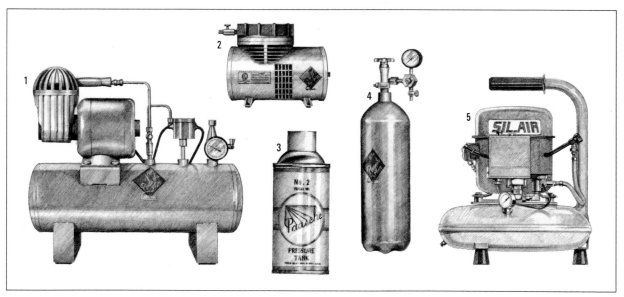

ABOVE Propellants vary from the traditional tank compressors (1), which are bulky and noisy, and cause a variation in pressure, to the new tank models, such as the Sil-Air (5), where the pressure is constant. Other types include direct compressors (2), operated by a foot-switch, air cans (3), and air cylinders (4) fitted with attachments.

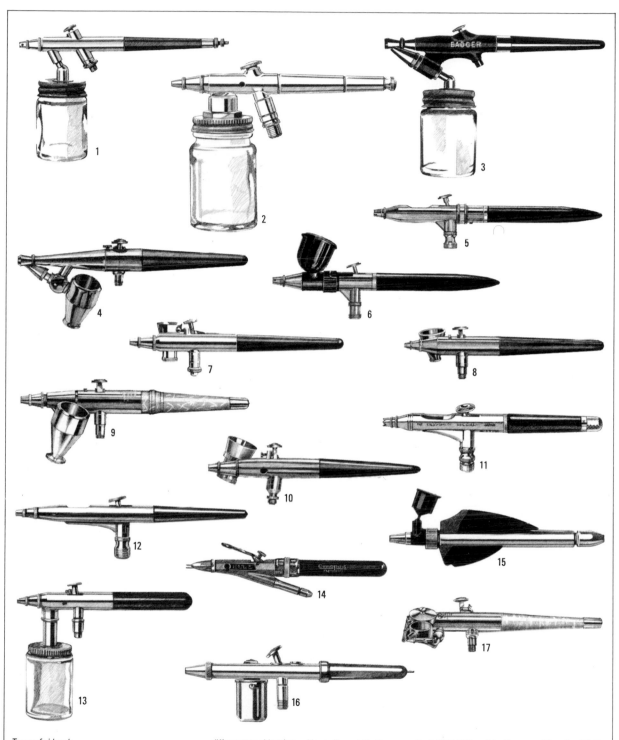

Types of airbrush

The Badger 200 (1) and the Thayer and Chandler E (2) are both single-action airbrushes with the needle inside the body. Two examples of external atomizers, airbrushes which are designed so that the medium and the air flow meet outside the main body, are the Badger 350 (3) and Paasche H (4). These are known as diffuser-type airbrushes, with needles outside the body. Generally considered the most popular category of airbrush is the independent double-action type. This category includes the Super 63 Aerograph (5), the Sprite Aerograph (6), the Badger 100 (7), the Paasche V1 (8), the Paasche VL (9), the Thayer and Chandler A (10), the Olympos (Iwata) 100 A (11), the Olympos (Iwata) SPA (12), and the Thayer and Chandler C (13). The Conopois F (14), the Humbrol 1 (15) and the Grafo 11B (16) have fixed needles and double-action. The Paasche Turbo AB (17) has a fixed needle but is in a category of its own because it provides the artist with an opportunity to change and then fix the medium/air ratio.

Tank compressors

Unlike the old models, modern tank compressors are portable, quiet and maintain the air supply at constant pressure. They also have inbuilt moisture filters so there can be no danger of unexpected problems in spray consistency owing to moisture escaping into the hose.

When the motor is switched on in the compressor, the reservoir tank fills with air to a high pressure, but the tank is fitted with a regulator which can be set to pass a lower, constant pressure into the hose attachment to supply the airbrush. For example, while the pressure allowed to build in the tank may be up to 80 psi (550 kilonewtons per square metre), the pressure allowed through to the airbrush can be set to a suitable level of 20 or 30 psi (140 or 210 kilonewtons per square metre). Whereas in the older type of compressor the pressure of the air supply dropped slightly as the tank gradually emptied, in modern versions the supply to the airbrush is stable because the pressure in the tank is always higher than required. Although the pressure in the tank does drop occasionally, the motor mechanism still works only inter-mittently to keep the reservoir always filled.

These compressors are convenient, clean and safe. They are fitted with check valves to ensure that the air cannot flow back from the tank towards the pumping systems, and there is a safety valve which lets off excess pressure if it builds up too high. Either two or five airbrushes can be run from one compressor, depending upon the manufacturer's specifications.

A word of warning is necessary in this context. If the air supply is released from the tank at the highest pressure possible the airbrush may be damaged. This can also be dangerous to the operator if the spray contacts the skin – the pressure can force air or particles of medium into the skin.

Direct compressors

Small compressors are also produced without a reservoir tank for the air. The air supply is created by a motor fitted with a diaphragm system and it is pumped directly into the hose connecting airbrush to compressor. One problem with this system is that the diaphragm creates a pulsing air flow and this makes the quality of the airbrush spray vary.

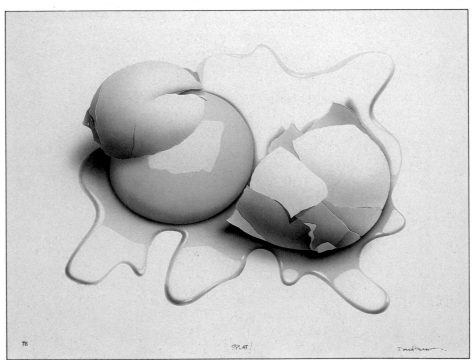

ABOVE *Splat!* David Jackson. This example shows the high degree of control possible with the airbrush. A fine graduated tone suggests the transparency of the egg white; modelling on the underside of the white in a flat grey implies volume. The highlights have been masked to allow the white of the board to show, retaining a transparent quality; the subsequent hard shapes were softened with a rubber. The soft shadow on the yolk was sprayed freehand, within the masked shape.

ABOVE *Warren Beatty*, Mick Haggerty. The grainy effect of spatter can be very striking in graphic work. A spattered texture can be achieved either by increasing the amount of paint and decreasing the amount of air or by using a spatter cap. With a double-action independent airbrush, pulling the lever back draws the needle out of the nozzle, making the aperture larger. By pressing the lever down slightly, a small amount of air will propel large particles of paint at the surface. Alternately, a spatter cap can be fitted, replacing the nozzle cap: this will give the same effect. Spatter caps vary in size and shape according to the model of airbrush.

The mini-compressors are cheaper than the tank type, but because of the pulse problem, and the fact that a moisture trap and regulator are not usually incorporated, they cannot be recommended for fine or detailed work, although they function well for general purposes. Manufacturers are working on improving direct compressors. A new type marketed by Royal Sovereign is claimed to be pulse-free and it is possible the problems will soon be overcome by manufacturers in the near future.

Air cylinders

Large cylinders of compressed air can be bought or hired. They are refilled by the suppliers when they run out. If a cylinder is used as air supply it must be fitted with an attachment for the air hose, incorporating a pressure regulator and preferably also a measuring gauge, so the air supply does not run out unexpectedly in mid-flow. Such fitments are available in some countries, but in other areas they must be custom-made by specialist dealers.

Air cans

Several manufacturers now market small cans of compressed air, together with a special fitment with a valve-opening device which screws on to the top of the can and has an outlet on which the air hose is fitted. The advent of air cans made airbrushing more simple; it is a relatively cheap way to learn control of the airbrush before deciding to invest in more sophisticated equipment.

Air cans are not suited to prolonged or highly skilled airbrush work. They simply empty out as they are used, so there is a gradual reduction of pressure. Because they contain a relatively small amount of air, this may run out at an inconvenient moment. For use with simpler types of airbrush, and for work on a small scale or work which does not require precision, air cans are perfectly adequate. They are certainly more convenient than compressors for home use because of their size.

Other sources of air

At one time, simple foot pumps were quite widely used to power airbrushes because of the problems of the old, heavyweight compressors. Another solution was to attach an air hose to the valve of a tyre and use the air pressure from the deflating tyre. There really is no reason to use either of these methods any more, since compressors and air canisters come in a broad price range, and are convenient, clean and require no particular effort from the artist.

Attachments and accessories

Moisture traps and pressure regulators can be attached between the air supply and airbrush hose if the original source does not have these fittings. A small moisture trap is available for the Paasche airbrushes, designed to be inserted into the hose itself. Since developments in propellant devices have been so rapid and efficient within the space of a very few years, it is likely that the need for such attachments will continue to decline and the nature of accessories will change. It is advisable to consult the supplier when buying airbrush equipment for advice on any potential problems.

Each manufacturer develops their own equipment and matches fitments to their own products. Air hoses, for example, come in different sizes and the screw threads in the fittings may not match a different type of airbrush or compressor. Thread adaptors are now available which make it possible to connect any airbrush to any compressor.

Badger 150 and 200, and Paasche H series, V and VLS airbrush models have interchangeable nozzle sets, from fine through medium to large. The heavier nozzle is intended for broad areas of spraying, as in car customizing or model making, while the fine nozzles are suited to lighter media used in graphic work and illustration.

DeVilbiss airbrushes do not have extra nozzle sets for ordinary use, but they can be fitted with a spatter cap. This rearranges the air flow, causing a coarser distribution of paint particles, useful for simulating rough textures such as stone or coarse fabric. DeVilbiss are one of the few manufacturers to supply this device. With other independent double-action airbrushes, the operator must discover a method of manipulating the lever control to produce a spattered effect.

The other main airbrush accessory is the colour cup or jar. This mostly applies to suction feed models with jar attachments held under the body of the brush. The Badger 150 and 350, the Binks Bullows Wren and Paasche F-1 have different-sized jars. Some airbrushes with side-mounted colour cups can be fitted with a larger cup or jar.

An airbrush holder, a clip which can be fitted to a drawing board or worktop, can be a useful aid. The airbrush can be placed in the clip during pauses in the work or after cleaning. This reduces the danger of spillage from the colour cup if the artist stops spraying to mix more medium or lift a mask. But an airbrush must never be left standing for any significant period with colour in it or the medium will start to dry, eventually causing damage to the airbrush.

The air eraser

This special product of the Paasche airbrush company works on the same principle as an airbrush. There is no central needle controlling passage through the nozzle, but the instrument emits a spray of fine pumice powder, or similar abrasive. The powder is held in a sealed cup on top of the body of the brush. It is drawn into the tip of the airbrush by pressure from the air current, which passes through a central channel towards the nozzle. The amount of powder allowed into the nozzle is controlled by an adjustable screw at the top of the powder container.

The air eraser simply blasts away the surface of the artwork, but since the particles are so fine it interferes less with the surface texture than other methods of removing paint – scratching or wiping back. The eraser can also be used as an engraving tool on glass or metal, but the powder does fly up when it encounters a resistant surface, so proper safety precautions should be taken, such as use of a mask and goggles.

Care and maintenance

The airbrush is composed of many tiny parts, all delicately tuned to provide the optimum performance. It is worth taking care to maintain the airbrush properly to avoid simple faults which could interfere with its working capacity. If a major problem occurs which cannot be corrected by dismantling and checking the parts immediately visible, the whole airbrush should be taken to an approved servicing agent. Shops selling artists' equipment do not always provide after-sales service so it is a good idea to ask where your model can be sent for servicing, or write to the manufacturer for advice.

Some problems may be easily remedied, but at least one source of trouble can be avoided with proper care. The channels for air and fluid are extremely fine, so it is vital that the airbrush should be kept absolutely clean. It is advisable to use water-based media whenever possible as these pose fewer hazards to the airbrush. The medium must be carefully diluted to the right consistency and should not contain any coarse fillers or pigment, moist lumps or dried shreds of paint. A medium which dries and clogs quickly, such as acrylic paint or Indian ink, is a greater risk than drawing inks or liquid watercolours, but artists can and do use a variety of substances in the airbrush with great success, providing a thorough cleaning routine is followed.

When using watercolour, inks or water-based dyes, flush clean water through the airbrush every time the colour is changed and immediately after the work is finished. The same applies to acrylic paints, but these dry more quickly and form stringy, plastic

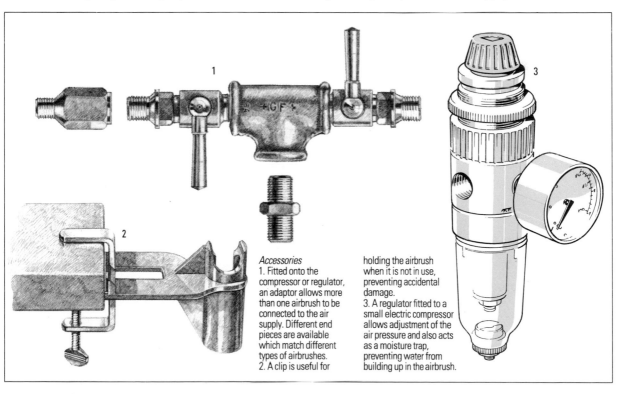

Accessories
1. Fitted onto the compressor or regulator, an adaptor allows more than one airbrush to be connected to the air supply. Different end pieces are available which match different types of airbrushes.
2. A clip is useful for holding the airbrush when it is not in use, preventing accidental damage.
3. A regulator fitted to a small electric compressor allows adjustment of the air pressure and also acts as a moisture trap, preventing water from building up in the airbrush.

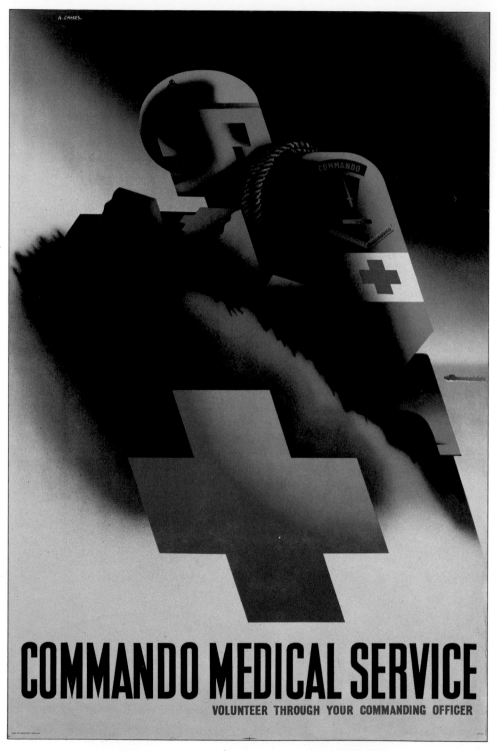

COMMANDO MEDICAL SERVICE
VOLUNTEER THROUGH YOUR COMMANDING OFFICER

ABOVE This powerful image by the British graphic artist Abram Games was produced during World War II. The range of effects and contrast of hard and soft edges suggest the use of different masking techniques: loose paper masks, cut stencils and Frisket. The texture of the lanyard could have been achieved by using rubber adhesive. Blown-under spray diffuses the edge of the ear, suggesting volume and depth.

shreds which do not dissolve, so cleaning must be even more swift and regular. If oil- or spirit-based mediums are used, the airbrush must be rinsed out with the appropriate solvent and then flushed through with clean water. Masking fluids or fixatives are treated in the same way. Clean the airbrush even if it will only be left for a short time, as it is impossible to estimate when or how quickly the medium will dry.

The nozzle

Different types of airbrushes vary slightly in the construction of the spraying nozzle. In airbrushes with internal atomization the nozzle generally consists of a hard metal tip

TOP *No War Toys*, Bob Zoell. The propaganda of Vietnam protest, Zoell's work exploits the airbrush's ability to create flat areas of colour.

ABOVE LEFT *EFM System*, Conny Jude. Here the airbrush has been used to create a splattered texture. Water was sprayed onto ink.

ABOVE RIGHT This advertising image by Vincent Wakeley shows the advantages of working with gouache. Flat colours can be sprayed first and highlights added subsequently. This is an easier method: first-time decisions do not have to be kept.

which sheathes the taper of the needle. This is covered by an air cap or spray regulator, through which the air passes, and which emits the atomized spray. These components are screw attachments, and in many airbrushes there is also a tiny circular washer, or O ring, at the base of the nozzle.

All these components are extremely delicate and the best way to keep them clean is to flush out the airbrush thoroughly at each stage of spraying and after use. Airbrush users develop different ways of attempting to clean dried paint from the nozzle area, but anything hard or abrasive poked into the end of an airbrush potentially shortens its life. Though certain remedies may work in the short term, it will only be a matter of time before irreparable damage is caused. If there is an obstruction in the tip which seriously affects spray quality or blocks it altogether, the airbrush should be returned to the manufacturer or sent to a recognized servicing company for professional attention.

Soaking the airbrush and colour cup before flushing out may remove dried medium. Warm or slightly soapy water can be used, but it is inadvisable to let the airbrush stand in a chemical solvent of any kind. If there has been an obstruction, or even if the airbrush is apparently clean, there may be a slight accumulation of colour in the nozzle which will be blown out when air is next passed through it. Always clear the airbrush before starting work. You can apply extra pressure when cleaning by spraying the airbrush full blast with the tip pressed down on a piece of waste paper, but it is vital to ensure that the needle is retracted. Nothing, however soft, should be pushed into the tip of the airbrush unless the needle has been retracted or removed.

If the nozzle is fitted with a washer, check that the ring comes out of the airbrush when the nozzle is removed. It is such a minute part that it is easily overlooked, but if it stays in the airbrush it will be blown out and lost during cleaning. The washer is essential to the quality of the spray: a sign that it may be missing is the bubbling back of medium inside the colour cup during spraying.

The needle

The fluid needle is one of the most delicate moveable parts of the airbrush and must be treated with great respect. It is replaceable, but there is no point in incurring this extra expense where a little care and attention will make it last. The needle tip has an extremely fine taper and can be bent easily through carelessness or accident in dismantling the

airbrush, relocating the needle or adjusting the nozzle end. A needle tip which is slightly off-centre may be realigned by rolling the taper gently against the palm of the hand or on a soft piece of paper, but when an actual bend like a tiny crochet hook has formed the needle should be replaced. A damaged needle causes uneven, spattered spray.

To sharpen a dulled needle, trap the angle of the taper under one fingernail on a dampened oilstone. Roll it gently back and forth, always following the angle of taper. To clean the needle tip, dip it in water and roll it in the same way on a clean piece of paper.

Always retract the needle when dismantling the airbrush and withdraw it very carefully. To return it to the body of the brush, rest the shaft on the cushion of one fingertip and gently guide it into place. Make sure the lever control button is forward and down or the lever may obstruct the path of the needle and blunt it. In airbrushes which have a brass tip nozzle section, a blow from the needle can crack the brass tip as well.

The needle is secured by a locking nut screwed on at the end and concealed within the handle of the airbrush. Replace the locking nut and handle gently, screwing only finger-tight. Do not exert heavy pressure when adjusting or unscrewing the parts as this may cause internal damage to the airbrush.

In models such as the Aerograph Super 63A, where the needle passes through a recessed colour cup, a build-up of paint at either end of the cup can cause the needle to stick. As the airbrush is held downwards during cleaning, any dried medium at the back of the colour cup may pass unnoticed, so it is important to check both ends. Remove the needle and wipe the shaft, then clean out the colour cup thoroughly. Gum arabic used as a fixative often causes this problem as it is naturally adhesive. A needle which is firmly stuck may be more easily removed through the front of the airbrush. Take off the nozzle and apply pressure to the blunt end of the needle to push the shaft through the airbrush tip.

Some manufacturers provide a reamer needle with sharp edges on the taper which is used to clean out the tip of the airbrush. This can also be a good use for a needle which is damaged and of no further use in its normal role. Place the taper on an oilstone and rub it down to produce a fine, flat plane on either side. A hooked end should be removed at the same time. It should be stressed that continual interference with the nozzle area, however careful, will sooner or later damage the brush.

FAULT-FINDING CHART

Key to fault-finding chart

1. Single action spray gun
2. Single action external atomization airbrush
3. Single action internal atomization airbrush
4. Double action internal atomization fixed airbrush
5. Double action internal atomization independent airbrush
6. Paasche Turbo

The illustrations below and on the following pages show the results of a selection of typical faults, identified and explained in the chart.

Problem	Analysis	Remedy	Model
no air flow	● pressure drop in canister, caused by drop in temperature	stand canister in lukewarm water, or replace	
	● damaged or incorrectly positioned nozzle washer or spray head washer	replace or refit	3, 4, 5
	● air-feed blocked	remove nozzle and blast air through airbrush; check diaphragm assembly on air valve	1, 2, 3, 4, 5, 6
	● lever assembly broken	replace (professional repair)	4, 5
	● air valve stem broken	replace (professional repair)	1, 2, 3, 4, 5, 6
	● blockage in air-supply tube from compressor	remove airbrush lead and blow at high pressure	
	● air valve seal faulty	replace	3, 4, 5
air leaks through nozzle when airbrush turned off	● air valve springs and valve seal incorrectly tensioned	readjust or replace	1, 2, 3, 4, 5, 6
	● diaphragm assembly and air valve stem or ball badly adjusted	(professional repair)	2, 3, 4, 5, 6
air leaks through control lever	● diaphragm assembly or air valve stem packing piece broken	replace (professional repair)	2, 3, 4, 5, 6
air leaks at source	● loose connections	tighten	
	● washer in hose or connections worn	replace	
air pressure too high	● pressure of compressor set too high	turn down control	
	● canister overblowing	blow off air until pressure is as desired	
medium leaking from reservoir	● medium spilling from its container when airbrush held at acute angle	hold airbrush level	2, 3, 4, 5, 6
	● washers and joints incorrectly seated or too loose	check and re-set	3, 4, 5
	● nozzle washer missing or damaged	replace	3, 4, 5
medium leaking from nozzle while airbrush in use	● air supply inadequate	increase air or decrease medium supply	3, 4, 5
	● loose nozzle cap	tighten	3, 4, 5
medium flooding	● medium too thin	remix	1, 2, 3, 4, 5
	● needle too far back	reset needle; check lever action	3
	● medium feed pipe or nozzle set too high	adjust	1, 2

Problem	Analysis	Remedy	Model
medium not spraying	• nozzle too far from air supply	adjust nozzle	1, 2,
	• paint too thick or badly mixed	empty and clean paint container; remix paint	1, 2, 3, 4, 5, 6,
	• feed tube not immersed	add more medium	1, 2, 3, 4, 5,
	• medium flow from container blocked	clean	1, 2, 3, 4, 5,
	• dried medium left on nozzle	remove and clean nozzle and needle; tighten nut attaching control lever to needle	1, 2, 3, 4, 5,
	• needle wedged in nozzle	reset; check needle-locking nut	3, 4, 5,
	• pigment settled in medium	add thinner; agitate the needle or paint container	1, 2, 3, 4, 5,
	• loosened needle-locking nut attaching control lever to needle	tighten	3, 4, 5,
	• lever assembly broken	remove and clean nozzle and replace lever assembly (professional repair)	4, 5,
medium not spraying and/or bubbles in reservoir and/or spatter	• nozzle cap loose	tighten	3, 4, 5,
	• badly seated nozzle	remove and reseat	3, 4, 5,
	• nozzle washer or spray head assembly missing or damaged	replace washer or spray head assembly (professional repair)	3, 4, 5,
	• badly fitting nozzle and nozzle cap	replace one or both	3, 4, 5,
	• damaged or split nozzle	replace	2, 3, 4, 5,
A spattering or spitting	• inadequate air pressure relative to paint supply	adjust air pressure	1, 2, 3, 4, 5, 6,
	• dust or other particles in nozzle or nozzle cap	remove and clean	1, 2, 3, 4, 5, 6,
	• build-up of medium in nozzle cap	make sure needle is firm; clean with brush and thinners	3, 4, 5,
	• thick or badly mixed medium	empty and clean; remix medium	1, 2, 3, 4, 5, 6,
	• worn, cracked or split nozzle	replace	2, 3, 4, 5,
	• badly matched nozzle and needle	replace one or both	3, 4, 5,
	• dirt or excess moisture in air supply	remove nozzle and blast air through; check filter at air source	
	• medium clogging air feed	replace worn air valve washer to prevent medium seeping through; repair diaphragm assembly (professional repair)	3, 4, 5,
	• medium seeped into handle aperture, causing diaphragm assembly to break	repair diaphragm assembly (professional repair)	3, 4, 5, 6
B spattering at an angle	• bent needle or split nozzle	replace	3, 4, 5, 6
C spattering at start of strokes	• build-up of medium caused by lever being returned too quickly after each stroke	release lever more gently	4, 5
	• damaged needle	replace	4, 5

Problem	Analysis	Remedy	Model
continued	● build-up of medium in nozzle cap	make sure needle is firm; clean with a brush and thinners	3, 4, 5
	● dust or other particles in nozzle	remove and clean	1, 2, 3, 4, 5, 6
	● impurities or excess moisture in air line	remove nozzle and blast air through; check filter at air source	1, 2, 3, 4, 5, 6
D spattering at end of strokes	● impurities or excess moisture in air line	remove nozzle and blast air through; check filter at air source	1, 2, 3, 4, 5, 6
	● damaged or dirty nozzle or damaged needle	replace or clean	3, 4, 5
E blobs at either end of stroke	● hand stationary at start or end of stroke	move hand both before and after operating	1, 2, 3, 4, 5, 6
	● lever not eased in time	practise	1, 2, 3, 5
	● medium released without adequate air flow	reset lever action	4
F uneven strokes or flaring	● airbrush being operated from wrist not whole arm	use whole arm	1, 2, 3, 4, 5, 6
	● dust or other particles in nozzle	clean	1, 2, 3, 4, 5
G spidery effect	● airbrush too close to ground for nozzle or needle setting	move away or adjust	1, 2, 3
	● too much medium	adjust control lever to correct ratio with air	5, 6
	● medium released before air	reset lever action	4
H bumpy spray pattern	● air supply pulsating due to small compressor without reservoir	add regulator/moisture trap to air supply system	
	● dirt in nozzle	clean	1, 2, 3, 4, 5
	● nozzle cap or nozzle badly seated	check and adjust	3, 4, 5
	● worn nozzle washer	replace	3, 4, 5
I fine line appearing as diffused halo	● needle damaged or bent at end or burr at nozzle tip	straighten needle	3, 4, 5, 6
muddied medium colour	● medium container, feed, nozzle or nozzle cap dirty	clean	1, 2, 3, 4, 5, 6
needle failing to return after being pulled back	● needle locking nut not tight	tighten nut	4, 5
	● needle packing gland gripping on needle	slacken off needle packing gland screw; clean off build-up of medium on needle packing and lubricate	4, 5
	● needle will not go through packing gland	loosen packing gland screw and clean	4, 5
lever failing to return after being pressed down	● air valve spring has lost tension	stretch spring or tighten air valve spring retainer; replace if necessary	1, 2, 3, 4, 5, 6
	● sticky air valve stem	strip and clean or seek professional advice	1, 2, 3, 4, 5,
lever failing to return after being pulled back or lever flops	● needle spring has stuck or lost tension	re-tension spring; clean off old grease and re-lubricate	4, 5
	● lever assembly broken	replace (professional repair)	4, 5

MEDIA AND MATERIALS

Airbrushing tends to be associated with a smooth, uninterrupted surface finish, typical of much illustration and graphic art. Since it is also used to produce a variety of other types of two- and three-dimensional work, the substances sprayed through airbrushes and the surfaces which receive them are both equally varied. The choice of medium and surface depends upon the purpose and required character of the finished work. Whether the work is to be on a small or large scale, in monochrome or colour, smoothly finished or textured, and how it will be handled or displayed should all influence the choice of materials.

In theory, anything which is liquid can be sprayed on to any surface which is capable of receiving it. At the same time, materials and equipment are produced with particular properties and characteristics, so if they are used in an unexpected or especially demanding context, the result is at the artist's own risk. This chapter outlines the combination of materials most likely to achieve successful results for a given project and suggests potential problems and pitfalls.

There are three general guidelines which should be observed in airbrushing. Firstly, the airbrush should be kept clean – never left with medium drying inside – and it should not be subjected to abrasive or corrosive liquids. Secondly, the surface being sprayed should be stable and not too absorbent, and must be prepared properly to receive the medium if a special ground or protective coat is needed. Lastly, the medium itself must be of the correct consistency, however this is achieved. It should always be borne in mind that the fluid channel of an airbrush is extremely fine and any lumps, grit or dried particles of medium will clog the airbrush immediately. Materials manufactured specially for airbrush use are obviously the best choice if they are suited to the work in hand, but it is not necessary to keep to a narrow range provided the medium and the airbrush itself are treated with respect.

Although airbrush, medium and surface are the only vital equipment for trying out the technique, there are many other studio aids which are invaluable, especially for producing detailed illustrative work. Efficient masking materials have been developed to protect the surface being painted and provide the artist with absolute control of the range of the spray. General studio equipment, such as scalpels, rulers and templates are also needed and there are other materials and equipment which answer particular purposes.

Airbrushing for three-dimensional work introduces a further range of materials specific to practices such as model making, ceramics and textile design and in these cases there are particular technical demands. The following sections describe a broad range of media and materials which are used mainly in two-dimensional design, illustration and painting.

Surfaces

It is always advisable to test a surface for its suitability for airbrushing before starting on a major piece of work to make sure the surface does not lift, bubble or resist the spray. Smooth surfaces are best for fine, transparent work, whereas opaque paint builds up a heavier layer and may benefit from the extra grip of a slightly textured surface. Watercolour and inks gain brilliancy from a pure white support.

It is very important to keep a surface clean and free from fingerprints. Greasy marks resist the fine airbrush spray and this cannot be overcome after some paint has been applied. Finger marks can be wiped away from photographic paper, but it is not advisable to wipe illustration board or paper. It is better to avoid marking surfaces altogether by storing materials in a safe, clean area and handling paper or board only lightly by the edges.

Boards and papers

For illustration and graphic artwork where the results must be detailed and precise, the best support is a smooth, stable illustration board. Artists' board is usually composed of a layer of good quality paper mounted on a compressed paper or pulp base. It is important that the surface of the board should not lift, separate or bubble when it is dampened by a painting medium. Illustration boards are manufactured to maintain their smoothness and flatness throughout the working process.

A particularly good type of board for airbrush work is CS10 board. It is absolutely smooth and made to withstand marking if erasures and alterations are made to the artwork. Schoellershammer line board is similar and also excellent for airbrushing. The surfaces of these boards will not discolour or throw off fibres which could mar the finish of the work. They are relatively expensive, however, and although this is not a consideration in professional work, the relative beginner may find it advisable to consult an artists' supplier to find suitable alternatives. Most illustration boards are available in two or more sizes; some are double-faced

so work can be carried out on either side; some have a rougher tooth or texture which may not be suitable for a highly finished rendering but is perfectly adequate for general purposes.

An alternative to illustration board is Bristol board. This is differently composed, the thickness and strength being built up by the lamination of thin sheets of material. These boards are categorized 1-, 2- or 3-ply and so on, indicating weight and rigidity. Different sizes are available while surfaces may be smooth or medium (vellum). All art boards are designed for both airbrushing and work with sable brushes, ruling and drawing pens.

Watercolour boards also provide a stable, pure white surface. They can take a build-up of watercolour washes without buckling, but they have more texture than illustration boards. In airbrushing, this can be a drawback as the spray tends to pick up and exaggerate the tooth of the paper, especially if directed at an angle across the surface. But some artists find this adds interest and variety to the work, using these boards for this very quality. It should be noted, however, that masking film does not completely adhere to pits in the textured surface and spray may creep under the edge of a mask. Since the boards are made specifically for painting with soft brushes, the surface may also become fibrous if it is wiped or scratched back, and even low tack masking materials may stick too firmly to the raised texture and rip up the surface when removed. These boards are more suitable if a loose, freehand painting style is envisaged.

When choosing a board it is vital to ensure that it is manufactured for painting or drawing purposes. Mount boards can seem attractively smooth and colourful, but they are not made to withstand damping from a medium. The surface will separate from the base when it becomes wet and the board could literally fall to pieces.

Papers are on the whole less suitable than boards for airbrushing work since they inevitably buckle when damped, but they can be stretched on wooden board and secured with gummed tape to keep the surface relatively flat and stable. Their great advantage is that they are cheaper and may be used more freely by a beginner. As a general rule, any paper which is thin or highly absorbent, or which sheds surface fibres when lightly rubbed, is not suitable for airbrushing. Since papers of really fine quality are expensive, it is probably worth paying a little bit more for a board to ensure the work has stability and protection. To take advantage of a particular colour or texture only available in paper ranges, a sheet of paper can be mounted on board. This must be done with dry mounting or using a totally reliable and hard-holding adhesive, otherwise the surface will lift when wet and remain vulnerable to tacky masking films. Test masking film on paper to check that it can be lifted without damaging the paper surface.

CS10 paper is available in single sheets or smaller pads. It has the smooth, white surface finish of CS10 board. It can be anchored to a drawing board with masking tape, but being flexible it may be slightly dented or creased in handling and such marks become exaggerated by the airbrush spray. Check the paper against the light to ensure it is absolutely flat. The flexibility of CS10 paper is an advantage if it is used for work to be reproduced by a photoscanning method, which requires that the artwork can be curved round a drum. Although it is possible to lift the surface of a board, this is a delicate process and paper is a better alternative.

Ordinary artists' papers – cartridge and machine- or hand-made watercolour papers – can be used for airbrushing if they are stretched. Here again the choice depends upon the weight and texture required.

Another product made for graphics studios which provides a good surface for airbrush work is clear acetate, also known as cel, a stable, transparent plastic film available in pads, rolls and sheets. This can be used for overlays, where a design is built up in sections. The transparency of the support allows several sheets to be viewed simultaneously. It can also be used for any work in watercolour or ink which will gain from light passing through from the back of the work. Acetate sheets are used as the base for artwork displayed through an overhead projector. The material is available in different colours, but the colourless film is more common.

Photographic papers

In retouching, tinting and some technical illustration the images which will subsequently be airbrushed are first produced photographically. Both bromide and resincoated photographic papers are suitable surfaces. The resin papers have a tougher finish and cannot be satisfactorily altered by scratching back the medium once it has been applied. Care must also be taken not to mark the surface when cutting masks in place. The paper cannot withstand heat and is melted by dry-mounting processes; to mount resin-coated paper on cardboard, the paper must be laid down with a rubber

solution adhesive, which is perfectly robust for the task. Another slight disadvantage of this paper is that it does not accept sable brushwork too well, but once the surface has been sprayed it is possible to add hand-painted detail. Bromide papers can be dry-mounted to give them extra support. There is also a type of photographic paper with a matt surface resembling cartridge paper which is suitable for airbrush work.

Canvas and hardboard

For larger scale painting, airbrushing can be done on canvas or hardboard. Oil or acrylic paints are economical choices of medium and provide a durable surface finish. A canvas is made by stretching fabric tautly over a wooden frame and pinning or stapling it at the back. Fine linen artists' canvas is extremely expensive but it is good quality and is the traditional material for painters. A cheaper and increasingly favoured material is cotton duck, available in several weights and widths. It is a good substitute for linen, off-white where linen is a natural buff colour, but it does sometimes have flecks and impurities in the weave, although these are hardly noticeable when the surface has been prepared for painting.

For oil painting a canvas must be sealed with a coat of glue size and two coats of oil primer, each allowed to dry fully before the next is applied. If oil is absorbed into the canvas it will eventually rot the fibres, so good priming is vital. Acrylics are not harmful to the fibres, but the colours sink into the fabric as a stain if it is not primed. Acrylic emulsion or medium can be used to lightly seal the surface.

Hardboard can also be used as a support for oil and acrylic paint and must be primed in the same way as canvas. It has a very smooth surface which sometimes resists initial paint applications, so airbrush spray should be tested to discover the surface result. Egg tempera is a medium very occasionally used by airbrush artists and this is best applied to a traditional gesso ground, a smooth, brittle surface built up from several coats of whiting mixed with glue size. Because this ground is not flexible, hardboard or wood panels should be used as support rather than canvas. For a heavily textured surface for acrylics or oils, the unpressed back of hardboard works well, if it is first dusted and primed.

ABOVE There are many types of surfaces which can be used for airbrushing. Selection depends on the requirements of the artist and the type of medium.

Hot-pressed or coated boards are popular choices; watercolour or line boards and cartridge paper suit some types of work. Acetate is mainly used for animation.

Lighter fuel is useful for degreasing line boards, acetate and photographic paper, but should not be used on watercolour paper as it will sink into the surface, staining it.

Use stick erasers for removing fine detail or creating highlights. Putty rubbers are useful for removing fine pencil marks without damaging sprayed areas.

Paints and Fixatives

As a general principle, anything which can be made to a certain liquid consistency can be blown through an airbrush. Ideally, an airbrush medium should be the consistency of milk, although this standard can be varied according to the properties of the medium and the purpose of the work. Some types of paint and ink, however, are not suitable for use in an airbrush and among those which are commonly used, some are easier to handle than others. The important factor, whatever the medium, is thorough and regular cleaning of the airbrush and it makes sense to avoid anything which is difficult to clean or which has a particularly coarse or brittle texture. On a further cautionary note, certain media, solvents or varnishes are in themselves corrosive and may damage the internal parts of the airbrush, particularly the tiny O ring in the nozzle which can dissolve completely if an inappropriate medium is used.

Water-based media, such as gouache, watercolour and ink, are most commonly used in airbrushing. Many types have now been specially developed for airbrush use. Acrylic paints and egg tempera, which are also water-based although waterproof when dry, and media which require special solvents – oil paint, lacquer and cellulose – are less suitable for airbrush work. Photoretouching can be done using gouache or ink and there are also colours and dyes created for photographic purposes. Some ceramic artists also use the airbrush as a technical aid to apply slips and glazes to pottery.

All media consist of a colour agent dispersed in a fluid binder. The texture, consistency and colour quality vary greatly from one medium to another, depending upon the original ingredients and their preparation. The colour agents are either pigments or dyestuffs. Dyestuffs are soluble and mixed into the vehicle make a transparent solution. Pigments must be ground from various solid substances and are suspended as minute particles in a binder – oil, polymer or gum, for example. Media used for airbrushing should contain finely ground pigments which cannot clog or obstruct the needle and nozzle in the airbrush. Pigments have greater opacity and high colour values but dyes are more fluid, an advantage in certain types of painting.

ABOVE Gouache is a widely used airbrushing medium and often comes in tubes. It is always important to consult the manufacturer's colour chart to determine which pigments will stain. This is especially crucial when highlights are to be applied on top of another tone – the underlying colour might bleed through.

A few pigments are fugitive, which means that they cannot be prevented from fading. The colour loss may be gradual over years, or may take place in a matter of weeks if the paint surface is exposed to strong light. Some pigments cannot be ground as finely as others – white pigments, for example, are dense and yield relatively large particles in grinding. They also may separate from the binder more quickly than other colours. In media such as gouache, where the paint is designed to be opaque, there are nevertheless different degrees of opacity and some pigments bleed or stain more heavily than others. This must be taken into account if they are to be covered with lighter tones or given white highlights. Manufacturers' colour charts usually include information on the permanence of pigments and their staining power and opacity. Any type of paint which comes in a large range of colours will include some fugitive or impermanent pigments. Staining power in water-based paints can be tested quickly by allowing a small blob of colour to dry on paper and then washing it away to see how much mark is left. Some red and green hues, for example, have a considerable capacity to stain and this property can make a difference in airbrush work if there is any intention to overlay colours or to make alterations by wiping back the paint.

Another property that varies between different media is the process of drying. Some water-based paints dry simply by evaporation – the moisture content vaporizes. This may leave a relatively unstable, powdery paint surface, which remains water-soluble, as sometimes happens with gouache. Some liquid watercolours and inks dry by a process of absorption into the surface, leaving an even, waterproof film of colour. Oil and acrylic polymers dry partly by evaporation initially, but a chemical change also takes place which bonds the paint particles firmly so the surface is eventually waterproof. Oil paint has sufficient strength and flexibility to dry without cracking, even if thickly laid.

The chemistry of paint is an extremely complex business and few artists know, or need to know, every property of their medium. Most learn by trial and error, through their own experience and from that of others. In general, artists' media are a prime example of the principle of getting what you pay for. To use cheap paint is a false economy – the colour can be initially difficult to apply with any consistency and may then be liable to quickly powder, crack or flake.

The medium cannot be considered in isolation from the support or ground. Illustration boards and papers are specially manufactured to have a particular texture and stability and water-based paints can be used with satisfactory results. Oil, lacquer and cellulose paint may need an undercoat or ground because they can attack the support and eventually rot the fibres, though some work is done on plastic film which is produced to resist these problems. Note the manufacturer's instructions for oil-, spirit- or resin-based paints and ask the supplier whether special preparation is needed.

Colour and tone

Skill in judging colour and tone, and the ability to mix paint to match a required colour, must be learned by experience. There are no handy rules or shortcuts which substitute for familiarity with a given medium. A knowledge of basic colour theory can be useful, but commercially produced paints, though manufactured to very high standards, are not totally pure and colours can sometimes behave in unexpected ways when they are mixed. Nevertheless, a few principles of colour and tonal values will provide helpful guidelines.

Certain colours are mutually enhancing. These are the pairs known as "complementary colours" in simple colour theory. The pairs are red and green, blue and orange, yellow and violet. Red, blue and yellow are the primary colours and cannot be mixed from any other colours. (This theory relates to artists' colours – primaries in light and printers' colours are differently defined.) Green, orange and violet are secondary colours, each a mixture of primary pairs. In their purest state these colours appear very vivid when juxtaposed, and this property remains true through gradually more complex mixtures – for example, a deep red-purple reacts more strongly with a light yellow-green than with a green which is a balanced mixture of yellow and blue.

Colours tend to have a characteristic warmth or coolness. Red naturally seems warm and so does a bright sunshine yellow, whereas light blue is cool. But it is possible to mix, for example, a relatively cool red, which may have a bluish tinge or an orange cast. The balance of brightness and warmth in one colour against another was a device used in pre-Renaissance paintings, when few pigments were available and one colour might be given two or three different values by careful placing against opposite hues or well-judged addition of another pigment.

Tonal values are judged on a presumed scale of brightness ranging from black to white. Each colour has to some extent an

ABOVE This advertising illustration for Lego by Vincent Wakeley is a good example of the use of gouache. Although gouache lacks the brilliance of inks or the transparency of watercolour, it is easier to use. One great advantage is that highlights can be sprayed over the top of a ground, which obviates the need for preliminary masking. In this case, highlights have been applied to the red jacket. Considerable alteration is also possible for work in progress. Using gouache successfully, however, depends on getting the right paint consistency for an even result.

ABOVE The surrounding ring illustrates the artist's three primary colours – red, yellow and blue. In the centre, the spectrum of colours produced when light is refracted are shown: red, orange, yellow, green, blue and violet. In principle, the secondary colours – orange, green and violet – can be mixed from pure versions of the primaries. **RIGHT** Any two opposite colours on the colour wheel are complementary. The pairs are all composed of one primary and one secondary colour which are mutually enhancing. Red's complementary is green; yellow's is purple and blue's is orange. **BELOW** Greys and other tertiary or broken colours can be mixed before their application to the support or they can be created by layering different colours one on top of another. The warmth of these greys is a useful quality when retouching photographs.

These diagrams show the scientific way in which the six primary and secondary colours, with all their variations of hue, tone and chroma, can be given three-dimensional form. The most intense, pure versions of red, orange, yellow, green, blue and violet form a ring around the central circumference, and the hues merge; red gradually becomes orange for example. The complementary colours are opposite each other.

The top of the sphere is white and the bottom black, so all the colours of the spectrum are vertically ranged in tone from very light to very dark. The centre of the sphere is an exact mid-tone of grey. From the centre of the sphere the colours grow brighter until, on the outside, they are at their most intense. This variation in intensity is known as chroma. Attempting to represent colour in a form such as this is a useful exercise.

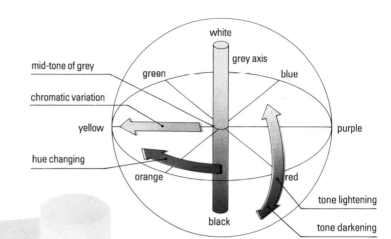

Presenting the colours of the sphere in blocks is the easiest way, as exact definitions in hue, tone and chroma can be made without having to concentrate on blending and vignetting at the same time.

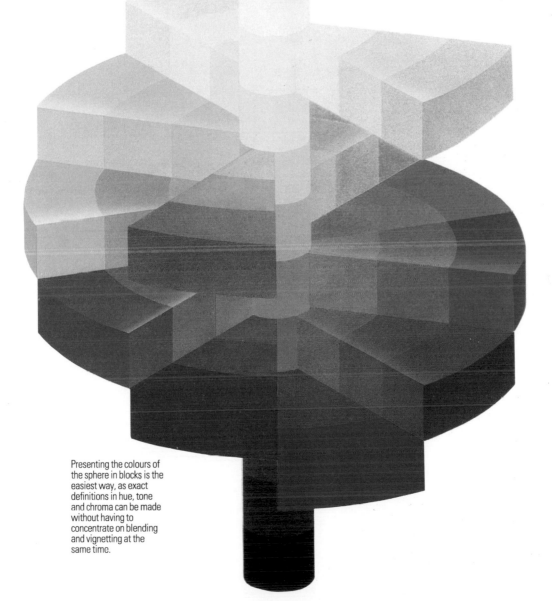

inherent tonal value: yellow is light, ultramarine is dark-toned, scarlet mid-toned and so on. The relative tones of various colours could be more or less identified by studying the range of greys which would result from taking a monochrome photograph of simple colour blocks. But tone is also a valuation of the light falling on an object, so in reality colours are modified by their position against the light source.

An artist working in monochrome, or with neutral mixtures, must also take account of colour properties in apparently simple tonal values. An example of this is found in photo-retouching. The greys in a monochrome photograph are usually warm and a straight mixture of black and white paint applied to the surface may stand out as a lighter tone when the retouched image is reproduced, because the grey is cooler than the original. A little sepia or Vandyke brown added to the mixture gives a warmer cast which matches the photographic greys.

Some interesting greys and neutral mixtures can be produced using colours, rather than by relying on black and white, which may be added merely to tint or shade a colour mixture. It is worthwhile experimenting to discover the variety which can be achieved. A range of brown and beige tones can be mixed from reds and greens, for example, with the addition of touches of white or black. Cobalt blue, raw umber and white mix to a very subtle grey. With the fine texture and control of the paint flow obtainable with airbrushing, it is also possible to build up optical mixtures of colours by layering them lightly on the support. This corresponds to conventional watercolour technique, where colours are built light to dark and modified in the process. A layering technique works only with transparent media, and has a more complex and luminous effect than is achieved when colours are mixed on the palette.

Gouache

Gouache, also variously marketed as a tempera, poster paint or designers' colour, is an opaque watercolour. The pigment is bound in gum, but since whiting is included to give opacity the colours can dry lighter in tone than they at first appear. All gouache dries quickly and some designers' colours have an acrylic binder which is waterproof when dry. Gouache is sold in tubes or jars; it is fluid but quite thick, so must be diluted with water for airbrush use. Poster paints are not suitable for airbrushing as they are coarse and unstable, being the cheaper type of gouache.

Gouache is available in a wide range of colours, and, because of its reliable opacity, light colours can be overlaid on dark and vice versa. Some hues, such as yellow, are inherently more transparent than others and if a layer of paint is not allowed to dry completely, light tones may be affected by bleeding and colour mixing from the paint beneath. It is advisable not to work too thickly with gouache; as the paint surface builds the upper layers may become chalky and unstable.

Because of its covering power and good colour range, gouache is popular and widely used by airbrush artists. The airbrush can be cleaned simply by flushing out with water as each colour application is finished. If there is a stubborn build-up of paint, the nozzle or colour cup can be soaked before clean water is run through the brush. Gouache will eventually dissolve even after it has hardened. The exception here is acrylic designers' colour. Dry acrylic is not water-soluble and it tends to form shreds, like fine plastic, which are difficult to remove. A regular, efficient cleaning routine is therefore all the more vital with this medium.

Obtaining the correct consistency for airbrushing is a skill in itself as gouache is relatively substantial. Paint which is too thin will separate into globules on the surface; if it is too thick the spray will be granular and liable to cohere in splotches of colour. For fine details such as highlighting, the consistency and opacity are particularly important. White highlights should be made using permanent white gouache, not zinc white which is essentially a tinting medium.

Watercolour

Watercolours are traditionally made from finely ground pigment bound with gum arabic. Again there is a very wide colour range available, including some which are not made in gouache, such as very subtle greys. The common forms of artists' watercolours have traditionally been tube paints, dry cakes and semi-moist pans. In recent years, gum arabic has become increasingly more expensive and difficult to obtain so synthetic substitutes are now often used for the binders. A relatively new development, and one which has particular application for airbrush artists, is liquid watercolour – intense, extremely fluid colours which are sold in bottles, usually with a glass dropper set in the lid used to transfer the paint to a palette or directly into the colour cup of an airbrush.

The characteristic of watercolour which distinguishes it from other water-based paints is its transparency. Because there is

no filler or body colour in the paint as there is in gouache, the colours show an added luminosity if they are applied to a white ground. They dry true, though slightly less intense than when wet. Tones must be built up from light to dark and each new application of colour modifies, but does not obliterate, the previous layers. If alterations are made which require the placing of light tones over dark, gouache must be used for its covering power, but its introduction will destroy the overall transparency of the work.

Tube watercolours can be used satisfactorily in airbrushes providing they are diluted to the correct consistency. Distilled water is often used as a diluent as it contains no impurities which would interfere with the colour quality or chemical composition of the paint. Some watercolours are dye solutions which eventually precipitate particles of colour and these can cause problems in airbrushing. Transparency is also slightly reduced in watercolour hues made from chemical dyes. Those with a high staining capacity sink into the support and lower the reflective qualities of the surface.

Liquid watercolours are excellent for airbrush work: they do not require dilution and the colours are very intense. A large colour range is available in most brands, but as a result the problem of impermanency arises. Bottled colours produced by Royal Sovereign Graphics, developed especially for use in DeVilbiss airbrushes, have a fixed colour range of 12 paints all of which perfectly mix. By mixing the correct proportions of

various colours together almost any tone or hue can be achieved. These watercolours are guaranteed light- and colour-fast; they will not fade or devalue at any stage of the painting process. Ranges produced by other manufacturers include a greater variety of colours, but some of these, by their nature, cannot be made fast, though all are good quality products.

Watercolour is rather more difficult to control than gouache as it wets the surface more quickly, but its transparency makes it a suitable medium for subtle colouring of line drawing, as well as for more fully rendered illustrations.

Ink
Drawing inks are produced in a number of ranges and types, some of which are water proof and some not. Waterproof inks must be carefully handled in the airbrush as they cannot be easily removed when dry. Those based on shellac form brittle, clogging particles and Indian ink, for example, should not be used because of this characteristic. Non-waterproof inks tend to settle into the support in the same way as some dye-based watercolours. They may also separate, with pigment forming a sediment in the bottom of the bottle, so should be shaken vigorously before use to redisperse the colour. All inks are transparent in the same way as watercolours.

Good quality drawing inks come in a number of colours, though fewer than in paint ranges. Some ink bottles are equipped with

ABOVE Special water-based paints are designed for retouching work with an airbrush. These are more finely ground than gouache.

Retouching paints often come in either gloss or matt finishes to enable the retoucher to match the texture of the photographic print.

a dropper, others with a dipper stick which holds less medium. Depending upon the composition of the inks they may dry matt or slightly shiny. If inks are diluted, distilled water is again better than ordinary tap water. Inks can be cleaned out of the airbrush by flushing with water and it can be stressed that cleaning cannot be too rigorous, especially if materials are used which become waterproof when dry.

Materials for retouching

All the media covered so far can be used for photo-retouching and tinting. Special film colours are also available, similar to liquid watercolours. Care should be taken in mixing colours for photographic work since it is vital that there is no adverse reaction in the consistency and colour of the paint, and tones in the photograph must be matched exactly if the work is to be effective. Opaque retouching colours are produced for work on negatives and prints in black, white, a range of greys, and some colours sold in jars, tubes or pans. The opacity of the paint is important as the purpose of retouching is to conceal or radically alter what is already there. In retouching studios much of the work can now be done with bleaching and dying methods, but for individual purposes inks, gouache and watercolours should be adequate.

Acrylic paint

Acrylic paints are usually diluted and cleaned with water, but when dry they form a tough, plastic film which cannot be dissolved or scraped away successfully. The paints were originally developed with large-scale brush painting in mind – they are an offshoot of industrial paints – but there is no reason why they should not be used in an airbrush providing the consistency can be controlled and the airbrush is kept scrupulously clean. Acrylic tube paints are thick and substantial, but free-flow colours have been developed which are more fluid and easy to handle. It is important that the paint should be thoroughly mixed with water for airbrush work and a few drops of water–tension breaker can be added to release the flow if necessary.

Some acrylic paints must be mixed with special diluents and cleaned with spirit solvents. For these, the same basic rules apply. Acrylics are generally sold in fairly large quantities, in tubes, jars or tubs, and although they can be used on board or paper without any previous preparation of the surface, it is likely that watercolour, gouache or ink will serve the purpose just as well, or better. When acrylic paint is sprayed on a larger scale, on canvas, the bigger quantities are convenient and the paint itself is more stable and hard-wearing than other water-based

ABOVE Watercolours and inks come in a wide range of colours and are highly suitable for airbrushing. Liquid watercolours and some inks are packaged in bottles with droppers, which are particularly useful for filling the colour cup of the airbrush. It is important to flush the airbrush out regularly with water when using ink, as it dries very hard.

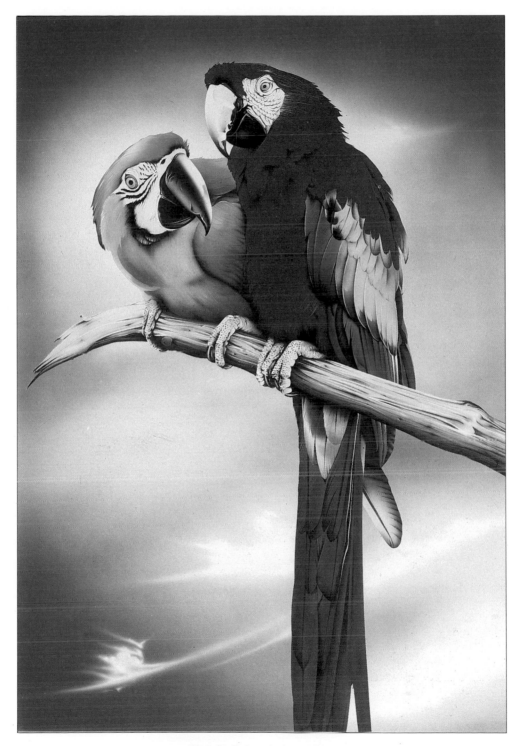

ABOVE *Parrots*, Ean Taylor. Ink is a good choice of medium for representing this subject – the colours retain their brilliance. The subtle changes in the plumage can be matched by the natural transition in hues possible with ink. The wispy cloud effect can be achieved by rubbing back the ink – a technique not possible with gouache.

media. The canvas should first be sealed with a coat of acrylic primer or medium as its surface is porous and it will otherwise soak up all the colour.

Egg tempera

Some commercially manufactured paints are sold under the name of tempera but these are not related to the traditional egg medium, which must be mixed by the artist from finely ground pigments and fresh egg yolks. The yolk is separated from the egg white, dropped into a jar and broken and the pigment is then mixed in. The paint is diluted with distilled water. It is not possible to mix large amounts and store them indefinitely – it is inconvenient to mix a quantity and the egg yolk goes off in a relatively short time.

Egg tempera is unlike any other medium. It has the transparency of watercolour but is completely waterproof when dry. However, ground pigments are very expensive and the mixing of the medium requires patience and expertise. Several artists have used the medium to great effect in the airbrush, but it should be noted that this is a quick-drying paint which must be cleaned out of the airbrush with all speed.

Oil paint

Oil paints are viscous and require special diluents and solvents. They dry very slowly and are not suited to airbrush work where a surface finish must be built up quickly, as the colours would be liable to mix on the support. The main difficulty in using oils for airbrushing is getting the right paint consistency. Tube or tinned paints should first be turned out into a jar and stirred very thoroughly, the medium or diluent being added slowly and stirred until no lumps of thicker paint remain in the mixture. Like acrylics, oil paint can also be strained through a sieve to guarantee smoothness. Turpentine and oils must be mixed with the paint to retain colour and textural qualities. White spirit can be used to flush out the airbrush and this can be rinsed away with warm water.

This medium is only really required for work on canvas, which should be well primed beforehand. The colours of oil paint change little as they dry and the artist is able to assess the true qualities of the work as it progresses. Modern ranges of oil paint contain a vast number of colours – care must be taken to identify fugitive pigments by consulting charts or asking suppliers.

Fixative

Waterproof media should not require a fixa-tive, but with gouache, which has a slightly chalky consistency, gum water can be sprayed through the airbrush to protect the finished work from powdering, dirt or scratching. Gum solution can be bought from artists' suppliers. The best proportion of gum to water is about one-third to two-thirds of the whole volume: the solution does not affect the colour or overall texture of the finished work, it merely provides a light protection and waterproofing. Gum dries quite quickly and can be responsible for jamming the needle of the airbrush – this should be checked if there are any problems. The gum can be rinsed out of the brush with water, but some particles may stay behind, particularly in airbrushes such as the DeVilbiss Super 63E where the needle passes through an open colour cup in the body of the brush.

Proprietary brands of fixative and paper varnish are sold in aerosol cans. These should always be tested against paint medium and support before they are used on finished work, as should bottled fixatives for spraying through the airbrush. Acrylic mediums can be used to spray a varnishing coat over finished paintings, but the acrylic has very strong adhesive properties and must be cleaned out thoroughly. Acrylic mediums are available which provide a glossy or matt finish, but since the surface of the dry paint is tough and even washable, a finishing coat may not be necessary.

Varnishes for oil paint are also sold in bottles and spray cans. They should be used to protect the surface and the paint colours. Varnishes should never be applied until the oil painting has completely dried out (which may take months): otherwise the varnish dries at a different rate to the paint and may crack. If oil varnishes are applied through an airbrush, the same rules apply as for oil paints. No water-based sealant can be applied over an oily medium; it simply will not adhere to the surface.

Media for special purposes

Where airbrushing is used for specialized purposes, the artist usually needs to use a medium dictated by the technical process or suitable for the particular surface. Lacquers, enamels and cellulose paints have all been put through airbrushes to decorate various three-dimensional objects. Simpler types of airbrush are used by model makers to spray paint finishes; here the manufacturers usually furnish information on suitable paints and how to care for the airbrush when using them. The Porsche company in Germany uses cellulose paint on plastic film to create their technical illustrations.

The airbrush can be a very useful tool in ceramics for applying glazes and varnishes, but again there are rules governing use of the media which should be investigated in that given context. Provided it is remembered that the airbrush is a delicate tool and that its paint channel is only a fraction of an inch wide, all types of media can be adapted for airbrush use. Check that the liquid is not corrosive or a danger to the airbrush, and also that it will not harm you to work in an atmosphere containing particles of the medium. When spraying solvents and chemical substances, the work should be done near an extractor fan and preferably while wearing a mask; with normal media these precautions are not necessary, although good ventilation is always advisable in a working studio.

Masks

Masking refers simply to the process of blocking out part of the surface with a protective covering, so that no medium falls in that area while another part of the image is being sprayed. Even when the artist has exceptional control of the tool, masking is a crucial part of the airbrusher's technique. Airbrush spray is by nature soft and amorphous: to obtain a hard edge of colour on a particular form, the spray must fall across a rigid material which creates the outline of the required shape. There is also an area of overspray in all but the closest work, and one colour can easily stray into another. Masking can be absolutely precise or designed to vary the linear and textural qualities of the work.

Masking film

Adhesive, transparent plastic film is the most efficient form of masking for precision work. It is supplied in flat sheets or on a roll. The adhesive side is backed with a paper layer until it is used. The adhesive is low tack so the film sticks securely to a surface but does not lift or damage it when peeled away. When the backing paper is removed, the film is laid over a drawing or photograph. The transparency of the film means that it is easy to see where a particular shape is to be cut to expose the painting surface. The sections to be airbrushed are cut out and lifted, the best tool for this being a sharp scalpel, and spraying can be applied as a flat colour or as graded tone. Spray which falls on the mask itself gradually obscures the surface beneath so it may be necessary to use clean film for cutting a mask for a different area of the image. Masking film can be applied over sprayed paint, but the work must be allowed to dry completely first.

The section of masking film which has been removed can be kept on a piece of the backing paper and replaced when the particular area is finished and another section is to be cut. Alternatively, the cut piece can be used to mask the original shape while the surrounding area is sprayed, if the rest of the mask is pulled off. This procedure saves extra cutting, and since the masking film is cut in place on board or paper, the risk of marking the surface with the scalpel is reduced. However, masking film does stretch, so the piece may no longer be precise enough to use as a mask. The opposite problem occurs if it proves difficult to replace it exactly and a fine line remains exposed between sections of the film. Here airbrush spray can accumulate when another colour is applied.

Until the development of adhesive film for masking, the solution was to use Frisket (a transparent, waterproof paper) or tracing paper, coated on one side with rubber solution adhesive. There is no advantage in using this method now. It is messy and time-consuming, though perhaps cheaper. However, there are two useful aspects of this technique – the mask does not stretch as film does, and when a Frisket is removed the dried rubber solution is rubbed away from the surface, lifting dirt or dust at the same time. In general, these are minor compensations; the Frisket mask is not as clean and accurate as self-adhesive film and a surface can be cleaned with a thin application of rubber solution, dried and rubbed off, without this being part of the masking process.

When masking a large area where airbrush spray has already been applied, a paper mask can be put down just inside the edges of the shape and masking film laid over the top, adhering to the artwork only at the edges. The paper mask should in this case be made from several overlapping pieces, rather than one large area, as a single piece exerts tension on the overlaid film and may cause it to cockle. Paper masks reduce the risk of paint being pulled off by the film, though this risk is slight in any case. A variation of this method is to use paper masks held in place by low-tack adhesive clear tape when masking small areas or complicated outlines. The tape can be cut with a scalpel in the same way as the film, and the surplus pieces discarded. A non-absorbent paper should be used for the centre of the mask. Naturally, it obscures the underlying area completely.

Masking film is not suitable for use on canvas, especially if large areas are to be masked – this would prove very expensive.

Also, masking material should not be cut in place on canvas as the support is flexible and the woven strands may be cut by accident or the surface badly dented by pressure from hand and knife. Masking tape is available in a number of widths from very thick to very thin, including a type so narrow that it can be bent around curves quite smoothly. For work on canvas, tape should be used to hold paper masks in place, creating the required outlines and edges.

Liquid masking

Several manufacturers produce a liquid masking solution, basically a rubber compound which dries by evaporation. It is painted onto the surface and dries to a flexible skin, which can be peeled or rubbed away when the sprayed area around it has dried. The fluid is either white or red and is applied with an ordinary paintbrush. This is a rather laborious process and liquid masks are best used only for small areas. The fluid dries quickly and tends to clog the brush as it is applied.

It is advisable to avoid using the liquid over an area which has already been sprayed as it must be rubbed quite vigorously. When it is used on paper or art board the surface can absorb the colouring of the red fluid and white masking occasionally leaves a yellowed discolouration when it is removed. Acrylic paints, which are adhesive and bond to form a flexible surface when drying, may adhere to the masking and seal it to the artwork, or may be drawn off with the mask leaving ragged edges. It is best to test before use on important work. With these qualifications in mind, however, for small areas fluid may be more suitable than film. In most respects, fluid is more suitable for photographic retouching than for original artwork. Photographic papers are less liable to stain or be damaged as the masking is removed than boards or papers, because this type of surface is less receptive to fluids.

Loose masks and templates

The great advantage of film masking is that, because it adheres tightly to the surface, the sprayed area will have a perfect edge. As a general rule, the thicker the mask or the greater its distance from the surface, the less precise the edge. With this in mind, paper, card and acetate, cut with a scalpel or craft knife, can also be used as masking materials. They can be pressed down on the surface by hand or by weighting them with, for example, coins placed close to the edges and corners. When a fairly light mask is not held down firmly, it will lift under pressure of the airbrush spray, and when the spray comes in at an angle it can penetrate quite a long way.

Card is a fairly efficient masking material but if it is thick there will either be a fine line left unsprayed at the edges of the mask, or a build-up of medium, depending upon the direction of the spray. If the card is lifted from the surface, the edge of the sprayed area will be soft, and will be more so the higher the mask is held. This applies to any loose mask.

A large variety of plastic templates are produced for graphic and technical use, ranging from simple geometric shapes, such as circles and ellipses, to specific shapes appropriate to technical work. Templates known as French curves include several shallow and deeply cut convex and concave curves within a single shape. There are also plastic lettering stencils and separate letter forms cut in metal plates. Spraying through ready-made templates may involve blocking part of the range of shapes with masking tape or film to isolate a specific form. Some templates have tiny holes for registering against a line drawing and these should also be masked out.

It is useful to assemble a collection of templates by cutting required shapes out of acetate, or from large photographic negatives which are no longer needed. A caterpillar mask consists of a series of undulating curves which correspond to the inner and outer curves of ellipses. Such templates can be cut with a sharp scalpel and will save time on individual projects, as well as reducing the amount of film cutting on the surface of the artwork.

Rubbed down lettering and textures, such as Letraset and Instantex, can also work as masks. If they are laid lightly and sprayed over, they can then be lifted with a dried ball of rubber solution adhesive when the sprayed medium is dry. This leaves a negative impression of the form which can be coloured up with a fine spray of transparent medium such as ink or watercolour.

Since the main thing required of a mask is that it should get in the way of the airbrush spray, some interesting effects can be achieved with less rigid or conventional materials. Cotton wool, corrugated card, perforated paper, lossely woven fabrics and fine wire mesh all form textures in the sprayed surface. All sorts of simple found objects can be used, provided they are washable, or disposable. These may be organic items such as leaves, or objects such as bottle tops or kitchen utensils. Such experiments have a certain curiosity value and may answer a once-only problem, but it is unwise to lean too heavily on chance effects

and ready-made forms. Considered use of more orthodox materials presents a great range of visual effects.

Cutting tools

A small surgical scalpel with a lightweight, sharp blade is the best tool for mask cutting. The knife must cut only through the masking layer, using the weight of the blade itself, not pressure from the hand. The blade should not be too long or narrow as it is then too flexible, nor is a curved blade necessary – the straight shape is easier to manipulate. An alternative cutting tool is a print trimmer. This comes as a round shaft, like a pen holder, into which tiny blades are inserted. Ordinary craft knives are too heavy and the cutting edge too thick to be suitable for masking film, but they are handy for trimming cardboard or paper, or for cutting loose masks. A steel rule or metal-edged ruler is necessary for guiding the cutting tool along straight lines: plastic and thin wooden rulers are too flexible and might be shaved away at the edges by a scalpel. Templates can also be used to guide the scalpel cuts, but again the pressure must be light and the blade should not be allowed to catch in the template edge or slip away from the true line.

Other equipment

Depending upon the type of work to be done, a number of other items may come in useful. Tracing and transfer paper for drawing up a finished design on the final surface, clean sheets of rough paper for masking, testing spray or checking a colour mixture are all basic aids.

A size 6 or 8 sable paintbrush can be used for mixing paint and transferring it to the colour cup of the airbrush. If a liquid medium is used, spare glass droppers may also be needed. Sable brushes – sizes 2 and 3 – are suitable for hand-painted detail, such as highlights and brush ruling. Technical pens and ruling pens should also be kept to hand.

The best palette for mixing media for airbrushing is the ceramic type which has slanted mixing areas and dipped wells for liquid paint. These are expensive but should last a lifetime and they do not discolour as plastic palettes do. However, many different types of palettes are available, in plastic, ceramic and metal, and a choice should be made according to the size of wells needed and the type of medium being used. Plenty of clean water should be on hand, in perfectly clean jars, for diluting paint and flushing out the airbrush. A squeezy bottle with a dropper is handy for adding water to paint.

RIGHT A mask is simply anything which prevents the spray from reaching the surface. For hard masking, adhesive-backed film is available in a variety of roll widths. Cartridge paper, tracing paper and blotting paper can all be used for loose masking. Rubber adhesive applied to cut shapes of tracing paper was the traditional masking method. Liquid masking is useful for fine detail; tape for simple straight masking or holding down one edge of a loose mask. Patterned dry transfers give a textured result. Reusable masks can be cut from acetate. Found objects – combs, fabric, mesh – may provide particular solutions. A selection of cutting equipment includes surgical scalpels, knives with swivel blades for cutting curves, and craft knives. Paintbrushes should be used to apply liquid masking. Good steel rulers make the best cutting edge.

BASIC TECHNIQUES

irbrushing is a skill which, like any other, must be applied to the artist's own creative aims and requirements. Basic drawing ability does not depend upon simple sleight-of-hand with particular tools and equipment. Although visual systems have been developed which can be an aid to drawing, the facility to render three-dimensional form through a two-dimensional medium rests ultimately on the artist's ability to perceive the nature of form in real objects and to develop capabilities of assessment and a visual memory to which technical skills can be applied. Airbrushing can be used simply to fill in a traced image, which requires no special artistic skill other than a reasonable eye for colour, or it can be a means of rendering a highly finished, "realistic" image. However it is used, certain basic techniques must be learned and understood.

For the range of technical skills needed to produce a range of airbrush work, the operator must master control of the lever action of the airbrush itself, regulating the breadth and consistency of spray, and should also understand basic masking materials and methods, whether cutting from masking film or loose materials such as paper or card, or using ready-made templates. The basic principles of technique apply to all types of airbrushes, but the independent double-action models offer a greater range of technical facilities than fixed- or single-action brushes. The following information assumes the use of a tool with full operational capacity.

Control of the airbrush

The first essential is to discover a comfortable, steady way of holding the airbrush and manipulating the finger control lever. There are no fixed rules: it is a matter of individual preference, similar to how you might hold a pen or pencil. The airbrush is balanced in the curve of the hand between thumb and forefinger, supported between the thumb and middle finger, leaving the forefinger free to manipulate the lever control. In general it is best to control the lever by pressure from close to the top joint of the finger, rather than with the fingertip itself. This reduces the likelihood of the finger slipping or trembling on the control button. Some people close the tips of thumb and forefinger together to give a pressure point which directs the movement of the joint, whereas others leave the forefinger in free movement. The precise action can be tested by just holding the airbrush as if it were a pen; modifications can be made later if necessary when the airbrush is put to use.

When the air hose is attached, there is a slight pull downwards on the airbrush. To counter this and ensure the hose does not fall across the work surface, it can be wrapped once around the wrist and steadied under the base of the thumb. Another factor which affects balance is whether the colour cup is large or small, and whether it is mounted on the side, top or underneath the body of the brush. Some people find a side-mounted cup more difficult to balance. Left-handed people will find that in general airbrushes

1

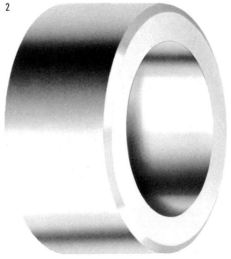

2

Vignettes
One of the characteristic effects of the airbrush is the vignette or graduated tone. Work from dark to light.

Holding the airbrush above the surface, move it back and forth in broad, even strokes, varying the distance from the surface to vary

the tone. If ink is used, the effect can be built up gradually using the same shade; with gouache, different tones may have to be mixed (1).

A simple exercise is to combine a series of vignettes to make a single form. Vignettes can suggest concave or convex surfaces (2).

Basic exercises with form
Once the technique of creating vignettes or graduated tones has been mastered, the method can be put to use to create basic shapes, with the aid of simple masking. Investigation and analysis of complex subjects will reveal an interlocking combination of these fundamental forms. Experiment with the rendering of these forms will reveal different ways of representing texture and materials.
1. To create a cube, cut three basic masks from masking film and vignette within the exposed areas. The darkest area appears the nearest, so the nearest corner should be this tone.
2. A cylinder can be produced using two masks. To give the illusion of volume and depth, a dark vertical line should be laid slightly off-centre, by spraying against a ruler. Lighter strips of tone are added around the object.
3. A sphere needs only one mask. The halo-shaped shadow should be placed within the circumference, spraying against a circle template held above the surface as a mask.
4. A cone is similar to a cylinder, but the shadows taper to a point. Use loose masks for the shadows.

are geared for the right-handed, although a few airbrush models, notably the Pasche AB Turbo, are made for both right- and left-handed use.

In some suction-feed models, the medium can be mixed in the colour jar or mixed in quantity and poured into the jar, which is then sealed except for the feed to the airbrush. For small colour cups and bowls, commonly a feature of gravity-feed airbrushes, the medium is dropped into the cup using a sable brush or glass dropper. A good quality sable brush should not shed hairs and as long as it is dust-free it cannot cause any blockage to the fluid channel. Most liquid inks and watercolours are supplied with a dropper, and the dropper method is ideal for fluid media used without mixing or dilution. With tube paint, for example a relatively thick medium such as gouache, it may not be necessary to mix a very large quantity and even when diluted the well of paint may be too small to be effectively picked up by a dropper, so a brush is easier for both mixing and filling. The colour cup should not be filled more than is necessary for a particular area of spray. In open cups the medium can spill out as the airbrush is moved and it may also start to dry before you have had a chance to use it all.

To test the consistency of the spray, the airbrush should be held perpendicular to the surface and about 6 inches (15cm) above it. The finger presses down and then back on the lever control button in one smooth action; at the same time the arm must travel across the surface to direct the stroke. When finishing a line of spray the lever is allowed forward and then up, again in one fluid movement, to stop the supply of medium before cutting off the air. If the lever is allowed to snap back it may disrupt the spray pattern and often leaves an amount of medium in the nozzle which spurts out when the lever is pressed again. It is quite usual to see a slightly heavier blast of spray at the beginning of a stroke until the controlling movement is mastered – it will take time to acquire a smooth and rapid coordination of finger control and arm movement. The brush should not be held too high above the surface even for a broad area of spray, as the medium may then dry slightly as it falls and produce a grainy texture. Sudden wrist movements cause a looped or flaring stroke, and in general there should be an integrated motion of arm and hand guiding the path of the spray.

A useful test of airbrush control is to spray an area of flat colour. This is done by working across the support from side to side, moving gradually down the surface. Ideally there should be no variation in density at the beginning, centre or end of each line of spray. To eliminate striping which may occur when the spray always follows a lateral path, the surface can be turned through 90° and a second layer of colour applied across the first.

Basic exercises

Airbrushing has two main advantages over other painting techniques. According to the height of the airbrush above the surface, the artist can produce either a broad area of even spray or a very fine line. Because of the fine and consistent texture of the atomized medium, the airbrush can make an even gradation of tone, or progress from one colour to another, without any perceptible breaks in the overall surface texture. Both these properties are used to the full in highly rendered illustration.

Establishing control

An exercise which helps to establish control of the airbrush is line ruling. A ruler is held with one edge pressed down on the surface and the other tipped up slightly. The airbrush is run along the ruler to create a very fine line if the nozzle is held close to the board, or a broader, hazy line if the guiding ruler is tipped up further from the surface. Any excessive pressure at the start of the stroke or abruptness in releasing the control lever will show as a variation of width and density at either end of the line. A hesitant motion will create interruptions in the path of the spray. Spidery trails flaring out from the line indicate that lever control is too heavy and sudden, or that the paint consistency is too thin. For this exercise, a wooden or metal-edged ruler should be used – plastic is too flexible – and the fingers and underside of the airbrush can rest lightly on the edge for support. The flat, not the chamfered side of the ruler is best, otherwise the airbrush may slip out of line as it is moved.

Basic shapes

The technical capabilities of the airbrush must be married to the artist's understanding of conventions which govern the rendering of three-dimensional form on a two-dimensional surface. This has been the major preoccupation of painters over the centuries and various tricks and systems have been devised to achieve this aim. The rigorous analysis of the fundamental nature of three-dimensional form is exemplified by Paul Cézanne's (1839-1906) famous statement that all natural forms could be analyzed

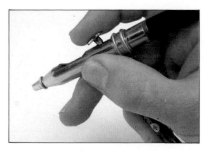

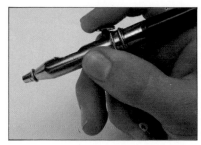

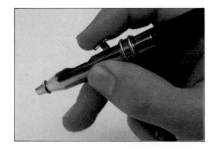

Holding the airbrush
1. Hold the airbrush as you would hold a pen, with the thumb and middle finger supporting it underneath. To release the air flow, press down the button with the index finger.

2. To release the paint, pull the button back while keeping it depressed.

3. If a smooth effect is required, it is important to stop the paint flow before stopping the air flow. Ease the button back to its original position.

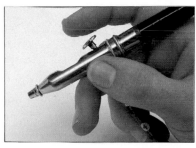

4. Stop the air flow by lifting the index finger from the button, so releasing the pressure on the button. With practice, all these movements can be regulated so that undesired spattering is avoided.

Cutting and using a mask
1. Cover the support – a piece of paper or board – with masking film and smooth out any wrinkles.

2. Place a piece of tracing paper, with a sheet of artists' carbon paper beneath, on top of the masking film and transfer the existing image onto a board.

3. Cut around the outline of the image that has been transferred onto the masking film, using a ruler, if there are any straight edges, and a scalpel.

4. Lift a corner of the cut shape from the surface with a scalpel and peel it back.

5. Using the airbrush, paint the unmasked area as required

6. When the section has been sprayed, allow the paint or ink to dry. Replace the cut shape in its original position, and repeat the process with other shapes and coloured sprays as desired.

Tearing a mask
1. If a mask is not stuck to the support, some of the sprayed paint or ink will seep behind the edge. To make this loose type of mask, tear a piece of fairly thick paper.

2. Spray along the torn edge. If a lined or ridged effect is required, move the mask at intervals.

Retouching a photograph
1. This procedure can be used to add colour or otherwise retouch a print. Peel the backing from a piece of masking film, without fingering the underside.

2. Place the film over the surface of the print – in this case, a picture of a jug – and avoid bubbles or creases by smoothing out the film with the palm of your hand.

3. Without cutting too deeply and ruining the print, use a scalpel to cut around the outline of the jug and the edge of the print.

4. Peel away the part of the film covering the background, to reveal the area that is to be sprayed.

5. The background is to be vignetted dark at the top and light at the bottom, so by turning the picture around, begin airbrushing the top with broad, even strokes. Work horizontally in a smooth arc towards the lighter end.

6. When the vignette has been achieved, lift a corner of the masking film with the blunt edge of a scalpel and peel the film away.

Airbrushing a straight line
1. The small ridge at the tip of an airbrush helps to hold the airbrush firm while moving it along the edge of a ruler. Before spraying, test the air and paint flow on the mask.

2. Holding the ruler balanced on a book or an object of an appropriate height, slide the airbrush along the ruler to practise a smooth movement, then spray evenly in one direction.

3. The intensity of the vignette can be varied depending on the proximity of the airbrush to the support. Here a sharp line is being sprayed. Ensure the paint is dry by blowing air through the airbrush onto the image.

Cleaning the airbrush
1. Soak up any excess paint from the reservoir using a paintbrush or an eyedropper.

2. Fill the reservoir with clean water and spray it through the airbrush. Repeat the process until the water sprays out clear.

3. Remove any moisture from the reservoir with a clean, dry brush before using the airbrush again or putting it away.

LEFT Representing textures and materials convincingly involves careful study of the way light is reflected from different surfaces. These two exercises show how textures can be suggested on flat surfaces – the cubes – and curved surfaces – the cylinders.
1. The matt texture of rubber can be suggested by light spattering.
2. Glass allows other objects to show through.
3. A reasonable contrast of tones suggests perspex.
4. Chrome is highly reflective. Highlights and shadows will be hard-edged and strong.
5. Highly polished steel shows a strong contrast between light and dark.
6. Mild steel is a duller metal and the contrast will not be as great.
7. Spun aluminium is matt. Contrast is minimal.
8. Stove-enamelled steel has a speckly texture.
9. A cast-finished metal is dull. Texture can be achieved by spattering.
BELOW This 1928 cover design for the Bauhaus journal was the work of Herbert Bayer. Basic airbrushed forms given depth by strong cast shadows produce a striking contrast with the flat montage.

ABOVE The type and direction of lighting is an important consideration when representing form. In straightforward illustration, the aim should be to present as much information as possible, as clearly as possible. In this example, a hard light from the right-hand side gives a strong, dramatic result, but at the expense of some of the detail (1). A diffused light coming from the left-hand side reveals more aspects of the form, but is rather soft (2). A combination of both gives definition while revealing essential information (3). Throughout the progress of the work bear in mind where the light source is and maintain consistency to avoid distortion through the incorrect placing of shadows or highlights. Good reference will help.

as a combination of cylinders, spheres and cones, represented in proper perspective. In airbrushing work, basic exercises are designed to teach the artist how to define the distribution of light and shade over such simple shapes so that they have the correct three-dimensional appearance. Once learned, these tonal keys can be applied to break down and assess the structure of more complex objects, giving a logical system of representation.

The range of forms used to develop airbrush technique adds the cube to Cézanne's list. (He was referring to nature, in which there are few right-angled corners, whereas airbrush illustrators are often concerned to represent man-made forms – angular, rigid and symmetrical.) The basic outline form of a cylinder, cube, sphere or cone can be achieved using a ready-made template or by cutting a simple mask from adhesive film, cardboard or stiff paper.

A simple rectangle can stand as the basic side view of a cylinder; then it is the artist's task to apply tonal gradation to the shape in such a way that the surface appears to curve. This type of pictorial illusion can be manipulated so that an object appears to either project or recede from the plane surface on which it is painted. In a cylinder, a convex curve is typified by reflected light at the edges of the shape. The darkest part of a cylinder is never on the edge, although this is where the form is curved furthest away from the viewer, and probably from the light source. In airbrushing conventions, the dark tone is usually placed in the lower half of the shape but not falling to the bottom edge. Dark tones at either edge actually appear to come forward, so this convention can be employed to suggest a concave curve, though the same basic outline is used as for the convex curve.

The same rule applies to a sphere. To make a basic circle appear three-dimensional, the dark tone is applied fading around a curve a short distance in from the edge. The contrasting highlight area should be placed off centre so it does not appear to be enclosed. Concentricity in the bands of tone within the circumference of the circle will make the form appear dished. When applying the darker tones to a sphere, the airbrush should be used to make soft bursts of spray which merge to form an arc of solid tone, rather than directed in a linear sweep around the circle. A sweeping brush motion sets up movement within the form as the accelerating spray path narrows and assumes a particular direction.

When rendering three-dimensional forms it is best to imagine a single light source which illuminates the form systematically. It must then be judged which areas will be shaded from the light and which will be best lit or fully reflective. A cube is usually shown with three faces, one top corner pointing directly toward the viewer so the planes visible are the top of the cube and the two vertical sides meeting at the edge leading down from the top corner. The form is suggested simply by the use of three basic tones – light, medium and dark – one on each plane. A slight grading of tone across the individual planes gives a more realistic effect, but the three-dimensional impression can be established using only flat colour.

Tone and texture

An object reflects or absorbs light not only by its position in relation to the light source but also according to its texture and substance. The clearest example of this is in the difference between two metal cylinders, one shiny and one matt. The shiny surface has high tonal contrasts and sharp divisions between the tones, while the dull finish is characterized by a closer tonal range and smooth gradation from light to dark. These differences can be achieved technically by the use of different types of masks. A mask which is adhesive or absolutely flat to the surface gives the sprayed area a hard linear edge. A loose mask held slightly away from the surface gives a definite edge, but it is softer and fuses into the underlying tone. To give the impression of a matt surface with minor tonal variations, no extra masking is needed within the basic outline shape. Careful control of the width and density of spray bands across the shape is all that is required to give it form.

Although there are certain basic rules which can be applied to the rendering of tone and texture, it is important to observe real objects and assess their characteristics. Light reflection, and shadowing and surface detail essentially describe particular forms. Cast shadows, on a flat surface or of one object against another, help to emphasize three-dimensional space and edge qualities. If there is a secondary light source, for example daylight from a window as well as artificial light, there is a lighter, fuzzed edge to the shadow which may also modify its shape, depending upon the direction of the light. Translucent and shiny surfaces are subject to modifications of colour and tone caused by reflection or transmission of colour. Subtle use of reflected light on the edge of a plane surface gives extra definition to a form.

There are various ways of achieving different textures in airbrushing and one is by using the capabilities of the airbrush itself. In independent double-action models the texture of the spray can be altered, since air and medium supplies are separately controlled. A higher proportion of medium to air gives a coarse, slightly spattered spray. Experiment with the lever control will reveal the range of texture which can be achieved without the need to alter the consistency of the medium.

When simple shapes are understood, the principles of light and shade can be applied to more complex forms, which should be seen as composites of the basic shapes. The tonal structure can be identified even where there is a change of fabric and texture. Although a certain amount of basic practice is needed before starting on fully rendered illustrations and before investing in expensive materials for finished work, it is best to make up some composite shapes early on – the exercises will serve as models for skills which need improvement.

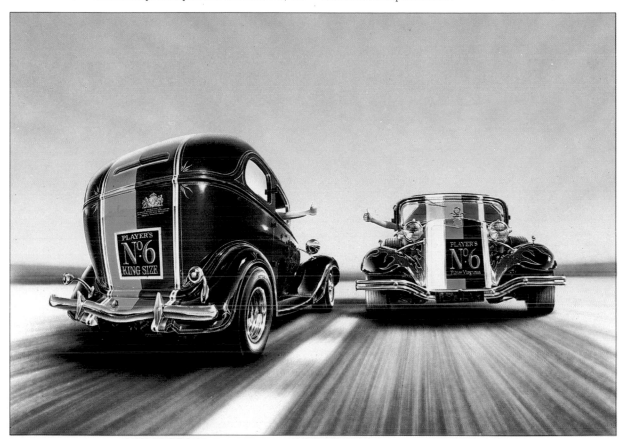

Lettering
1. The letters and outline were drawn on the board and the first tone sprayed, leaving an edge for highlight. The side strip was sprayed.

2. All of the letters were masked and a flat black tone was laid in for the background.

3. Using the same mask, areas were cut and sprayed brown; further cuts were made and yellow was added over the brown. The white areas were left masked.

1

Technical drawing
Accurate line drawing is essential for successful illustration. It is even more crucial for technical work, where the forms are often complex and interrelated. No matter how skilled the airbrushing or mask cutting may be, without a precise drawing as a basis for subsequent rendering, the end result will not be effective. There are a number of special techniques which should be mastered before attempting simple technical illustration; for more complex work, considerable practice in projection will be required.

Ellipse construction
A circle seen in perspective is an ellipse: this form is fundamental in the rendering of sections or cylindrical objects in perspective. If a cube, with circles described on each face, is drawn in perspective, the circles will appear as ellipses. The circle touches the cube at the midpoints of each side: in perspective this can be used to determine the major and minor axes of the ellipse (1). Ellipses can be drawn using ellipse templates, but they can also be constructed by the trammel method. First establish the lengths of the major and minor axes and mark these on a strip of paper (2). To construct the ellipse, move the strip of paper, keeping the inner mark in register with the major axis and the outer mark in register with the minor axis.

Connect the points (3).
Orthographic projection
Illustrators can use engineering plans to construct three-dimensional drawings. There are two basic ways in which information is presented: first and third angle projection. In first angle projection, what is viewed from the left is drawn on the right (4). In third angle projection, more commonly used, what is seen from the left is also drawn on the left. (5).

2

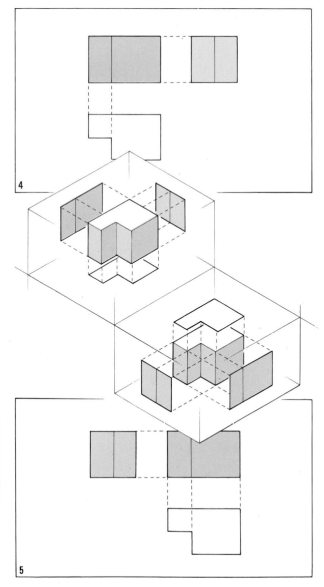

4

3

5

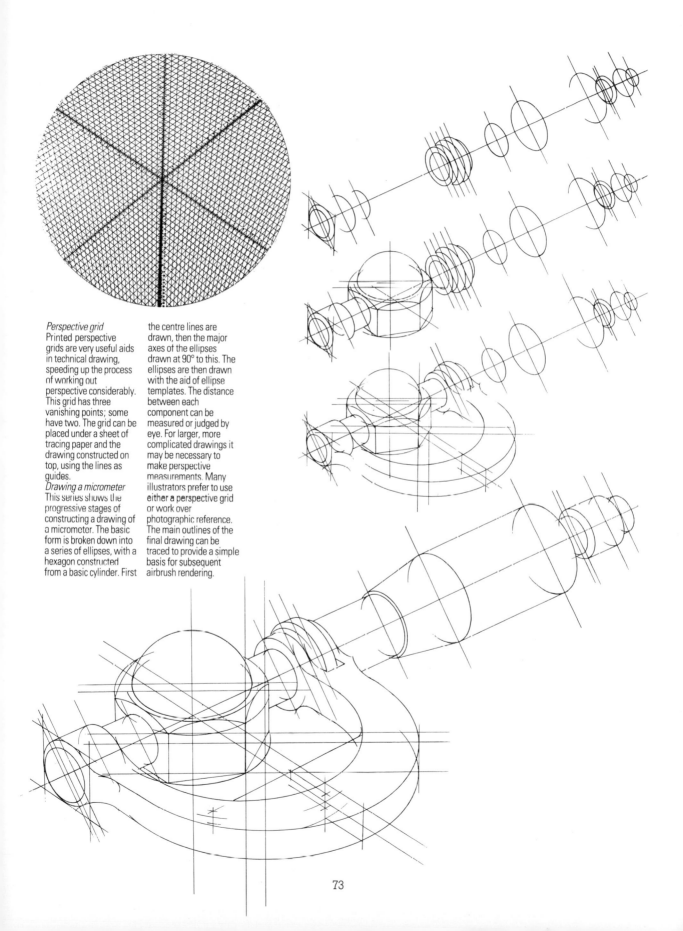

Perspective grid
Printed perspective grids are very useful aids in technical drawing, speeding up the process of working out perspective considerably. This grid has three vanishing points; some have two. The grid can be placed under a sheet of tracing paper and the drawing constructed on top, using the lines as guides.

Drawing a micrometer
This series shows the progressive stages of constructing a drawing of a micrometer. The basic form is broken down into a series of ellipses, with a hexagon constructed from a basic cylinder. First the centre lines are drawn, then the major axes of the ellipses drawn at 90° to this. The ellipses are then drawn with the aid of ellipse templates. The distance between each component can be measured or judged by eye. For larger, more complicated drawings it may be necessary to make perspective measurements. Many illustrators prefer to use either a perspective grid or work over photographic reference. The main outlines of the final drawing can be traced to provide a simple basis for subsequent airbrush rendering.

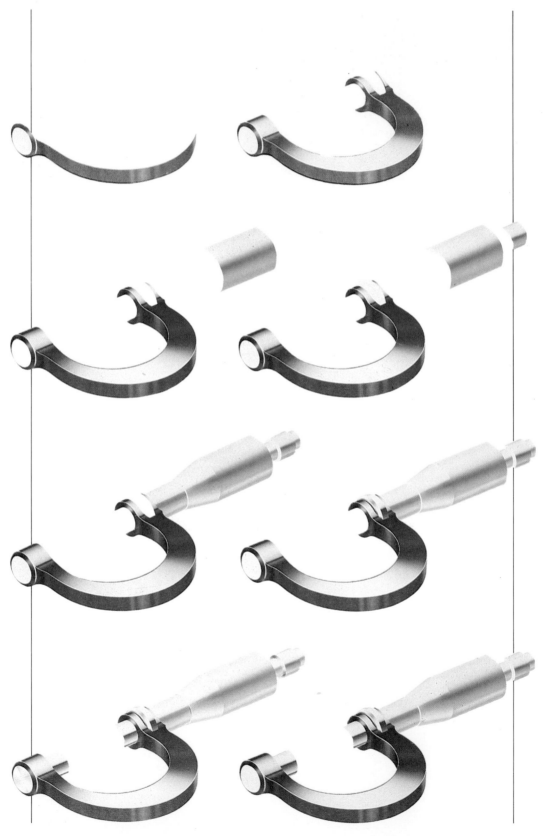

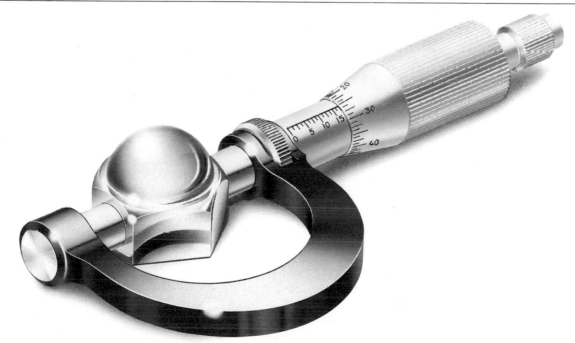

Rendering a micrometer
The illustrations on these pages show the stages of airbrush rendering of a micrometer. The biggest areas – the horseshoe shape and the handle – were sprayed first to provide a key. Masking film was used for the entire illustration, except for the straight lines which were created by spraying against a ruler. Detail was added with a ruling pen, as were the fine lines on the handle. Highlights were taken out with a rubber or scalpel. Spot highlights on the horseshoe edge and nut were created by taking out the middle with a scalpel and softening the shape with a stick rubber before spraying lightly over the top. The majority of the airbrushing was executed in watercolour.

Masking techniques

Masking is an integral part of airbrush work. In a few cases the planning and cutting of masks is a more important aspect of technique than the use of the airbrush itself – in design and illustration masking is vital to the artist's control of the image. Airbrushing cannot provide the edge qualities created by ordinary brush painting and in addition to the naturally soft character of the spray within any given area, if the airbrush is at any distance from the surface there is an amount of overspray which cannot be precisely calculated. To answer the needs of graphic artists a thin, adhesive masking film has been developed which allows complete accuracy and this is the material most widely used. But any material which stands in the path of the spray is technically a mask. There is a considerable range of effects that can be achieved by this technique.

Using masking film

The thickness of the masking material affects the edge qualities of the sprayed area, as does the angle of airbrush spray. Transparent, adhesive masking film is thin and sticks firmly to the surface. It cannot be lifted by the pressure of the spray and no medium seeps underneath, unless the mask is stuck to a noticeably textured surface. It is plasticized and non-absorbent and can be cut in straight lines, smooth curves or intricate outlines.

Masking film is bought in sheets or rolls with the adhesive side protected by backing paper. The backing paper is removed and a section of film laid over the working surface. The mask is cut in place and, because it is transparent, a drawing or tracing can be clearly seen underneath, giving a guide for cutting the film. The masking also adheres to surfaces which are already sprayed so it can be used at all stages of the work. Any previous spraying must be completely dry before adhesive masking is laid over it and, in the case of gouache which has a slightly powdery, dry surface, it is advisable to fix the area with a light spray of gum water. Where detailed work has been applied with a sable brush or ruling pen it is not advisable to apply new masking film. The paint here is thicker and may lift when the mask is removed.

Masking film is either laid onto a specific shape to protect it while the area surrounding it is sprayed, or a sheet of film is laid and a shape cut in it and lifted to expose a particular section for spraying. Even if a shape is quite small, it is not enough to mask only around the edges as the overspray from the airbrush travels quite a distance and the whole work surface needs protection. When backing paper is removed the masking film is slightly stretchy, so it must be pressed down carefully and any air bubbles smoothed out. To lay a large sheet of film, only a small section of backing paper at one corner is peeled back. The adhesive corner can then be laid on the artwork surface and the edge of a ruler used to gradually smooth down the rest of the sheet from the top as the backing paper is peeled away from underneath. For smaller pieces the backing paper can be removed completely and the masking laid and smoothed out with the fingers, but it is necessary to take care that the mask does not stretch and exert tension on the surface and that it is not allowed to stick to itself as it is handled. When the mask is in place it is advisable to check that there are no tiny holes which may be filled by airbrush spray straying on to the surface outside the area which has been purposely exposed.

The masking is cut using a sharp, surgical scalpel and to avoid damaging the surface underneath this must be done with a very light touch, using only the weight of the blade itself, not pressure from the hand. Scoring from the blade on the artwork cannot be fully disguised and repeated cutting in the surface of a board, however light, destabilizes the surface so there is a risk that this will then lift with the mask. When using a ruler or template to guide the cutting tool there is a natural temptation to press quite hard to control the path of the cut, but again the only pressure should be that of the blade itself.

To lift the cut section, the scalpel blade is gently inserted under the edge and the masking film coaxed up and peeled back on itself. When the blade is inserted it must be held flat against the surface to avoid digging into the artwork. The movement to lift the film should be smooth and even to prevent it taking up the board surface or sprayed area underneath. The sections cut away from the main mask can be saved by sticking them to a piece of the backing paper or other surface which cannot grip the adhesive. These can then be replaced to mask the area which has been sprayed and protect it while other work is done in the surrounding areas.

When spraying over a mask, the airbrush should be held as nearly as possible at right-angles to the surface. Otherwise, there will be a build-up of colour at the edges of the mask, or a tiny unpainted hairline will appear as the spray falls across the mask onto the exposed surface. With masking film this is not so noticeable, but the thicker the mask used, the more exaggerated the effect. If a gum fixative is applied to dried paint, it is better to remove the masking film first where

possible, as the gum sometimes adheres to the mask and leaves a rough edge as the fiilm is lifted.

The advantage of saving cut pieces from a mask is that both the inner and outer shapes can be masked for only one cut on the outline, thus saving wear-and-tear on the surface. However, because masking film stretches in handling it is sometimes difficult to replace a cut section precisely, in which case a new mask must be cut. If the outline of a shape is particularly complicated it is vital to check that every scrap of the film has been lifted out of the exposed area. If the cutting is not done as one smooth operation there may be fragments left in sharp angles or inner curves which can be overlooked when the main area is removed.

Masking film is transparent but the covering still affects the artist's perception of tone and colour underneath and the airbrush spray will eventually build up on the surface of the mask and completely obscure what is underneath. Both these factors have an influence on the apparent effect of the colour being applied. There is a tendency to spray too dark a tone because it cannot be seen in full contrast to the true surface. To overcome this problem, masking can be partially lifted during the work to allow an assessment of the overall balance of tone and colour. If the mask becomes too obscure it may be re-placed with clean film, but it is better to keep cutting on the surface to a minimum. Paint or ink dries more slowly on the non-absorbent mask than on a board or paper, so care must be taken not to smear colour on to the artwork when lifting the mask.

Loose masking

Masking film will not shift during spraying and it enables the artist to achieve a clean, hard edge on every shape, but a number of other materials can be used as loose masks to provide hard or soft edges, or different textures. Loose masks can be cut from cardboard or paper; here the thickness of the material, the distance from the surface and the angle of airbrush spray can be combined in different ways to produce a variety of effects. Almost any type of cardboard or paper can be used although if a particularly absorbent material is used the spray will seep through to the artwork surface. Blotting paper, for example, could be used to create an unusual edge quality, but a little more control is usually required.

A hard-edged shape cut from paper or cardboard and held down firmly on the surface produces an edge on the sprayed area almost as accurate as that obtained by masking film. Paper, being lighter, may be lifted by the force of the spray, and if thicker cardboard is used spray might accumulate

Masking effects
Experiment with different types of mask will reveal a variety of effects.
1. Paper hold close to the surface gives a sharp edge.
2. Paper held above the surface gives a diffused outline.
3. Paper curved in the middle gives a buckled effect.
4. Masking fluid can be sprayed through the airbrush to give a textured effect. Paint is sprayed over the fluid and when the surface is dry, the masking is rubbed off.
5. A circle template held to the surface gives a hard shape.
6. A template held above the surface gives a soft effect.
7. Here a template is held down at one side.
8. This shape is the result of bowing the template.
9. This flame effect can be gained by spraying through at an angle.

at or miss the edges of the shape, depending upon its angle against the mask. These problems can be turned to advantage however – as the mask is gradually raised from the surface the edges on the sprayed areas become progressively softer. This quality enables greater variation of tone without cutting several different masks. Acetate is also a good material for loose masks. A mask which is flexible can be curved away from the surface to cause a variation of soft and hard edges with only one spray action. To create an irregular outline, acetate can be lightly scored and snapped. Loosely torn paper can give a textured edge. Torn masking tape produces a similar edge, but because it can be stuck down like masking film it has a sharper effect.

Plastic templates of curves, ellipses, and other shapes including letter forms, can be used directly for masking or as a guide for cutting cardboard, paper or acetate masks. A number of ordinary household objects and materials make other textures and patterns – cotton wool gives a hazy edge, a comb or saw blade leaves its silhouette on the surface and loosely woven fabrics create texture across a broadly sprayed area. Absorbent materials will only be useful once, but any rigid or non-porous material can be used over and over again.

The masking sequence

In many ways, the ability to determine the correct sequence in which to spray and mask the various components of an image is the key to airbrush work. Like other aspects of airbrushing technique, this demands a thorough knowledge of the potential of different media, an understanding of tonal values and the conceptual ability to analyze the components of an image. Although the masking sequence is crucial for every piece of work, there are no definite rules which can be applied consistently. Every problem is different and solutions necessarily vary. Some broad guidelines can be suggested for achieving specific effects, but it is impossible to devise a foolproof method which will work on all occasions: only experience can teach the airbrush artist how best to solve a particular problem.

In general, many images can be broken down into several basic areas, although the order in which these are sprayed will vary. Common components include background, main colours and tones, shadows, textures and highlights, and fine detail (often applied by hand with a brush, pen or other drawing media). A background area, for example, may be laid in first or last: if it is sprayed last, however, it is important to retain a mental picture of the overall tone while the work is in

Edge effects
1. A straight line can be produced by running the airbrush along the edge of a ruler.
2. Graduated bands can be achieved by

vignetting from one hard edge – masking film or cut paper.
3. A fuzzy line results from vignetting from both sides of a ruler.
4. Moving the airbrush

up and down while decreasing the amount of paint gives a smoke-trail effect.
5. A fine crinkled edge can be made by spraying against torn tracing

paper.
6. Torn blotting paper gives a softer edge.
7. Torn cartridge paper gives a line similar to torn tracing paper.
8. This line can be made

by tearing paper and moving the two sides apart to spray in the middle. This effect is useful for suggesting reflections in the side of a car, for example.

9. Here paper has been torn in a V and a vignette sprayed from one edge.
10. The softest effect of all can be made by spraying against cotton wool, useful for clouds.

ABOVE *The Man Who Japped*, Chris Moore. About half of this illustration was freely sprayed; masking was used to create patterns and the sleek lines of the spacecrafts. The diamond pattern on the red circular light around the missile is the type of effect that can be achieved by masking vertically with an ellipse template and then horizontally with a straight paper edge. To create the diffused shadow on the missile, a mask was probably held at some distance from the surface.

1

Illustrating a car
Once basic control and simple exercises have been mastered, it is best to attempt a fully rendered illustration. Cars make ideal subjects, as their shiny metallic surfaces are well suited to airbrushing techniques. This example, an illustration of a Kurtis 500S, shows how colour and form is built up. The first stage was to produce a master drawing on tracing paper. Using transfer paper, the main outlines were transferred to CS10 board, the surface most suitable for work in gouache. Masking out the background, a base colour, rose tyrien, was sprayed on the bodywork, except the front wheel-arches and the wheel-arch behind the window. Alizarin crimson was then sprayed to give a deeper red (1). The front wheel-arches were then sprayed with alizarin crimson and deep orange lake mixed with ivory black to give the sharp reflective tones. Ellipse templates and cut paper

were used as masks. Permanent white was sprayed on the front corners. A mask was cut leaving the upper bonnet, lights and highlights on the back wheel-arches covered, and the bodywork was sprayed using mixtures of the same colours as before. Cut pieces of film and paper were used as masks to give shapes on the side and bonnet. Torn paper and rulers were also used. After the back wheel-arches were sprayed, the masks on the highlight areas were lifted and these areas blended in. The backs of the headlights were sprayed (2). A mask was cut to expose the seat area, but not its surround. Ivory black and light purple, and ivory black and Windsor blue were sprayed lightly over the whole area. A piece of paper was held over the windscreen and further spraying darkened the surrounding area. The seat surround was masked and sprayed using the same colours. The lower bonnet and

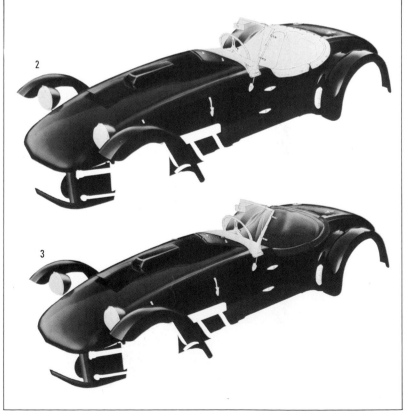

2

3

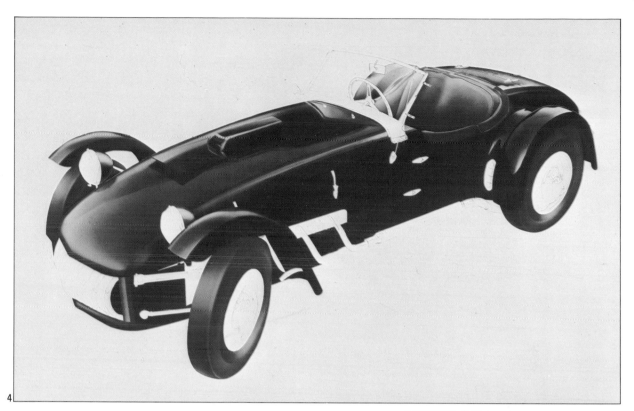

4

5

6

reflection in the bonnet were sprayed, with pieces of film held against the outside edge to prevent overspray on the background (3). Tyres were sprayed ivory black and built up with spectrum yellow. Windsor blue was added to give shaping. At this stage, all of the major tones and shapes had been established and it remained only to add

chrome trim and fine detail (4). The wheels and hubcaps were the first areas of chromework to be sprayed. A base tint of Payne's grey (in watercolour) was laid first, worked over with Payne's grey mixed with spectrum yellow and Windsor blue. Highly polished or reflective surfaces, such as chrome, demand special care. Lines must be kept as

sharp as possible to heighten the impression of shininess. Working in the centre of the hubcap, the illustrator sprayed a "horizon" line on the hubcap against a mask created from torn paper. Torn paper, ripped into a suitable shape, was used to give a fuzzy, slightly contorted line following the contours of the surface (5). The tones cither side of the line

were established next. As is the convention when representing shiny surfaces, the top portion was given a hint of blue (a "sky" reflection) and the lower portion a hint of a warm, earth colour (a "ground" reflection). . The dark areas on the bodywork were sprayed with a mixture of ivory black and light purple. Retouching ink was used to give further depth (6).

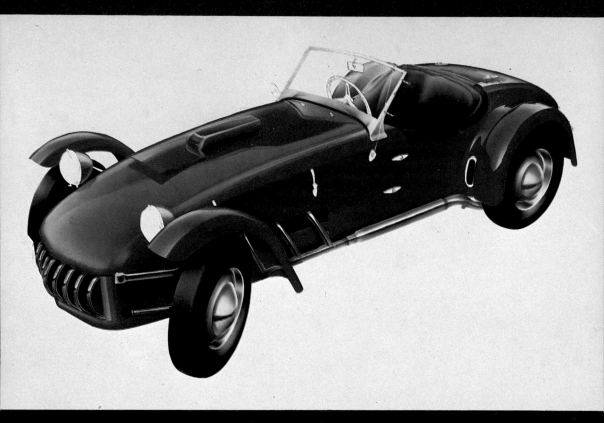

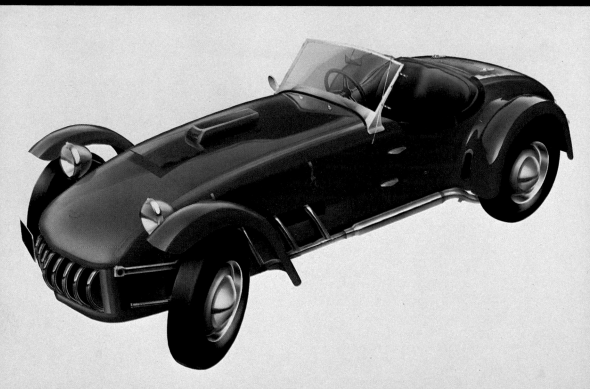

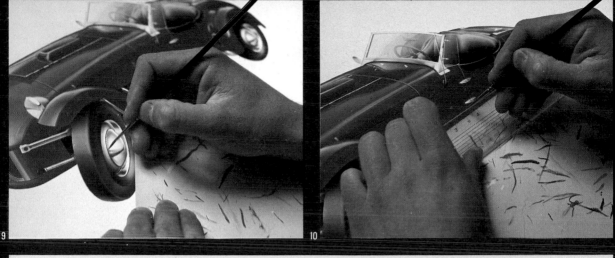

9 10

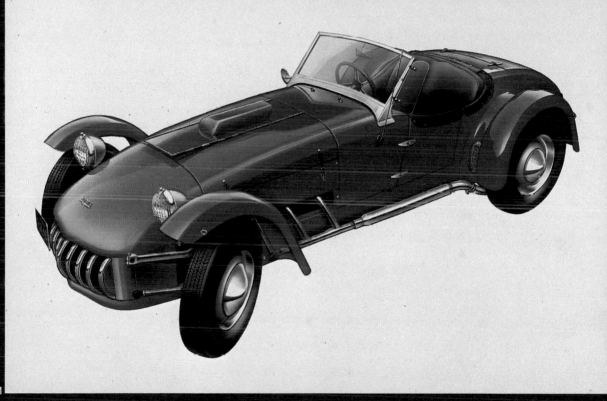

11

For the next stage of the illustration, a series of masks were cut for the back wheel-arch ventilation, the hole in the side of the car for the exhaust, the underneath of the front wheel-arch and the area behind the front grille: The chromework on the front grille, exhaust pipe, headlight rims and windscreen surrounds were sprayed, using the same techniques and colours as were used for the hubcaps (7). A mask was cut for the steering wheel and rear-view mirror; these were sprayed. The steering wheel was sprayed with deep orange lake mixed with ivory black to give brown. The steering column was sprayed in Payne's grey, the rear-view mirror in Payne's grey and spectrum yellow. Both were kept light as they were behind the windscreen. A mask was cut for the windscreen and permanent white, mixed with touches of Windsor blue and spectrum yellow, was sprayed, using torn paper masks (8). Fine details, such as the number plate, tyre treads, emblem, aerial and hinges were hand-painted with a sable brush (9). Highlights were applied by hand, freehand, or with the use of a ruler or French curves (10). In the final stage, the side window was sprayed with a touch of permanent white. The reflection in the windscreen was softened with white. Permanent white was sprayed to create highlights on the front wheel arches and on the bonnet. The front of the upper bonnet bulge was resprayed completely – permanent white was sprayed first to cover previous work. Highlights on hubcaps were swabbed with moistened cotton wool wrapped around the sharp end of a brush (11).

progress and the way this will affect the design. An area of basic, middle tone can also be sprayed first, to give a key for the range of light and dark tones to be added, or a key colour can be established. In illustrating a car, the basic colour of the car body can be sprayed first and smaller masks then cut to develop the detail of separate sections with their particular shadows and highlights.

A softly graded area of colour is achieved by airbrushing freehand within a single masked shape, but if high tonal contrasts and hard lines are needed, extra masking film or loose masks can be applied within the outline. To save cutting, colours can be overlaid in a transparent medium such as ink or watercolour, to develop the range of hues. For example, a rainbow effect can be obtained within a masked shape by spraying a band of yellow between red on one side and blue on the other, allowing the colours to overlap and produce the secondary colours of orange and green. If, on the other hand, each band of colour needs to be a definite stripe, separate masks for each would be required.

To indicate the transparency of a material such as glass or perspex, underlying detail is fully worked first. The impression of transparency is created by overlaying surface colours and tones using such transparent media as ink or watercolour. It is possible to simulate the transparency of, for example, a window or bottle, by working each area separately with detailed description of the variations in tone and colour representing surface reflections and distortions in objects seen through the glass. This can be done with an opaque medium and requires patience and concentration to make it work. A transparent overlay may give a more coherent impression of the real appearance.

Surface detail, such as highlights, textures and lettering should be added when the main spraying of tone and colour has been completed. Hand-drawn detail applied with a brush, pen or other drawing media, is time-consuming and delicate. It should be done as the final stage of an illustration, as brush-painted medium dries thicker than airbrush spray and is more vulnerable to damage. Much airbrush illustration contains a good deal of hand-drawn work, and such detail should be identified at the start and borne in mind throughout the working process. The overall balance of tone and colour should be thoroughly checked before any work is added by hand. If a sprayed tone needs adjustment the brushwork would be covered by subsequent spraying, if put in at an early stage, and drawing media applied over airbrushing may resist further spray.

Corrections to airbrush work can be difficult due to the uniform texture of the spray; any interference in the surface creates a different finish which must then be concealed. Gouache painting can be corrected simply by overspraying, since the paint is opaque and has good covering power, and gouache can also be used to correct watercolour, although the transparent quality of the original spraying will be lost. Inks and watercolours, unless dried and waterproof, can be wiped back lightly with a damp cotton wool bud to lift the colour. This technique can also be used to create highlight areas. A small area of paint can also be gently scratched back with a scalpel blade. These techniques are used more in photo-retouching where the paper surface is less easily damaged, but illustration boards are also resilient. Ordinary drawing and watercolour papers should not be scratched, as this raises a nap which will remain obvious.

Starburst highlight These distinctive highlights feature widely in a certain type of airbrush work – adding glamour to high-gloss images and sparkle to illustrations of shiny, metallic objects.
1. Using a scalpel and a metal ruler, cut a thin sliver from a piece of stiff paper. The shape should taper to a point at both ends.
2. Spray once through the mask.
3. Move the mask four times, spraying in each position. Spray collects in the centre.

ABOVE This logo by John Rogers features a dramatic highlight which increases the impression of shininess on the metal surfaces. This type of lettering can be created by a straightforward use of masking film. Clouds are sprayed in gouache and final highlighting painted with a brush. To complete the starburst, a dot is sprayed.

As with any painting or drawing technique, there is no substitute for experience. Expertise in spraying and masking is acquired gradually, with new ideas for solving particular problems occurring all the time. Airbrushing, though it tends to create a polished and convincing finish, will not conceal a basic inability to understand form or a slipshod attitude to drawing technique generally. Practice will bring rewarding results within a relatively short time, even though it may take years to fully realize the potential of the technique. The ability to use the airbrush successfully depends on the integrated application of perceptual and manual skills – the tool as such should not be expected to take responsibilities which primarily belong to the artist.

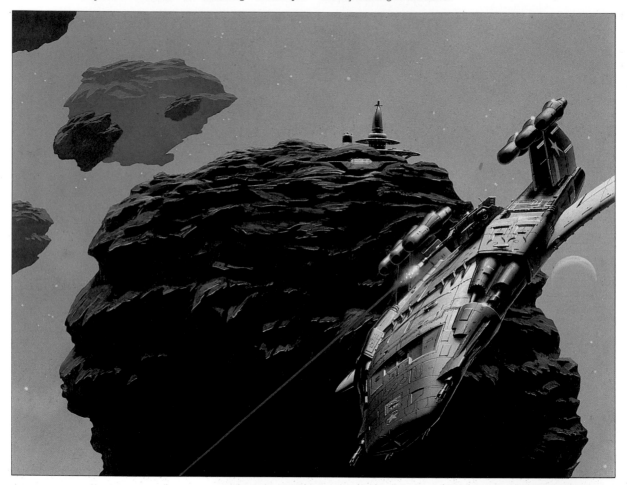

ABOVE Airbrushing lends itself well to the creation of spectacular fantasy illustrations, where an illusion of reality is crucial for the success of the final effect. In this science fiction illustration by Chris Moore, airbrushing provided the means to create the basic structure of the spacecraft and to lay in the tones of the sky. The highlights and fine detail on the ship were hand-painted in acrylic. The distant asteroids only were sprayed.

RIGHT Doug Johnson's illustration for the sleeve of a record by the rock band Judas Priest shows the type of dynamic image which is well suited to airbrushing. Such a clearly defined design requires extensive planning to establish the masking sequence. The masking itself needs to be carried out accurately and meticulously. Only the ruled lines and dots of the highlights are brushwork; the rest is sprayed.

ABOVE This sensitive and finely executed illustration by Richard Manning is a good example of the use of watercolour. For the textured background, blue and ochre were each sprayed using a splatter cup. The tradename on the hammer was stippled with a fine paintbrush; the handle also includes brushwork.

THE GRAPHIC IMAGE

Airbrushing today is an integral part of the graphics industry in all its many facets. Over the past century, the world of graphics has undergone a revolution: the airbrush has been one of the important catalysts in this development.

In the traditional view, graphic works are those executed with drawing media, a pen or pencil for example, and by printing techniques. That part of a painter's output which is termed graphic work usually consists of minor studies compared to the major oeuvre of full-scale oil paintings. Recently, however, categories within the fine arts have been subject to redefinition and the use of acrylics, collage and drawing media in major works by many artists has removed some of the mystique attached to oil painting.

The graphic arts comprise all forms of illustration and two-dimensional design and decoration. The traditional association of graphics with drawing and printing media derives from the fact that such work has usually been intended for reproduction and relatively wide distribution and was there-fore tied to techniques suitable to particular processes of reproduction. But, as in the changes taking place in fine art, categories in graphics have broadened. Printing methods for books, posters, broadsheets, magazines, papers and packaging are now sophisticated and reliable and there are ulti-mately no limits on the media and techniques which can be used by illustrators and designers. Within specific design areas there are naturally restrictions imposed by the nature of the project or the medium.

There is no single definition of the term graphic which adequately represents its full associations. A graphic description is one which conjures a clear and vivid mental picture of the subject. In another sense, graphic strictly means relating to writing – the study of handwriting is "graphology". To a mathematician the term denotes the pre-sentation of information as a chart or dia-gram, a form which can be plotted on a graph.

The variety of interpretations of the term are reflected in the broad spectrum of ap-

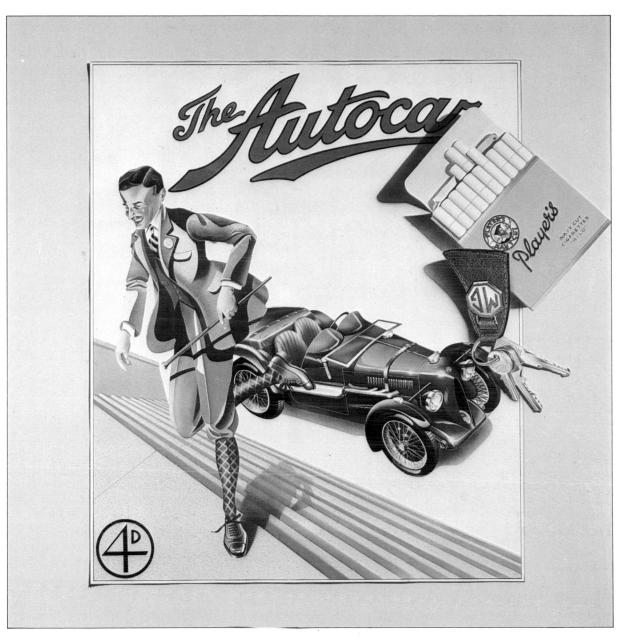

LEFT *Mayday*, Mick Haggerty. One of the most distinctive effects obtainable with the airbrush is the spattered texture, which works well with clean lines and edges. Here, the main illustration and lettering have been produced with hard masking; the remainder is spattered. Spatter caps give a random spattering, but Conopois manufacture a stipple cap which produces the same effect in controlled lines.

ABOVE A group of three illustrators, known as Wurlitzer, were among the first to concentrate on airbrush work in the late 1960s. This advertising image harks back to the automobile brochures of the 1930s and 1940s. The techniques used here are typical of the range commonly used today. Both cut loose paper masks and masking film have been used, with a certain amount of hand-drawn detail with a sable brush. Thin strips of masking film have been used to make the diamond pattern on the figure's socks, while a loose mask gives an effective cast shadow on the steps. Brushwork is evident on the lettering on the cigarette packet and on the key ring. Gouache, sprayed close to the surface, gives spot highlights on the bodywork of the car as a final touch.

plications of graphic art. Graphic work is now required in numerous contexts, including film and television, and the range of imagery involved is often known as "visual communications". This heading sums up all aspects of graphics – direct association with writing and typography, diagrammatic presentation of statistical or systematic information, figurative and narrative illustration, and the necessity to communicate immediately through symbol and image required by advertising and public information resources. The graphic image spans a range which includes simple, internationally

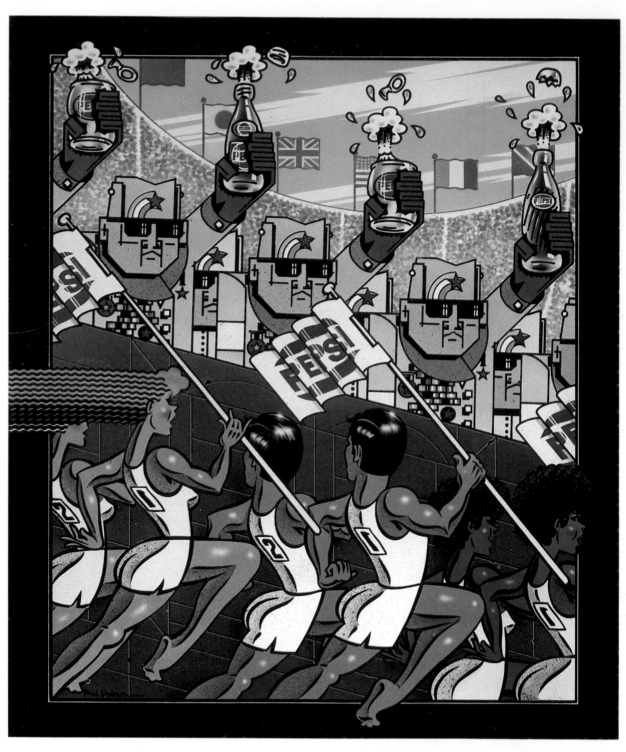

ABOVE *Pepsi*, Phil Dobson. Although this image looks like a complicated piece of work, the intricacies are mainly executed in line. The airbrush has been used to apply flat areas of tone. The outlines are drawn with a sable brush; the airbrush is used as a colouring tool. The faces of the Russians and their fur collars have been spattered. Spot highlights have been applied to the athletes' limbs.

ABOVE RIGHT *UFO*, Tom Stimpson. This is a typically rendered illustration, where the major element is airbrushing. Here the particularly soft effect of spray has been exploited for the background – the smoke trails, clouds, fields and hedgerows. The sharper edges of the spacecraft and planes can be achieved by hard masking, but a fair proportion of the detail is hand-painted: this work is usually executed last.

recognizable symbols, such as those used to indicate the facilities available in airports or large railway stations; the multiple forms of packaging for consumer goods; advertising of all kinds on small or large scale; all types of books from comics to encyclopedias; plans and guides for transport systems, buildings or cities; the title credits of films and the overall design of full-length animated features.

What all these things have in common is that they are required to speak directly to the viewer to convey a specific message or idea. There is no obligation on a painter to communicate either directly or indirectly, and a painting may hang in a gallery for years without any two people having the same reaction to it. But graphic work is produced specifically to communicate with other people and it fails in its function if it gives no instruction or information, or if it arouses inappropriate associations.

By its nature then, much graphic work deals with letter forms and words – the visual symbols of language itself. This presupposes two conditions; one of these is that the viewers have a language in common, the other that within the audience there is quite a high level of literacy. Although certain associa-

tions can be evoked by purely visual means, such as colour and tonal contrasts, the vital function of written elements in graphic design is demolished if the audience is unable to read. Even in the most technologically advanced societies, mass literacy is a relatively recent phenomenon, so the written word has long been associated with political power, since it bestows the ability to approach a wider range of ideas and to communicate on an impersonal level. The growth of visual communications media has been inextricably linked to the increased perceptual capacities of its audience and it is hard to say which has been cause and which effect.

In most societies pictures have spoken louder than words and it has been the function of the artist to channel communications. Until the Renaissance, art was closely associated with tribal and religious purposes and did bear an obligation to communicate. The frescoes and sculpture of medieval churches and cathedrals, for example, were not commissioned for purely decorative purposes. They were also the only way in which many worshippers could obtain a vivid description of the stories attached to their religion, since they could not read the Bible. The

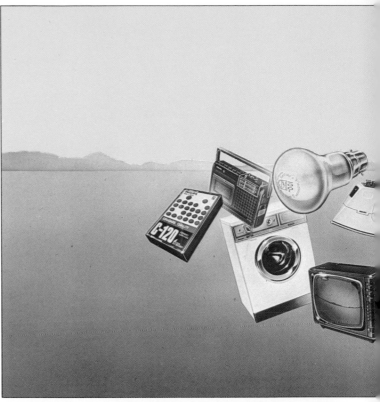

ABOVE Typical of the work produced during airbrushing's first period of popularity, this poster for London Transport from the 1930s shows how spraying techniques can be used in conjunction with a striking design to imply a sense of volume. Such work involves simple masking.

ABOVE RIGHT This advertisement for Phillips – the Horn of Plenty – by Adrian Chesterman is a technically demanding piece which requires a high level of expertise. Although the airbrush is used to impart a sense of realism, a photograph would have been much more difficult to set up and would have brought in many problems of perspective. In this type of work, the airbrusher makes considerable use of photographic reference.

RIGHT Where the design, use of colour and lettering style are so crucially important, the airbrush is reduced to a simple colouring tool.

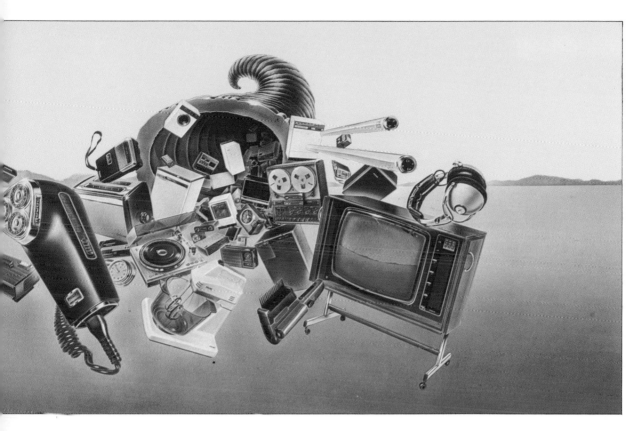

designs on pottery and metalwork have served the same type of function in other societies and eras. Religious paintings also had a political function, in that a portrait of the patron might be included either as a peripheral figure or as model for a figure in the story. The status of the patron was established and his wealth made apparent, since his inclusion was recorded proof that he had commissioned the work.

With the development of printing media and a greater availability of paper from the fifteenth century onwards, mass distribution of information became possible. Woodcuts and engravings were the early mass media forms and the process continued through the invention of other printing processes, gradually assuming a broader political function than the earlier religious associations. The political upheavals of the eighteenth and nineteenth centuries in Europe and the United States, coupled with and partly caused by the massive move towards industrialization in the Western world, set a pattern which has culminated in the current global extent of modern communications.

Pictorial languages, hieroglyphics and pictographs, have not exerted the same influence as they require interpretation and must be read sequentially. However, in forming a critical understanding of the nature of mass communication, Marshall McLuhan has drawn attention to the power of the single pictorial symbol if it can present a whole, specific message immediately. It is common to hear artists use the term "readable" in description of purely visual imagery.

The average Western viewer has gradually received a highly sophisticated visual education through graphic arts, mainly through advertising resources, including film and television. The artists and image-makers can now play on that complex understanding even if the audience is not formally aware of its own capacity. Examples include advertisements which are deliberately obscure in some respect, forcing the viewer to interpret them through his or her own store of knowledge. In some instances, advertising imagery has become so representative of a product that the verbal or typographical information can be cut to a minimum. One prime example is the well-known British advertising campaign for Benson and Hedges cigarettes. The smooth gold packet is presented in a variety of unexpected, associative situations and the product name is barely noticeable. Once this format was established, the style of the images themselves were enough to put across

ABOVE This advertisement for Lee Jeans by Bob Murdock is a strong graphic image showing a fairly simple use of the airbrush. The airbrushing was executed in ink. The main areas of tone were masked and sprayed first. The nose, mouth and contours of the figure are enlivened by cut highlights, where masking is left in place to allow the white to show through. The modelling on the arms and face was produced by using loose masks for softer edges. The outline was hand-drawn with a brush.

For the lettering, a black outline was drawn in first. Red and yellow vignettes were then sprayed, giving a subtle blending of colour where the colours overlap.

RIGHT *Technical Ecstasy*, Hipgnosis. This award-winning record cover for Black Sabbath was produced by a studio well known for its work in the field of record cover design. After the basic idea was decided, the designer George Hardie drew up the image in pencil on tracing paper. The photo-retoucher, Richard Manning, began

work on a dye transfer print of a photograph of an escalator. He bleached out areas of the print to white to provide a basis for adding the robots. These were airbrushed in grey and green dyes; highlights were knifed. The perspex sides of the escalator were coloured yellow and striped using the same techniques. Because an area at the top of the photograph was missing, the marbled tiles had to be extended by airbrushing. The black line was added by hand; the green by bleaching and washing colour in.

the message of the advertisement. A direct replacement symbol was employed by Kodak in using the human eye as a simile for the camera shutter. In this case the focus on display of the company name could be minimal once the association was programmed into the viewer's mind. The Kellogg's K is a straightforward use of the same type of assumption.

Advertising is always cited in discussions of the power of graphic design because it is ubiquitous, well understood and ranges from the very subtle to the crashingly obvious. There are other design areas which are perhaps worthier, but are less recognized. The mechanics of advertising design have been exposed and appreciated, but when the result is displayed in a magazine, the reader is less likely to consider the work which has gone into designing the page where it appears, and by extension the whole magazine. The same applies for books. All illustration can be appreciated as a skilful or engaging image in its own right, or as adding to the reader's perception of the narrative it accompanies. But the precise placing of the illustration on the page, its physical relationship to the text, the shapes and combinations of letter forms used for text and headings – these are all elements which have been thoughtfully chosen and designed as a group. At the same time, each of

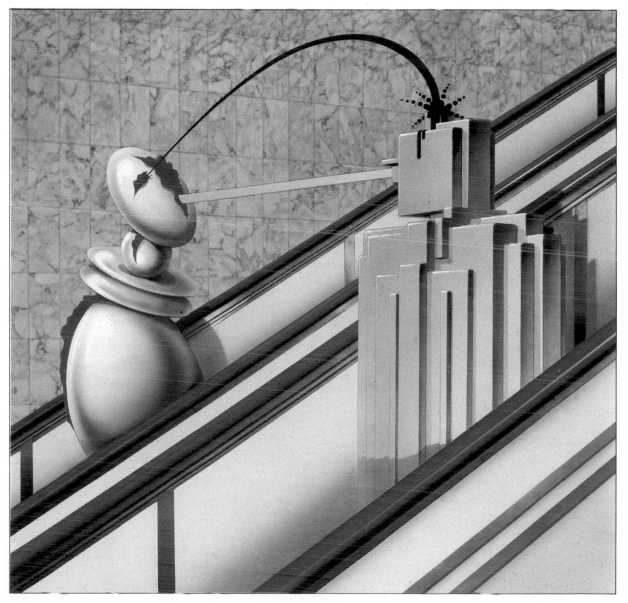

PORSCHE
924

Porsche make it possible.

Maybe you thought your motoring options had all but dried up.

That the size of your budget or family or the economic policies of your company were forcing you into a corner.

May we bring to your attention the possibilities of a Porsche 924?

A Porsche that balances space and comfort with sporting performance and remarkable fuel thrift.

That offers the genuine economy of fine engineering – and steadfast reliability. 12,000 miles between routine servicing, the Porsche 6-year Longlife guarantee.

All for a starting price of £8,200.

Fast, frugal, fun: Porsche make it all possible with the 924.

Porsche Cars Great Britain Limited, Richfield Avenue, Reading, RG1 8PH. Tel: 0734 595411.

For Tourist, NATO, Diplomatic and Personal Export Enquiries. Tel: 01-568 1313. The present Porsche line-up includes the 924 Coupé and Lux Coupé – from £8,200; the 911 SC and 911 SC Sport Coupé and Targa – from £13,850; the Car of the Year 1978, the 928, at £19,500 and the Turbo at £25,000. Prices shown are correct at time of going to press and include car tax, VAT and seat belts. Delivery and number plates are extra. For further information and details of leasing facilities available contact your nearest official Porsche Sales and Service Centre.

Main dealers: South East: A.F.N. Ltd., Isleworth. Tel: 01-560 1011. A.F.N. Ltd., Guildford. Tel: 0483 38448. Charles Follett Ltd., Mayfair. Tel: 01-629 6266. Malaya Garage (Billingshurst) Ltd., Billingshurst. Tel: 040 381 3341. Maltin Car Concessionaires Ltd., Henley-on-Thames. Tel: 04912 4952. Motortune Ltd., Kensington. Tel: 01-581 1234. **South West:** Dick Lovett (Specialist Cars) Ltd., Wroughton. Tel: 0793 812387. **South:** Heddell and Deeks (Motors) Ltd., Bournemouth. Tel: 0202 510252. **Midlands:** Swinford Motors (Continental) Ltd., Stourbridge. Tel: 038 482 3047. Roger Clark (Cars) Ltd., Narborough. Tel: 0533 848270. Gordon Lamb Ltd., Chesterfield. Tel: 0246 451611. **East Anglia and Essex:** Lancaster Garages (Colchester) Ltd., Colchester. Tel: 0206 48141. **North West:** Ian Anthony (Sales) Ltd., Knutsford. Tel: 0565 52737. **North East:** JCT 600 Ltd., Yeadon. Tel: 0532 502231. **North:** Parker and Parker Ltd., Kendal. Tel: 0539 24331. Gordon Ramsay Ltd., Newcastle upon Tyne. Tel: 0632 812829/814383. Gordon Ramsay Ltd., Bishop Auckland. Tel: 0388 5601. **Scotland:** Glen Henderson Motors Ltd., Ayr. Tel: 0292 81531. Glen Henderson Motors Ltd., Glasgow. Tel: 041-943 1155. Glen Henderson Motors Ltd., Edinburgh. Tel: 031-225 9266. **Northern Ireland:** Isaac Agnew (Retail) Ltd., Glengormley. Tel: 02313 7111. Isaac Agnew Ltd., Belfast. Tel: 0232 663231. **Channel Islands:** Jones Garage, St. Saviour, Jersey. Tel: 0534 26156.

Porsche advertising campaign
This series of advertisements, featuring illustrations by Gavin Macleod, shows the variation in design and layout in an extensive campaign. Although it is now rare, this type of representation still works well. The product can be shown in the best possible light, with a high degree of realism but a simplification of detail that makes for a strong and elegant result. Such a commission represents the pinnacle of an airbrush illustrator's career. Cars are an ideal subject for airbrushing. The work demands careful tracing from photographic reference and precision control of spray.

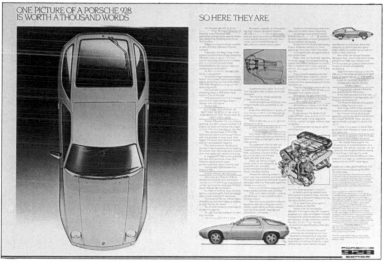

these elements has been designed previously in another context altogether.

A sign, symbol or image may be intended to have universal meaning, or to take on different associations according to its context. A major factor in the expectations set up in the audience is the style of image presented. In the second half of the twentieth century, photography has emerged as the natural medium of information, as still photographs or as film. To modern audiences, the photographic image is a vehicle of truthful information and it also seems immediate and up-to-date. When choosing to communicate by other pictorial means, by paintings, drawings or diagrams, the designer must take account of the different associations these forms provoke. Fashions in design which are based on nostalgia particularly depend on this aspect. Hand-drawn can equal "old-fashioned", a quality which may be designed to appeal to warm emotions or to a feeling of

superiority. Graphic design is, like all other arts, self-referential – fashions come and go and are later revived. But each time the designer is also communicating to a new audience, who may not remember or recognize the origins of the style, so it is also linked to current conventions. A hand-drawn image can also push the viewer forward in time. Drawing may be the only way to represent a futuristic image which suggests something vastly superior to current availability: the image cannot be photographed because it does not yet exist. Here too conventions develop, because of the wide distribution and influence of graphic work.

The work of graphic artists is influenced to a high degree by the market – the manufacturers and publishers who commission artwork, and who constantly have in mind the market for their own goods; and the

ABOVE The success of this illustration depends on the fine balance between hard, sharp edges and soft, graduated tones. This is particularly evident in the difference between the tones in the side panel above and below the halfway line. The highlights on the front wing are pure white and hard-edged. The simple, effective treatment of the wheels depends on accurate tracing from a photograph. RIGHT This illustration by Philip Castle is typical of airbrushed advertising illustration. The original drawing would be the most difficult aspect of this type of work. The sky is a simple vignette; the soft tone and cloud shapes work well with the hard metallic surfaces. Starburst highlights add sparkle to the image. The illustration was designed to be equally effective in colour and black and white and in different formats.

ABOVE *Coffee Morning*, Conny Jude. A witty combination of simple airbrushing and pen and ink drawing, this image demonstrates the contrast between the type of three-dimensional modelling the airbrush can produce and the different qualities of line work. The artist has used airbrushing just for the legs, freely spraying within the outlines created by hard masks – one for each side of each leg. The transparency of the ink suggests the sheerness of the stockings. Overall, the image has a freshness lacking in other more finished examples and shows how the airbrush can be effective used very simply and directly and with a minimum of masking.

artists' agents, art editors and advertising consultants who stand between the business and art worlds and manipulate to some extent supply and demand. Artists are therefore sometimes forced to recognize that the work they want to do may be different from the work they have to do. Changes in graphic style may be slow or sudden, instigated by the client's search for a new image or ideal, or by the artist's persistence in promoting work which may initially meet with an unwelcoming response. Graphic work is subject to fashion in other aspects of contemporary life – in recent years it has been closely connected to styles of presentation in film, television, music, fashion clothing and photojournalism. Graphic art always reflects the feeling of the times, although in service of clients it is also called upon to lead public taste or is occasionally held back by unnecessary conservatism among those who pay for the work.

The role the airbrush plays in this subtle process of image-making derives both directly and indirectly from its close association with photography. As a tinting and retouching tool, the airbrush has its place in the range of photographic techniques. But at the same time, because airbrushing can be used on its own to simulate "photographic" realism, an entirely different type of graphic image is made possible. In advertising and illustration in general, the airbrush is crucial

ly important as the means for creating the imaginative, fantastic, or even absurd images so familiar in the repertoire of graphic art. Spectacular science-fiction subjects, glistening products and eye-catching visual puns are outstanding examples of the use of the airbrush in graphics, but the versatility of the instrument means that it also has a humbler, often unnoticed application, which is no less widespread to add colour, tone or texture to a variety of diagrams, technical work and line drawing.

The airbrush in graphic art

The airbrush is used by many graphic artists and illustrators simply as one of a range of tools. As such, airbrushing is combined with other techniques and may be only a minor, if crucial, part of a graphic image. It may be, for example, the quickest way to lay in a background tone, over which an image can be hand-drawn or brush-painted. It may also be used to lay in a hazy tone which softens the overall effect of a brush painting, to achieve a splattered texture on a flat ground, or to add sparkling, explosive highlights to a surface. But a large number of illustrators, from the many competent artists who simply earn a living to the most influential and sought-after figures of the graphics world, derive their style from the technique of airbrushing and use the full range of its potential as the prime feature of the work.

Composite car detail
1. An area of this illustration by John Harwood was selected to show a masking sequence. One mask was cut and the red areas sprayed.

2. Two vignettes were created to make the reflection in the metal. The darkest area of the window was sprayed first, in a mid-tone; overspraying in lighter shades made this area darken

gradually.
3. By careful planning and working from dark to light, only one mask was needed. Masking film was removed from the darkest areas first.

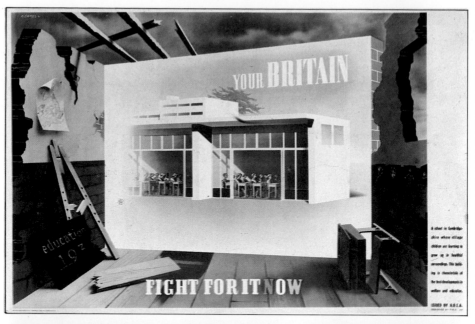

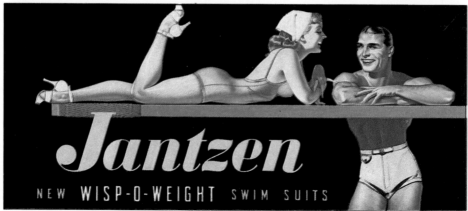

Illustration

Airbrush illustration has had two distinct phases of popularity, one lasting from the late 1920s to the mid 1940s and the other beginning in the late 1960s and continuing today. In the intervening period it simply went out of style, for no easily definable reasons. Perhaps, in the period following World War II, there was a general move to rebuild and reassess which discarded graphic associations with the previous difficult years. In any event, when airbrush art returned to popularity it was above all bright, celebratory and fun. Many of the artists of the 1960s who experimented with the airbrush only gradually realized the extent of its previous history. The re-emergence of the airbrush was part of a phenomenal expansion in graphics. Always an eclectic art form, illustration has fed since then not only upon current trends but also upon its own past, to produce the widest range of imagery ever available on such a large scale. Owing to global communications and multinational corporations, graphic art has spread worldwide, absorbing a wealth of common influences to create an international pool of imagery which is drawn on for public display.

The main applications of the airbrush in its first full phase of development were in poster art and magazine illustration, much of this for advertising purposes. Posters and hoarding advertisements are now so ubiquitous that it is difficult to realize the novelty and freshness of this type of art during the 1920s. An influential figure of the period was Joseph Binder, who worked first in Vienna, then in the United States, often using the airbrush to create his deceptively simple,

JOIN THE ATS

ASK FOR INFORMATION AT THE NEAREST EMPLOYMENT EXCHANGE OR AT ANY ARMY OR ATS RECRUITING CENTRE

TOP LEFT One of a series showing the old Britain replaced by the new, *Fight For It Now* was designed by Abram Games in 1943. The airbrush work is fairly rudimentary, but clearly associated with the new technology.

ABOVE LEFT George Petty's illustrations for Jantzen swimwear in the late 1930s show subtle and skilful draughtsmanship and confident, economical use of the airbrush. White sprayed over orange on the underside of the girl's figure creates a flesh tone where colour shows through.

ABOVE The ATS girl, a British recruiting poster by war artist Abram Games, issued in 1941, became the focus of controversy. Intending to dispel the unattractive image of women in the army, the poster was criticized for its glamorous appeal and was not reprinted. It shows airbrushing used to create a smooth finish, over a crayon drawing which provides a wax resist.

striking imagery. Binder was one of the first artists to recognize the birth of a new art form and to investigate a new technique which expressed the symbolic and aesthetic messages he wished to convey. He worked from his own studio as early as 1924 and in addition to poster work he also designed what are now known as corporate identity products – trademarks and logos which become the public symbols of particular companies. Binder is quoted as having said that he would rather be a "Number One Designer of Posters than a Number Two Picasso". This marks a real understanding of the coming importance of graphic art, and the fact that it would have to develop its own theories of presentation and execution, building into these its own standards of excellence in a context quite different from that of fine artists.

European influence was strong in this period of graphic development. E. McKnight Kauffer, American born but pursuing a career in London, and A.M. Cassandre (Adolph Mouron), working in France, both shared Binder's approach. Distilling a form to its basic essentials, developing symbolic images rather than realistic representations of objects, and heralding above all the arrival of the machine age, and the speed of modern travel and communications, these artists formed their individual, characteristic styles which heavily influenced the graphic art of the 1930s.

McKnight Kauffer returned to the United States in the early 1920s to attempt to resettle there, but his style was not well received. It was later, in London, that he became widely known for his series of posters for London Transport. His work showed an attitude to formal representation drawn from fine art movements such as Cubism and Futurism.

In this period the graceful linear style of Art Deco became highly popular, typically showing geometric forms and soft, striking colours, as well as perfect qualities of surface finish. Cassandre's art, like Kauffer's, was fully cohesive in conception and execution. All of the early poster artists stressed the same requirements in their work – an image which was immediately arresting, fully descriptive and also wholly memorable. Cassandre's version of his idea of poster art was "brutality perhaps, but also style".

Other European artists made their presence felt in the newly developing field of graphic art. In Paris, a Russian emigré, Alexey Brodovitch, made use of ideas gathered during his time as a set designer for the Ballets Russes under Diaghilev. His attitude to technique was to experiment continually, replacing the conventional artists' materials with instruments of the new technology, embracing any product of his age which could contribute to the form and texture of his art. In 1934 Brodovitch became art director of *Harper's Bazaar* and many major talents in photography and design were given an outlet under his direction.

Both Herbert Bayer of the Bauhaus and Binder left Europe to settle in America during the 1930s, among countless other artists of all disciplines, and their work as teachers

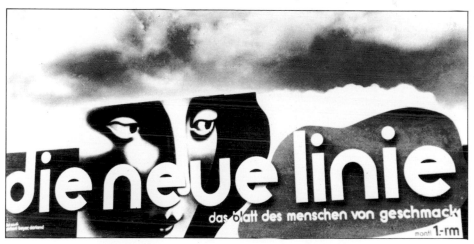

LEFT The airbrush was particularly effective in conjunction with the striking graphic style of the 1930s. Here, flat areas of colour were laid in first, with the highlights and cloud shapes added on top. These shapes were hard masked and sprayed in neat vignettes. Gouache is the best medium for over-spraying because of its covering power.
ABOVE This Bauhaus design for the periodical *Die Neue Linie*, 1932, shows the use of airbrushing with montage. Simple masking and spraying over photographs created striking results.

and consultants had a lasting influence on American design. The first major American airbrush artist was Otis Shepard, whose advertisements for Wrigley's chewing gum are now standard works. Shepard had met Binder in Vienna and was further influenced by his work later in the United States. What Shepard appreciated about the European designers was the fundamental soundness of their design sense and the ability of their imagery to communicate directly. He applied these principles to his own work, and it was reported that he spent hours "researching" among ordinary people, his real audience, in an attempt to understand what they would see and absorb in a poster.

He believed that a truly effective symbol would cut through social and educational differences – that it could have an almost primitive appeal in conveying its particular message. Shepard was largely responsible for popularizing airbrushing, setting the standard of flawless finish and sophisticated representation which became a fundamental characteristic of contemporary graphic art.

A lighter kind of imagery, but no less demanding can be found in the work of the pin-up painters of the 1930s, most notably George Petty and Alberto Vargas. Petty evolved a style halfway between realism and caricature. His pin-up girls had fun – they

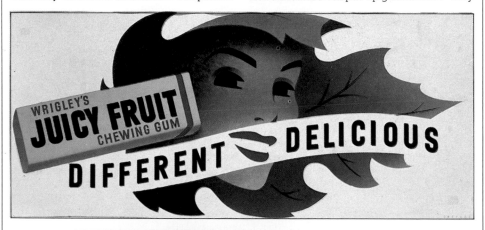

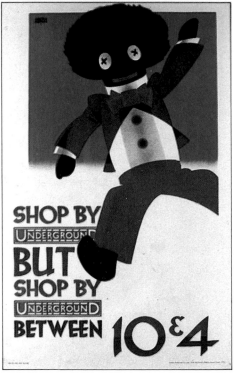

ABOVE Otis Shepard's advertisements for Wrigley's chewing gum are pure airbrush illustrations, showing a singleminded use of the technique unusual for the period in which they were produced – the 1940s. Shepard set a standard for this type of work and exerted a considerable influence on advertising imagery – the airbrushing enhances the smooth presentation of the product and the sense of carefree movement. Judicious use of masking techniques – giving hard shapes and softened tones – is combined with a powerful graphic sense. LEFT This poster, designed in 1928 by Austin Cooper for London Transport, shows a minimal use of airbrushing. At this time, the airbrush had not yet created its own style, but was simply used as one technique among the many at graphic artists' disposal.

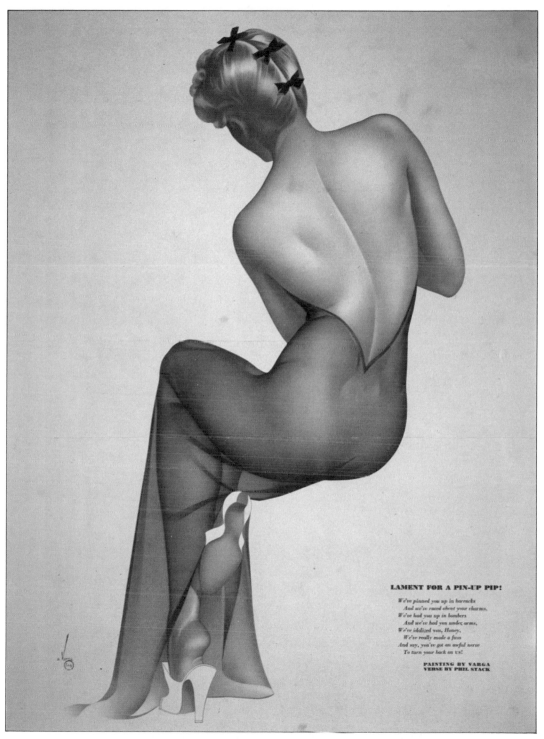

LAMENT FOR A PIN-UP PIP!

We've planted you up in barracks
And we've raved about your charms,
We've had you up in bombers
And we've had you under arms,
We've idolized you, Honey,
We've really made a fuss
And say, you've got an awful nerve
To turn your back on us!

PAINTING BY VARGA
VERSE BY PHIL STACK

ABOVE *Lament for a Pin-Up Pip* (*Esquire*, November 1944), Alberto Vargas. The pin-up "Varga" girls date from the 1940s, the most successful period of the artist's career. Vargas' work is a highly finished blend of chalk, watercolour and airbrushing techniques. He begins with a detailed sketch in chalk, which is transferred to watercolour board. The board is soaked and dried, and watercolours treated with glycerine to keep them wet. These techniques give a subtle blending of colours without hard edges. He uses the airbrush when the watercolour painting is nearly completed, to provide a soft finish. Frisket is used to block areas not to be painted. For edges, he has a number of curved templates.

played tennis, went dancing, spent hours on the phone to boyfriends, and specialized in titillating poses in which the figures, though always at least partially clothed, leave little to the imagination. The style depended on a highly plastic rendering of form and perfect surface finish. Alberto Vargas had a highly individual approach. He had studied in Paris and claimed influences as wide-ranging as the- paintings of Ingres and the popular magazine illustrations of the early years of this century. Working painstakingly on his paintings, he employed the experience of many years of investigation in conventional artists' techniques: watercolour, oil painting and pastel drawing. He used an airbrush only to impart a delicate finish to finished brushwork. Despite all his study, Vargas was occasionally carried away and created a figure which was an anatomical impossibility – these only delighted his devoted fans all the more.

Both men worked for *Esquire* magazine, Petty from its introduction in 1933 until 1941 and Vargas from 1940 to 1946. During this period, *Esquire* developed the centre page foldout, a combination of poster and magazine illustration, and both the Petty girls and

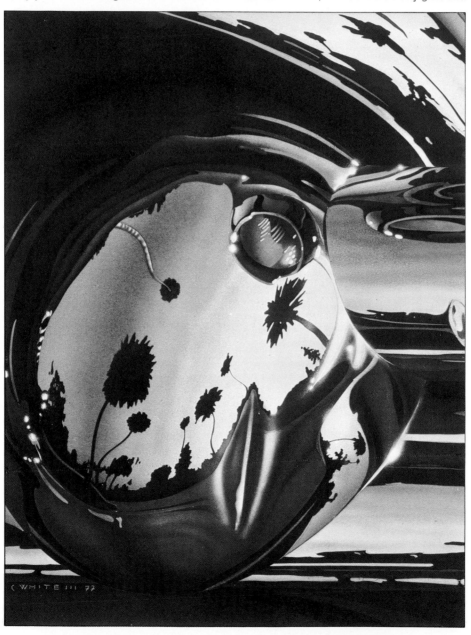

the Varga girls (the "s" was dropped) appeared on calendars and became symbols of American culture in their own right, far exceeding the original intentions of the magazine publishers. Vargas' association with *Esquire* ended badly. Through naivety or goodwill he allowed himself to become tied to a contract which demanded a minimum of one painting a week for 10 years, and which made over the rights of his work entirely to the magazine. When Vargas stopped working for *Esquire* in 1946 he began four years of legal action to recover his rights, a dispute he eventually lost. Vargas later took similar work with *Playboy* magazine and this, and the earlier work of both Vargas and Petty for *Esquire*, set fashions which have survived despite the more common use today of photography for such illustrations.

The Varga girl became a treasured symbol of the United States during the war years. She appeared accompanied by various patriotic slogans and even dressed in army uniform, to encourage the troops overseas

who received copies of the magazines and calendars. A grimmer kind of patriotism was expressed in posters meant to caution and encourage those left at home. In Britain, many of the finest examples were produced by the artist Abram Games, working directly for the War Office from his appointment in 1941. His posters exhorted the able-bodied to fight and those at home to be aware of the need for endurance, secrecy and defence in the fight against demoralization and disease, which had come to Britain with the destruction caused by widespread bombing.

Games used the airbrush as a major feature of his technique and his imagery shows understanding not only of current graphic conventions but also of the haunting qualities of the Surrealist and Metaphysical styles of painting which had been predominant in the 1930s. Games, like Vargas, was the son of a photographer, which perhaps accounts for the familiarity of both men with use of the airbrush. The airbrush again proved its close connection with photography in highly finished images which were as truthful and

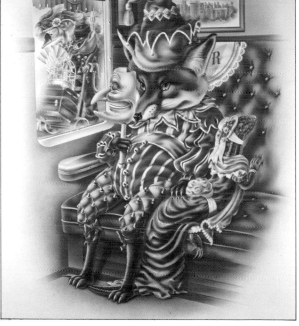

LEFT This gouache illustration by the American airbrush artist Charles White III does not include much freely sprayed or hand-drawn work. The outline shapes of the bumper and trees and landscape reflected in it were produced by hard masking. Within these outlines the airbrush was used to produce vignettes. ABOVE LEFT The Italian artist Paolo Garretto was a notable exponent of the airbrush in the 1930s.

Here in a cover for *Fortune* magazine, the airbrush has been used to produce two contrasting textures – a flat tone for the basic areas and a coarse stipple effect. The combination gives a strong graphic result.

ABOVE RIGHT Alan Aldridge's *Butterfly Ball* was influential in popularizing the airbrush at the outset of its second main period. Aldridge's technique includes a fair amount of brushwork.

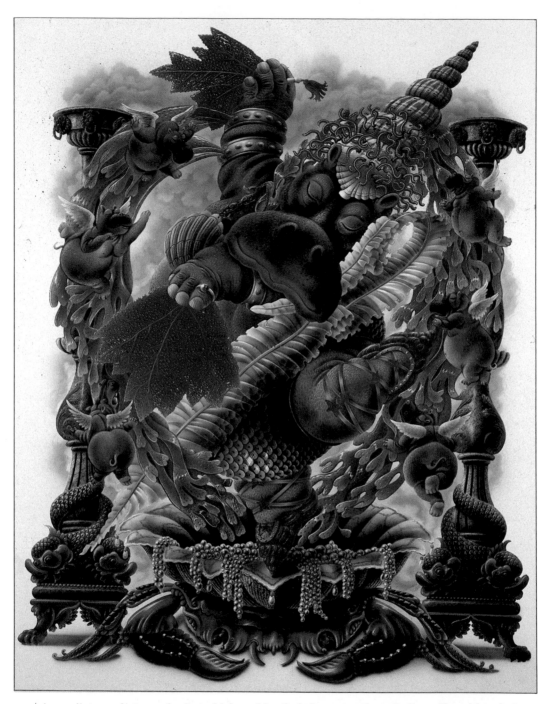

immediate as photographs, but which could
be strictly designed to direct the viewer's
attention towards a desperately urgent
message. The typographical instruction of
Games' posters and its integration with the
imagery is evidence of his comprehensive
design ability.

Countless propaganda posters were pro-
duced by both sides in the war, many lean-
ing heavily on the qualities of airbrushing for
their impact and symbolism. The airbrush
had also been used as a tool in political
illustration of the 1930s, notably in the work of
Italian-born artist Paolo Garretto. Garretto
studied art in Rome and later moved to the
United States. His caricatures, of major
figures such as Gandhi, Hindenburg and
Kemal, and in another field Stravinsky and
Toscanini, are strangely evocative. In the
smooth, inhuman qualities of the airbrushed

LEFT Aldridge's work looks highly complex, but the success of the airbrushing depends on meticulous drawing and careful balancing of colours. The airbrush is used for basic colours and shapes, with the aid of hard masking. Free spraying and vignetting add shadow and texture. Most of the fine detail is applied last with a sable brush.

TOP LEFT This advertising image by Dave Willardson displays straightforward airbrush work – loose masking for the facial contours – brushwork for fine detail. The slashes of colour in the background show the type of effect which can be created with liquid masking. First, areas of colour are sprayed; these are then masked with liquid masking or wax crayon. After the rest of the work has been sprayed, the masks are removed to show lines of textured colour.

TOP RIGHT This all-airbrush image by Charles White III shows an effective use of loose masking for the soft edges of the light beams.

ABOVE Near Miss (1979), Philip Castle. Castle begins his paintings with a drawing on masking film. Each shape cut out during airbrushing is replaced after spraying to protect finished areas, and allow colours and shapes to show through for matching.

SUE·SAUNDERS
ART EXPO 1981

World Wide Posters

TOP LEFT This self-promotional poster was the work of two illustrators. The bottom half of the illustration is airbrushed. The work displays very competent and accurate mask cutting, especially on the china and tablecloth. In such work, a great amount of preparation is necessary, compared with the time spent actually cutting and spraying.

TOP RIGHT Soft vignettes, loose masking and some brushwork for details combine to suggest transparency and lightness.

ABOVE This album cover for Motorhead by Adrian Chesterman shows a combination of techniques. Hard masking produced the basic shapes. The explosions were freely sprayed. The highlights were knifed – scratched back rather than masked.

finish each portrait looms in isolation from the page.

The end of the war basically marked the end of the first great flourish of airbrush art, though the airbrush was still used as a basic designer's tool in illustration for book jackets, comics, music sheets and in advertising and packaging. It was also used in photo retouching, but for a period during the 1950s and early 1960s, the inventiveness of previous years was lost.

During the late 1960s a new style in illustration arose from developments in the arts and general culture in the 1960s and early 1970s. This was a boom period economically, when spending was fast and free, and advertising rapidly invented new images to match the variety and technical sophistication of its products. Two important developments occurred which stimulated the production of airbrushed imagery in this context. One was the explosion of youth culture, and its particular expression through rock music. The other occurred when poster art partially freed itself from its graphic obligations and became a wilfully decorative art form. A general boom in advertising and publishing created a demand for more styles of illustration.

Quite why airbrushing became so intimately connected with these cultural expressions depends upon one of those mysterious collisions of circumstances which are from time to time responsible for sudden changes and inventions. Airbrush manufacturers can trace a considerable rise in demand for airbrushes dating from the early 1970s but by that time the airbrush had already been available for over 70 years. Time and time again, major contemporary illustrators describe how they found a neglected airbrush in a college or graphics studio, or rediscovered a tool which had been an earlier gift and had lain disregarded for years. They all realized that the airbrush had potential for a new expression which was directly suited to the time. Once airbrush work was brought to public attention, a self-generating demand was created.

Creating texture with transfer film
1. The chin area of an illustration of Henry Kissinger by David Bull was reconstructed to show textured effects. First a base tone was sprayed.

2. Textured transfer film was burnished onto the surface in selected areas to act as a mask. These areas were sprayed over and the form gradually built up in different tones.

3. Shapes cut from thin acetate were used as loose masks. Spray drifting under gave softer edges. The areas of transfer film were taken up to reveal the texture.

4. Dark areas were intensified, working freehand, and contours blended in. Highlight areas were worked over with a stick rubber, almost back to white.

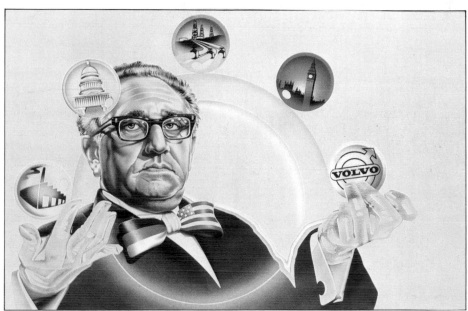

Dave Willardson is an American illustrator who was one of the first of the new generation to discover the importance and versatility of the airbrush. Willardson had owned an airbrush for years, and one day picked it up when he needed to produce a smooth gradation of tone in a piece of work. The airbrush obligingly solved his problem; thereafter he actually began to submit airbrush work for publication without payment, simply to promote the use of the tool. During the quiet period of the 1950s, the airbrush had collected an old-fashioned image and had again become associated more with photo-retouching than with original artwork. During the next few years a number of artists started to use airbrushing to convey their own stylish imagery. Bob Zoell and Charles White III in the United States and Philip Castle and Alan Aldridge in Britain were

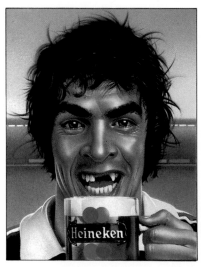

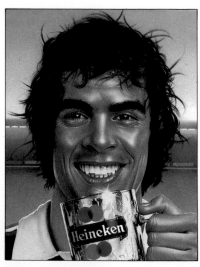

TOP Torn paper masks are the best way of achieving the effect of a crumpled surface, wood grain or reflection.
ABOVE Mick Brownfield's illustrations for a Heineken campaign show most of the major airbrushing techniques. These include spatter for the dark shadow on the upper lip, hard masking for the main outlines, starburst highlights, loose masking for the hair, and hand-painted detail for lashes, some highlights, lettering and the foam on the glass. The background lines were sprayed using a ruler as a mask.
RIGHT Doug Johnson's poster for an Ike and Tina Turner tour relies heavily on hand-painted detail for shadows and highlights. The background is smoothly airbrushed.

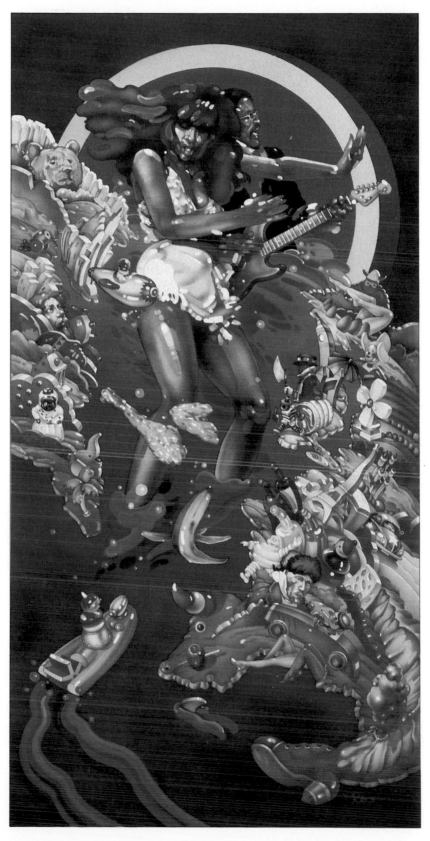

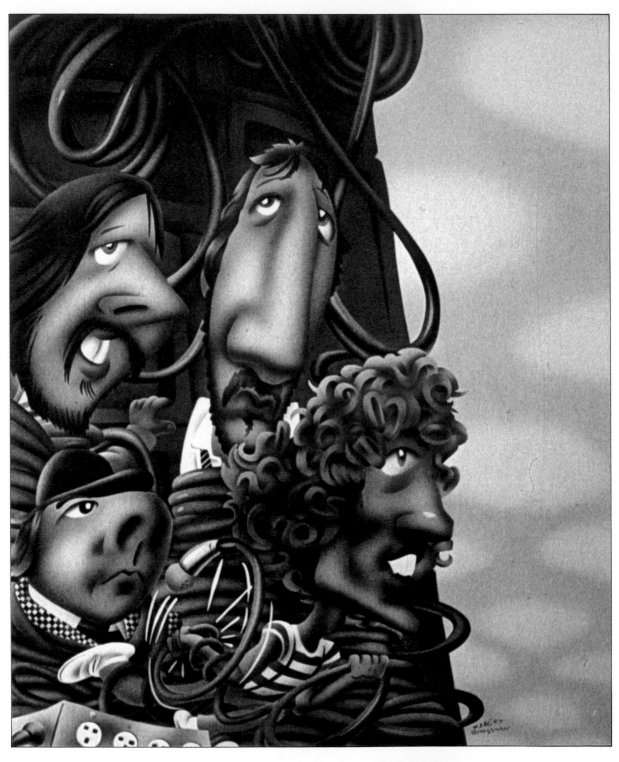

ABOVE *The Who*, Robert Grossman. Grossman is well known for his caricatures of pop stars; his technique depends on a relatively simple use of the airbrush. Loose masking, producing a hard edge one side and a vignetted tone the other, accentuates the distorted contours of the faces. Here the main emphasis is on the interlocking of basic shapes, rather than a contrast of textures or colours or rendering of detail.

Engine detail
1. The outline and some details were drawn and transferred to a board. Using ink, black was sprayed as a key. One mask was cut and sections exposed one at a time.

2. Colours were built up slowly, spraying against the edge of a ruler to give diffused lines. The soft gradation of the colours was used to give the shape. Inks can be oversprayed to intensify gradually.

3. Some colours were allowed to drift to link areas together. As is the convention, a warm tint was applied at the bottom for a ground reflection and a cool tint on top for a sky reflection.

4. The lettering was cut and sprayed, the background added and a ruling pen was used for fine lines. In work executed on a large scale, highlights can be knifed without affecting the final reproduction.

leaders in the field. White and Willardson worked for a time in partnership as a design team. Aldridge produced a good deal of work in collaboration with the expert airbrush colourist Harry Willock and later in his own design studio, "Ink".

As the new airbrush generation discovered their heritage they were able to draw on the exemplary expertise of artists such as Bayer, Binder and Cassandre, but because the character of the age was so different, so too was the imagery it produced. During the early 1970s, airbrushing acquired its association with the slick, highgloss, instant impact imagery which has proved both a blessing and a curse. Vargas had warned artists using airbrushing: "Don't try to make it do what you should have done..." and British-born Mick Haggerty, now a successful illustrator in Los Angeles, has said, "The airbrush is like a gun... in the hands of an amateur it's a deadly weapon." The airbrush is a means of expression which applied to an excellent concept produces excellent results. Although there are enough examples to show that many illustrators fail to recognize this plain fact, there are also many highly imaginative and extremely skilled airbrush artists who have not achieved the status of a Philip Castle or Charles White III.

Airbrushing is used in a variety of styles of work. Among other major American artists, Doug Johnson notably uses it in conjunction with other painting and drawing techniques to form fluid, glittering representations, often of standard American symbolic figures – the Statue of Liberty, Uncle Sam, the American footballer. Taki Ono, working in collaboration with photographer Lisa Powers, makes free, colourful interpretations of photographic images. Bob Zoell has applied airbrushing to cartoon figures of his own invention, and paralleled the work of artists of World War II by producing a new propaganda – protest – for a new war, Vietnam. Robert Grossman has developed a style of political caricature and social commentary, while others work simply to visualize the feelings and fantasies running under the rapid pace of everyday modern life.

Music and cinema, the major entertainment industries of the twentieth century, have provided a number of outlets for contemporary illustrative talents. Record album covers are an industry and an art form in themselves. Many are purely airbrushed

ABOVE *Cadillac*, Ean Taylor. Hard masking is an ideal technique for representing the straight lines and angular shapes of machines and lettering. When hard masking is used to determine most of the image, a high degree of precision is demanded. Each shape cut from the film to expose the surface must be replaced exactly when spraying is completed so as not to create any areas of unwanted overlap. This illustration gains its brilliancy from the use of ink as a medium; it includes little hand-painted detail.

ABOVE RIGHT This sticker designed by George Hardie for Pink Floyd's album *Wish You Were Here* shows the effects of simple vignetting within hard-masked shapes. Ink gives subtle colour transitions and vibrancy.

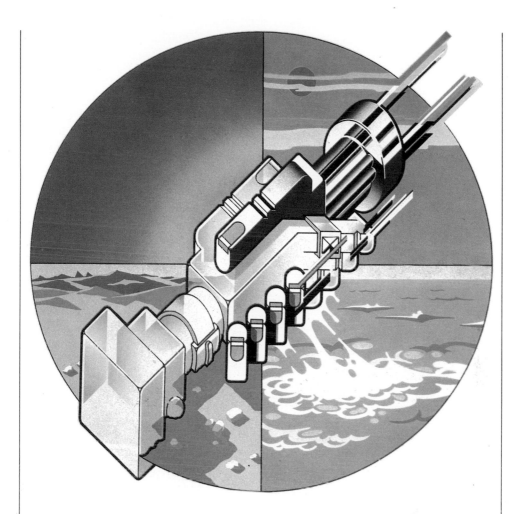

paintings, others sophisticated combinations of new photographic techniques, retouching and conventional design methods. By combining the image of a band, the actual appearance of the musicians and the imagery expressed through the song lyrics and their free associations, artists can exploit any graphic, photographic or painterly style in their interpretations. The major personalities of music, film and television are also subjects for poster art, whether in promotional material or as modern icons.

Alan Aldridge produced some of his finest work in this context. He was responsible for an illustrated book of lyrics from The Beatles' songs and has developed his style through countless illustrations and his own illustrated books, such as *The Butterfly Ball*. Aldridge's work of the 1960s was typified by lush, descriptive colour and heavily highlighted modelling of forms. Philip Castle's work is altogether cooler – a form of highly polished photographic realism which he invented as a young artist entirely self-taught in airbrushing technique. He composes complex

images containing surprising combinations of his favourite subjects, particularly cars, aeroplanes and women. His fantastic but convincing composite images include the exotic portraits of photographic models and actresses, fully equipped with perfectly painted mechanical parts. The smooth finish of airbrushing enables him to combine flesh and metal as if they were organically connected. In recent years Castle has moved more towards pleasing himself in his creativity. He has exhibited his airbrushed paintings rather than taken on graphic commissions, though in the past the latter have been many and various.

The range of airbrush work from fact to fantasy is seen both in advertising art and book and magazine illustration. In advertising it may be used to present the product in a perfect state, to make it appear even more stylishly necessary than it really is. This is most clearly seen in a number of advertising campaigns for automobile manufacturers, a long tradition in advertising which has lasted through from the 1930s. Airbrushing is also

used to render unexpected juxtapositions or to impose the product name on a slick, desirable object related only by the structure of the advertising and promotion business itself, as in the image showing the racing car promoting John Player cigarettes. While such objects can or do exist, and could be photographed, airbrushing is used to add a unique quality to the image which underlines the message – this product is special.

Fantasy in illustration reached one peak in the 1930s with the early popularity of science fiction and horror magazines. Science fiction, being both wholly imaginary and based on current science fact, is an area particularly fertile for airbrush illustration. The characteristic effects of airbrushing, the high shine of metal and perspex, the bursts of cloudy spray which can represent unearthly light all add to the creative range.

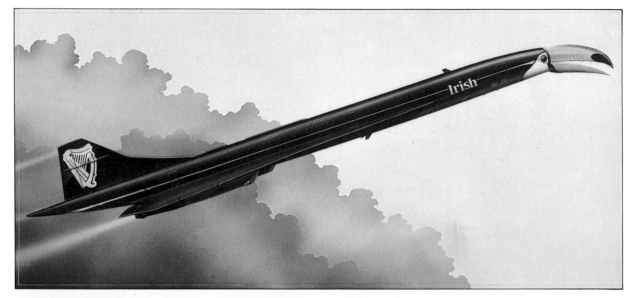

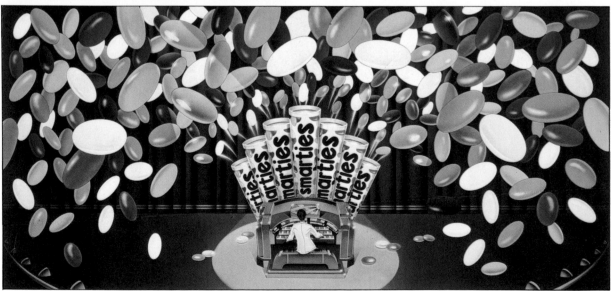

TOP Gavin Macleod's *Irish*, part of a Guinness campaign, shows a subtle blend of hard and soft edges in the clouds, produced by vignetting from the edge of a cut mask.

ABOVE This illustration for a Smarties advertisement by Peter Owen is a lively combination of strong, powerful colours inside thin black outlines. This work was designed to be reproduced on a huge scale, for a billboard 30 feet (11 m) long. To ensure clarity at such a size, the airbrushing had to be particularly clean and precise.
RIGHT *Fury*, Tom Stimpson. This illustration for a book jacket was sprayed using inks and gouache. The hard lines were produced by hard masking with film, the soft lines around the face by masking with paper. The explosions were produced by spraying gouache over ink close to the surface to create blots – this type of effect is put to good use here. The spaceships were hand-painted in gouache.

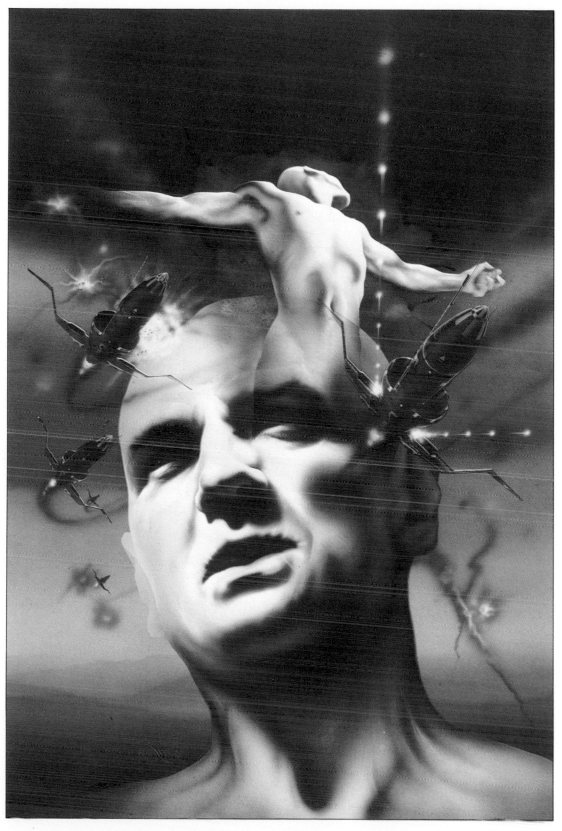

Airbrushing is also used more prosaically to present facts and offer straightforward educational information. Technical illustration is one aspect of this, a subject treated fully in the following chapter. Within the past ten years there has been an increasing fashion in publishing for books which explain the structure and function of all sorts of objects and processes – industrial and technological, biological and medical. Many of the illustrations used in this type of work are essentially diagrammatic. They are designed to explain gigantic physical systems, such as railway networks, in a simply assimilated form, or to show the historical development of the form of an object or process, or to reveal the inner workings of machines and man-made structures, as well as organic structures in humans, animals and plants. General ideas and systems can also be illustrated – population densities, trade and distribution systems, economic theories. It is possible to build up purely visual representations of all these subjects by either compositing objective and photographic reference, projecting from plans and graphs, or inventing diagrammatic analyses. The airbrush is used in this context both as a simple colouring tool, for its speed and even spray texture, or in order to vary the expressive qualities in different parts of the design, to use texture, highlighting and shading as parallels for different aspects of the object or idea being illustrated.

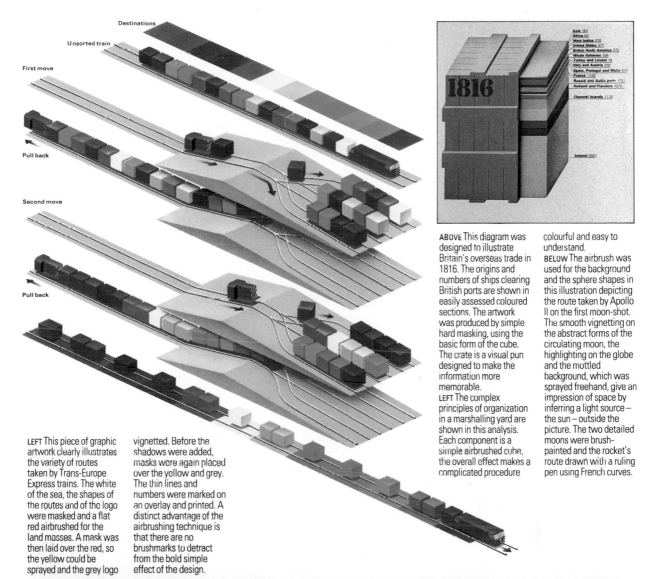

Destinations

Unsorted train

First move

Pull back

Second move

Pull back

| Asia 164 |
| Africa 60 |
| West Indies 506 |
| United States 277 |
| British North America 772 |
| Whale fisheries 164 |
| Turkey and Levant 18 |
| Italy and Austria 230 |
| Spain, Portugal and Malta 549 |
| France 1442 |
| Russia and Baltic ports 1721 |
| Holland and Flanders 1070 |
| Channel Islands 1115 |
| Ireland 6861 |

1816

ABOVE This diagram was designed to illustrate Britain's overseas trade in 1816. The origins and numbers of ships clearing British ports are shown in easily assessed coloured sections. The artwork was produced by simple hard masking, using the basic form of the cube. The crate is a visual pun designed to make the information more memorable.

LEFT The complex principles of organization in a marshalling yard are shown in this analysis. Each component is a simple airbrushed cube, the overall effect makes a complicated procedure colourful and easy to understand.

BELOW The airbrush was used for the background and the sphere shapes in this illustration depicting the route taken by Apollo II on the first moon-shot. The smooth vignetting on the abstract forms of the circulating moon, the highlighting on the globe and the mottled background, which was sprayed freehand, give an impression of space by inferring a light source – the sun – outside the picture. The two detailed moons were brush-painted and the rocket's route drawn with a ruling pen using French curves.

LEFT This piece of graphic artwork clearly illustrates the variety of routes taken by Trans-Europe Express trains. The white of the sea, the shapes of the routes and of the logo were masked and a flat red airbrushed for the land masses. A mask was then laid over the red, so the yellow could be sprayed and the grey logo vignetted. Before the shadows were added, masks were again placed over the yellow and grey. The thin lines and numbers were marked on an overlay and printed. A distinct advantage of the airbrushing technique is that there are no brushmarks to detract from the bold simple effect of the design.

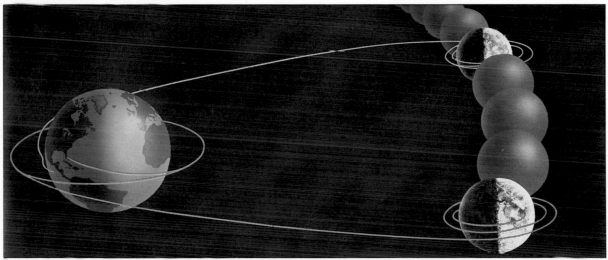

Animation

A separate area of graphic design in which airbrushing has been well and consistently used is film animation. This work originally started early in the century. The major innovative work of Walt Disney's studios, with *Pinocchio* in 1939 and *Fantasia* in 1940, proved the value of airbrushed effects in full-length, high-budget animated features. Disney himself singled out the airbrush as a vital tool in his studio's creative processes and underlined the necessity of having highly skilled airbrush artists participating in animation work.

Animation depends upon the production of a separate image for every minute change in the action of the film. These images must be absolutely accurate and exactly matched one to another. Artists must be capable of developing the form and movement of a specific figure through thousands of different views and attitudes. The original principle of animation was to produce the series of images on transparent acetate sheets which were hole-punched and registered so they could be assembled in strict alignment as a running sequence. Images can be superimposed and techniques of film photography are, like still photography, developing all the time, but animation is still a long, laborious and highly crafted process. The use of the airbrush remains important for its speed, consistency and range of effects.

Although it is impossible to predict what innovations in technique or subject matter may occur in the future, both artists and clients agree that there is great potential for future development in airbrushing. New materials and equipment are undergoing research; fashions change constantly.

Simple animation using cut-out shapes
Terry Gilliam, animator of the Monty Python television series and Monty Python films, has devised his own unique style of animation using montage and airbrushing. Instead of making many individual drawings on acetate sheets – cels – he simply moves cut-out components of the image between the taking of each photograph. He first makes a drawing on paper and airbrushes in gouache, working from dark to light. He uses no hard masking, but masks with cut or torn paper to create the softened, exaggerated contours of his caricatures. Other images are produced by spraying in black and white and adding colour tints with ink or felt tip pens. The total shape and its components are then cut out of the paper and mounted on a background. A sheet of glass is laid over the artwork and it is photographed. To create movement, the component parts of the image are moved in sequence, a photograph being taken of each stage. With a total of 12 moves per second, the result is not smooth, but the jerkiness is part of the humour. In the example shown here, the only moving parts are the legs of the chicken.

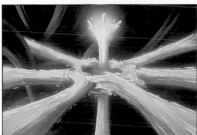

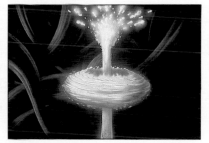

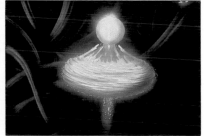

LEFT Another Terry Gilliam animation, these fish move their jaws and roll their eyes. They were airbrushed in ink, cut out and mounted on a background composed of a montage of deep sea photographs cut out of magazines. Although movement is minimal, lively sound effects increase the impression of motion.

ABOVE For a film illustrating Linda McCartney's single, *Oriental Nightfish*, Ian Eames (Timeless Films) produced over 5,000 airbrushed cels, making a smooth sequence of movements. Eames' airbrushing is done directly on cel in gouache without the use of either hard or soft masking.

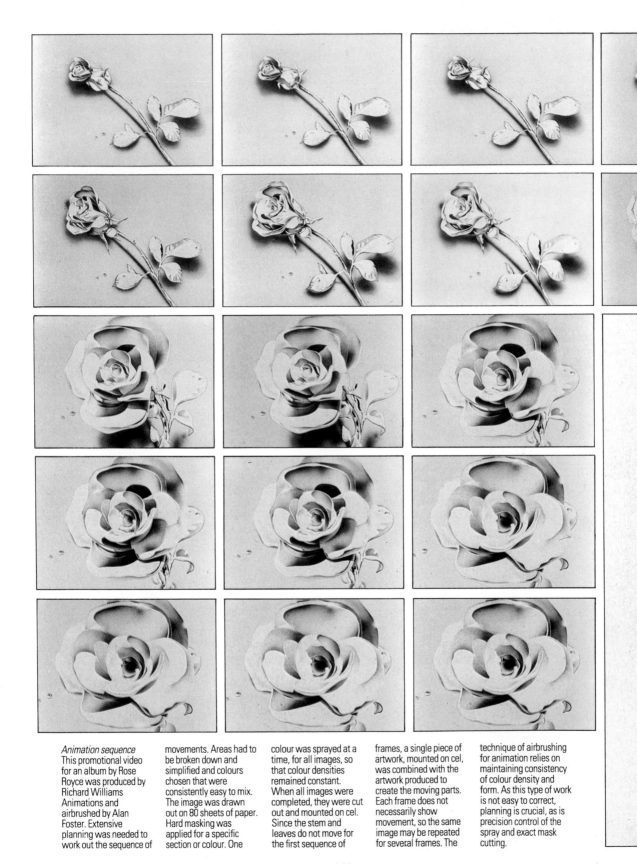

Animation sequence
This promotional video for an album by Rose Royce was produced by Richard Williams Animations and airbrushed by Alan Foster. Extensive planning was needed to work out the sequence of movements. Areas had to be broken down and simplified and colours chosen that were consistently easy to mix. The image was drawn out on 80 sheets of paper. Hard masking was applied for a specific section or colour. One colour was sprayed at a time, for all images, so that colour densities remained constant. When all images were completed, they were cut out and mounted on cel. Since the stem and leaves do not move for the first sequence of frames, a single piece of artwork, mounted on cel, was combined with the artwork produced to create the moving parts. Each frame does not necessarily show movement, so the same image may be repeated for several frames. The technique of airbrushing for animation relies on maintaining consistency of colour density and form. As this type of work is not easy to correct, planning is crucial, as is precision control of the spray and exact mask cutting.

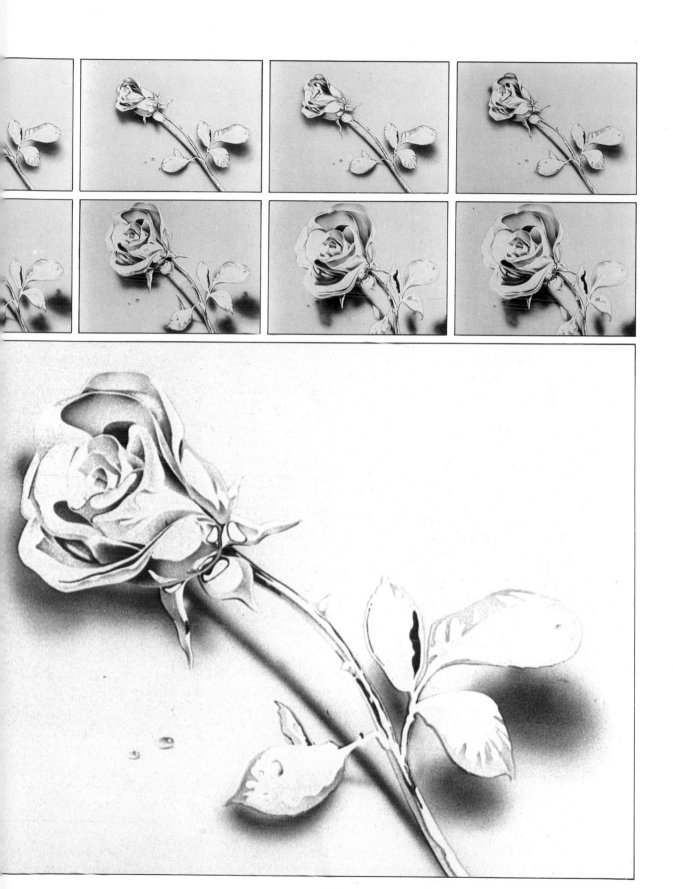

TECHNICAL ILLUSTRATION

Technical illustration is one specialized area of graphic presentation particularly well served by the characteristic effects obtained with the airbrush. The term originally applied to illustrations for manuals showing spare parts and maintenance of machinery, but it is now more broadly defined in relation to technological development as a whole, and can be said to show what man-made objects look like, how they work and, sometimes, the context in which they are used. Technical illustration proper does not include architectural or medical illustration.

When a drawing of a machine or component is commissioned, quite often the object does not exist except in plan and the artist must visualize it from engineering drawings alone. One important function of these illustrations is therefore to present the structure and appearance of the product for sales or educational purposes. Even if the product already exists, the artist makes a similar projection to render a cutaway image showing parts of an object which are normally concealed, such as the inside of a car engine. Occasionally, an engine will actually be cut in half to reveal its inner workings, but it is usually less expensive and more convenient to commission an illustration based on the engineer's original drawings.

Some technical illustration is produced in a simple, stylized form, while other examples are highly finished to give a realistic impression. The latter style has generated its own conventions of visual presentation; the images are technically accurate but can be easily assimilated. This tradition is not necessarily concerned with realism, in an accepted sense, particularly as there may be no actual model for the drawing, but is based on a logical combination of assumption and observation which ultimately produces a convincing result. The airbrush is an indispensable tool in this process: it can be used to cover quickly broad areas of tone and colour, or to make fine lines and delicate textures needed for details. But its main advantage lies in its capacity to make soft gradations of tone which subtly model three-dimensional form and achieve a smoother finish than ordinary brushwork.

Using masking techniques, the artist can break down a complex image and work through in a number of stages, protecting the finished surfaces in each section. The masking sequence must be carefully thought out and is an extremely skilful part of the work. Logical preparation of separately masked areas and the type of mask to be used clarifies the structure of the image. There is one disadvantage in masking: since it is not possible to see every area of the illustration at once, the artist must develop a keen eye and efficient visual memory, to retain a mental plan of the whole work while it is disguised by the masks. This is not an exclusive requirement of technical illustration, but the intricate nature of the work makes it all the more crucial.

The mental and practical skills of technical illustration are taught in special courses, distinct from those dealing more generally with graphic design and illustration. Although such training gives a thorough grounding in the drawing and painting techniques needed in this field, including use of the airbrush, some aspects of the discipline are even more specialized. In a prestigious company such as Rolls Royce, whose art department is responsible for the production of complex and beautiful illustrations of engines, the airbrush artist works only on colouring a highly detailed drawing which has been first produced by a line illustrator. The finished illustration may have demanded months of work from more than one person. On the other hand, a small manufacturer with a less extraordinary product may commission one artist for the whole work from start to finish.

There is a long tradition of technical illustration in which the machine is shown in a gleaming condition planted squarely on a pristine background. One purpose of illustrations of cars produced in the 1930s and 1940s, for example, was to make the product look bigger and better, however excellent it might be in reality. What these images have in common is that the object is invariably clean and unused. If the illustration acts as advertising for a product it must be seen at its best, to be appreciated aesthetically as well as technically, and an image which is designed to show how something works must illustrate each part and its connection to the whole as clearly and precisely as possible.

Recently, however, the accepted standards of technical illustration have been challenged. The range has been redefined by developments in the technology portrayed, and the graphic techniques available to the artists. Today a truck, motorbike or tractor is often shown in use, and the illustrator must apply the same attention to the location that surrounds the machine and the people who use it. The machine is still painted in detail, but its functional character is emphasized.

The airbrush may be the artist's main tool in such work, or used only to contribute to background or detail. The combination

ABOVE This illustration of a Mercedes van by John Harwood is representative of the type of work which makes use of studio photography as reference material. In contrast to the glossy graphic versions of automobiles, the aim here is to represent the product clearly and attractively, but with no further interpretation or superfluous glamour.

LEFT A standard approach in technical illustration is to portray the inner workings of a machine by removing the outer casing or bodywork. This view of a chassis and wheels is unusual in that it is a front-on, rather than a side-on representation. The use of industrial colours helps to reinforce the mechanical image.

of surface brush painting, airbrushing, and graphic aids, such as rubbed-down patterns and textures, transparent overlays and photographic collage provides the artist with a considerable range of effective techniques to match the variety in the subject. These techniques are also applied to simpler forms of visual presentation. A study of illustrations in books, magazines and catalogues shows how inventive these can be in style and approach. Popular interest in the workings of mechanical and industrial processes has generated new styles which can explain technicalities directly to people with no specialized knowledge of the subject, whether the illustration shows an oil rig or the mechanism of a wristwatch. These illustrations may be used to unravel the complexities of the contemporary world or to translate information on the history and development of a particular invention not otherwise seen in such detailed visual form. Simplified or diagrammatic images for this purpose may be quicker and easier to produce than highly finished art work, but the basic expertise required from the illustrator is much the same.

Procedures
Preparing the image
Airbrush illustrations of machinery and components show both the versatility of the technique, and the direct relationship between basic airbrushing exercises and finished artwork. Machines are composed of flat and curving planes, shiny and matt surfaces. Broad areas of the illustration can be quickly sprayed using masks and templates. The detail can then be added freehand, by ruling with an airbrush or sable paintbrush, or by cutting more intricate masks of varied size and thickness. Generally, hard edges and high tonal contrasts suggest a shiny surface; soft, graded tones look matt. Simple rendering techniques can be combined in different ways to produce extremely complex images. Many of the internal parts of an engine, for example, are cylindrical and once the technique of representing a cylinder is mastered, a large part of the drawing can be resolved. Connecting surfaces and other components can also be analyzed in this way.

Some illustrations consist of colour flatly applied to a linear drawing. The purpose of colouring is to liven up the image and define the component parts of the object more clearly, but the illustration itself tends to be diagrammatic. In this case a drawing in black line can be sprayed with transparent colours such as watercolour, ink or dye,

which will not obliterate the line. If the work is intended to create the illusion of form, on the other hand, an emphasis on line will detract from the three-dimensional effect. The linear basis for the work should form a clear guideline for mask cutting and colouring, but must also be easily covered by the paint and incapable of bleeding through when the work is finished.

A master drawing is needed, whether the reference for the illustration is taken from photographs, a model or engineer's plans. Methods of projecting three-dimensional form from an engineering drawing produce a network of lines from which the outline of the object emerges. The basic drawing can be transferred to illustration board via tracing and transfer paper. A less laborious way of reproducing it is to make a photographic print, with a grey line which is easily covered by the airbrushing. This is particularly useful if the artwork is required to specific dimensions as the size can be adjusted during the process of making the print. Photographic paper, especially the recently developed resin-coated paper, provides a good surface for airbrush work.

Applying colour
The choice of paint or ink depends upon whether the artist prefers to work with transparent or opaque colour. Transparency demands careful planning as the white of the paper stands as the highest tone and intermediary hues must be judged exactly. Watercolours and inks are available in a broad range of colours for this purpose. Gouache may prove an easier medium to work with as it is opaque and one colour can be covered with another if alterations are needed. Highlights are then added in the final stages of airbrushing, or with a paintbrush or ruling pen, using opaque permanent white.

It is possible to combine different types of paint, but in technical drawing there should be a consistency in the paint surface which corresponds to the arrangement of materials and textures in the object itself. A transparent grey is different in character from an opaque grey even though they have similar tonal values, and similar differences apply to the full range of colours. Different media should not be combined in presenting a subject with a uniform surface, or components made from the same material. Mixed media can be useful, however, to illustrate the variation in texture and finish between, for example, painted metal and highly polished chromium: the metal could be painted in gouache and the chromium in

watercolour to accentuate the contrast.

It is a good idea to begin a technical illustration by spraying fairly large areas, preferably in simple shapes. These can be masked and covered quickly, to give the artist a sense of progression and lay in a tonal key for the whole image. However, the main section through the object or a similar area of flat colour which links all the parts together should not be brushed in first as it could be difficult to retouch if damaged or marked in subsequent work. The section generally has a higher overall tone than the rest of the image and such a dominant feature affects every other part of the illustration.

There is a general tendency to misjudge tonal values in airbrush work when using masks, making light tones too dark and underemphasizing darker colours. In technical illustration the dark and mid-tones should be keyed in first. As the airbrushing progresses, it is easier to adjust the colours

from this tonal key than to try to darken the whole image if the light tones have been made too dull. Although gouache can be used to cover mistakes, if the image is continually resprayed and altered the paint becomes too thick and the colour is deadened. There is also more danger of the paint surface becoming unstable or colours bleeding through from previous layers. Gouache corrections to a watercolour painting will not have the same quality as light transparent tones.

The ability to mix paint to the right colour and consistency is part of the skill needed by any artist using any medium or technique. The technical illustrator who works with an airbrush will often be working with greys and neutral hues and making fine adjustments in tone and the warmth or coolness of a colour. The paint consistency must be absolutely right for the airbrush and the surface being sprayed. Every part of an image which

BELOW This airbrushed illustration of a Rolls Royce engine was probably commissioned to attract advanced sales and orders. The heyday of the big aircraft industry studio work was in the 1960s; Ted Hickling and Duncan McKay were notable illustrators.

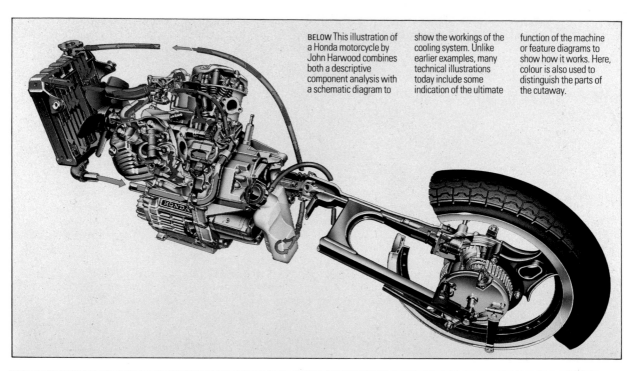

BELOW This illustration of a Honda motorcycle by John Harwood combines both a descriptive component analysis with a schematic diagram to show the workings of the cooling system. Unlike earlier examples, many technical illustrations today include some indication of the ultimate function of the machine or feature diagrams to show how it works. Here, colour is also used to distinguish the parts of the cutaway.

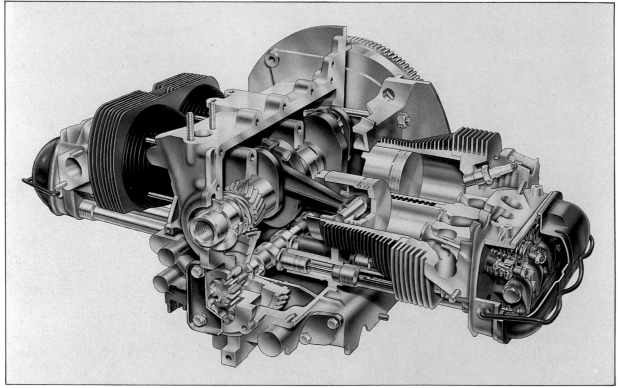

ABOVE This cutaway image of a Volkswagen engine by Roger Stuart is a good example of the type of standard work produced by technical illustrators. Aside from the obvious skills and expertise required to present such complicated information in a visually concise fashion, the illustrator must also be able to visualize the interior of a particular piece of machinery from photographs, or reference consisting of engineers' drawings and workshop manuals.

has the same colour should be sprayed at the same stage of the working process, while the tone and paint mixture are familiar, to avoid problems of matching hues at a later stage in the work. Certain colours can be very useful in rendering metallic surfaces. Payne's grey, a bluish-grey, and Davy's grey, which is tinged with green, are only available in watercolour ranges, so the use of gouache may involve some delicate colour mixing. Such factors should be taken into account in the original choice of medium.

To enliven the illustration and relieve the uniformity of surface and texture, reflected colour is often incorporated. Use of reflected colour is a visual convention of technical illustration and does not necessarily derive from real qualities of the object itself, or its function and usual location. In general, warm earth colours are touched into parts of the bottom of the drawing and cooler "sky" colours, those with a blue cast, are used at the top. Such opposite colours are mutually enhancing and the contrast gives the work a vitality which attracts the eye. There is no fixed rule about the exact combination of

colours, although they tend to work within the accepted principles of colour theory, pairing red and green, blue and orange and variations within that range. From a reference for the machine it can be observed where the reflected colours actually lie and this could be used as the basis for the airbrushing. The colour balance could also be reversed; for example, warm colours could be placed near the top of the object as if it were reflecting an evening sky. It should be stressed, however, that this is a subtle process and not immediately obvious. Real reflections can distort or confuse the appearance of a machine, which is of no help where the specific purpose is to present an interesting but fully informative image.

Some machine parts reflect each other: this provides the illustrator with a device for making an even more complex image. Here again, reflection which confuses the structure or interrupts the plane surfaces should be avoided, but wisely used, such detail can add to the impression of solidity and makes representations of smooth and polished surfaces seem more convincing.

ABOVE A good deal of airbrushed technical artwork is designed to illustrate manufacturers' brochures. Here, an airbrush drawing of the major chassis members of a Volvo has been combined with a line drawing showing the overall shape and form of the car. The characteristic effects obtainable with the airbrush are particularly suited to representing the high sheen of body finish. Highlights and shadows are essential for a realistic effect and contrast well with the simple line work.

Representing form and surface

The illustration must present a clean, well defined and attractive image of the product and one which is accessible to its audience, whether or not they understand every part of the machinery. Each aspect of tone and colour must be assessed for its effect in clarifying the overall structure of the drawing. The tonal values of the components can be manipulated so there is a constant balance of light and dark, strengthening the impression of mass and depth and defining the edges of separate parts without relying on linear devices.

In the conventions of technical illustration it is assumed that an object is illuminated by a single light source. Traditionally, this is taken to fall at a 45° angle from the top left. As with other rules in technical illustration, this is a helpful guide, not an immutable precept. For various reasons the artist may decide to use a different angle of light, perhaps falling from the top right. However, the main purpose is to keep a consistent illumination to emphasize three-dimensional form. This is another aspect of rendering which properly applied passes almost unnoticed, whereas if each component were given a different distribution of light and shade, the viewer would soon realize an incoherence in the image.

Another subtle technique is an adaptation of the principle of atmospheric perspective. This phenomenon was first made part of painting traditions by Leonardo da Vinci, who noted that objects in the distance appear hazy and less clearly defined than those nearer to the viewer. In a landscape, forms are diffused at the horizon and the colours tend towards a blue-grey cast, whereas in the foreground it is possible to see details and true local colour. In technical work the artist may be dealing with distances measured in feet at most, perhaps only inches, rather than the miles of a landscape, but if the furthest parts of the object are given slightly less clarity of tone and form than those shown nearest, a further perceptive dimension is added to the effect.

In a cutaway image, the inner surface of the machine is usually darker in tone than the parts it contains and the vertical section of the "cut". Throughout the image, at each change of plane surface, dark tones are set against light and vice versa, almost to the point of exaggerating the forms. Reflected light on the edges of cylinders, shafts and bolts, for example, draws them forward from the heavier tones behind, so the eye can follow the pattern of shapes within the space they occupy. Dark edges tend either to come forward, destroying the illusionistic effect, or get lost in the background colour, losing definition of individual elements. Details of delicate components become focal points because they break up the surface, so these must be tightly drawn and the tones matched carefully.

Such details may be too fine for airbrush work and some work with a sable brush may be necessary to complete the image. Finely ruled or hand-drawn highlights and lettering should be left to the last because paint applied with a brush is thicker than sprayed paint and a fine line may lift if a mask is applied and then pulled off. This instability is particularly noticeable in work on photographic paper. It may also be necessary to adjust the tones throughout the illustration, in which case painted lines will be covered by airbrush work and must be laboriously redrawn. A large and complicated illustration, such as those produced for Rolls Royce, provides an exception to this rule. Since the work takes a long time, the artist may include some brushwork detail before all the spraying is finished.

There are also conventions which govern the application of ruling and highlighting. When rendering screw threads, for example, it is usual to draw in a fine dark and light line for each turn of the thread, a procedure which is much easier than trying to grade the tones of one delicate line. In shadowed areas the light line can be read by the viewer, while the dark line is picked up across pale tones and highlights. A broader area of highlighting can be put in with a light tone such as pale blue or grey and enlivened with touches of white.

The basic techniques of ruling and masking are invaluable in technical illustration. Different ways of distributing tone in, for example, a cylinder can be further enhanced by variations between soft and hard edges, using adhesive or loose masks, and spraying over a hard edge directly or at a short distance from the surface. In this way an object can be made to look shiny or matt, even though the tonal arrangement itself may be the same in each case. The rule of light and dark contrast is well illustrated by the treatment of the inner and outer curves of a hollow cylinder. The bands of light and dark on the outside are reversed onto the opposite curve inside, so the structure cannot become confused by the continuation of similar values. Cast shadows are useful for throwing into relief a particular section of the machinery. The mask cut originally to outline the parts can be used to define the shadow area simply by shifting it to one side, placing it in position and spraying in a darker tone.

Ghosting

Where a cutaway image is not used it is still possible to indicate the inner workings of the piece of machinery by laying in a ghost image, as if the surface layer were transparent. This can be done in two ways; by working up the components in detail and laying a fine, transparent spray over the top to stand for the actual surface; or by drawing up the inner forms lightly over the uniform outer surface and spraying their colours delicately so they appear to emerge from underneath.

It is more appropriate to use watercolour for this process, since it has the necessary transparency, but it can also be done with gouache providing the spray is of the right consistency.

Airbrushing over photographs

Apart from reproducing a drawing photographically as a basis for the illustration, there is also a practice related to this type of work which consists of cleaning up a photograph to make a pleasing image and remove signs of the normal wear-and-tear on a machine in use. The object may be standing in a cluttered background, the surface may be marked or dirty, or the tonal values of the photograph itself may be indistinct, disguising the structure of the machine and making it difficult to identify clearly in its context. This leads to the area of photographic retouching, which is not solely concerned with images of technology, nor is it any longer mainly achieved by airbrushing. However, the same basic skills are needed.

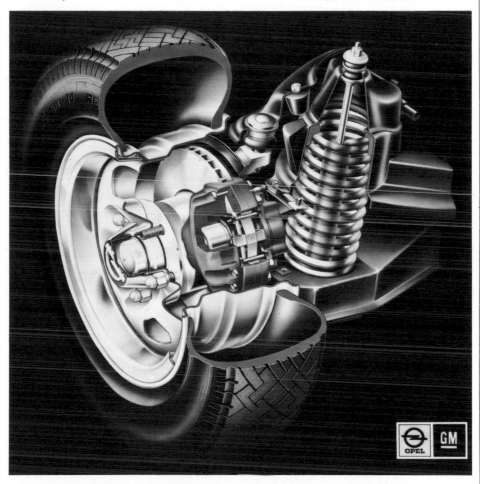

ABOVE This illustration of an Opel wheel and suspension unit by John Crump was executed on exposed photographic paper to provide a black background. The intention was to show the tyre emerging from the background, rather than exploit the traditional style of technical work, which usually features a white ground. The illustration was produced from a meticulous drawing. The tyre and chassis members were built up with white sprayed over the black background. Very fine brushwork was added around the circumference of the tyre. Some ghosting was added on top of the artwork showing the shock absorber within the spring. As is the convention, red is used to show cutaway mechanical components.

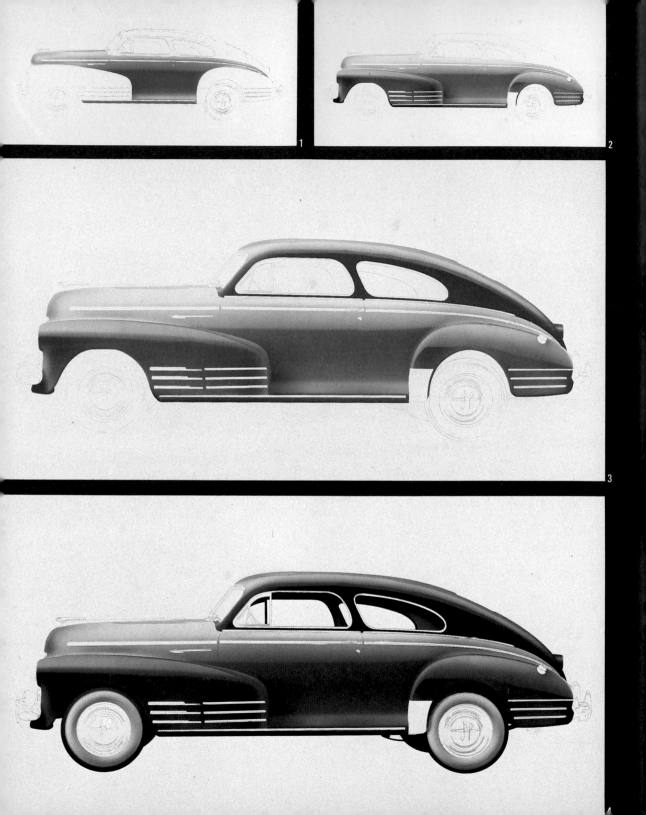

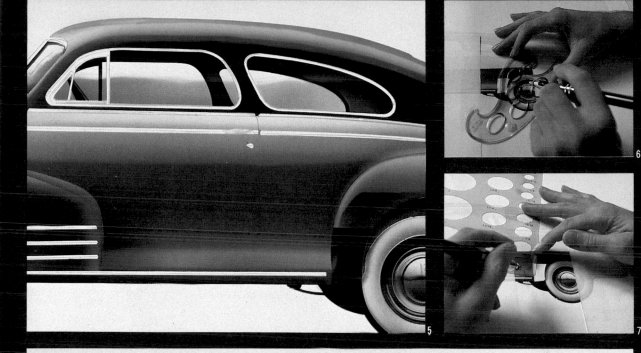

Making a "profile"
The side view or "profile" of a vehicle is a common style of technical illustration. This ink illustration of a 1942 Chevrolet Fleetline is given some depth, but many profiles ignore perspective altogether. After the drawing was made and transferred to

the board, a mask was cut to expose all of the light bodywork. The tones and reflections were built up, using curves and cut paper as masks. This base was executed in Payne's grey, with yellow ochre introduced to imply a ground reflection (1). Another mask was

cut to expose the wheel-arches and these were sprayed in the same way (2). The roof was exposed and sprayed using cut paper and curves as masks. Permanent white was used to strengthen the highlight and yellow ochre to tie the roof in with the bodywork (3).

When an even tone had been laid for each tyre, the black was masked and permanent white and spectrum yellow sprayed to suggest light catching the top. The bumpers and hubcaps were sprayed using cut paper masks. Yellow ochre covered with Windsor green gave a

ground reflection; Windsor green gave a horizon line; Windsor blue and Payne's grey gave a sky reflection. Reflections on the overriders were broken up by swabbing with cotton wool. The car interior was sprayed jet black (4). The car windows were sprayed

in Payne's grey, using cut paper masks. Permanent white was lightly drifted over the interior above the reflection implied by the Payne's grey (5). Circular templates were used as masks to create shadow areas (6, 7). The final stage was hand-painting (8).

MANIPULATING THE IMAGE

From the moment that the photographic image became reality, and throughout the middle years of the nineteenth century while the technical processes evolved and became more efficient, a fierce debate went on about the relationship of photography and painting, centred on the apparent objectivity of the camera as compared to the subjective truth of the artist's vision. At opposite extremes of the argument, one side regarded photography only with hostility and contempt while the other revered both the photographs themselves and the modernity of image-making by a mechanical process. In between were many people who realized that no artists' technique has autonomous vitality and, while recognizing the stimulating effect of such an invention, they learned to use photographic images in various ways to adjust or reinterpret an initially objective viewpoint. Many painters used photographs as reference material for their painted images, replacing some of the work that had previously been done by sketches and notes. Notable among these were Eugène Delacroix (1798-1863), Gustave Courbet (1819-77) and Edgar Degas (1834-1917), Delacroix only bewailing the fact that photography arrived too late to be of more use to him (he died before photographic techniques became relatively simple and widely accessible). Auguste Renoir (1841-1919) noted that photography had freed painters from some of their more tiresome labours, such as portraiture for purely documentary purposes. A few enterprising artists made their paintings over photographic images, relieving themselves of all the problems of rendering a subject from personal observation.

The photographers themselves, while believing in the importance of photography strongly enough to endure the laboriousness of early techniques, soon had to recognize certain limitations in their art. A portrait photographer could not choose to overlook the fact that a subject had a huge nose or three chins. And from the early years, the demand for colour photography was ever-present, requiring individual hand-colouring of each image until well into the twentieth century. To emulate the complex narrative style of Victorian painting, some photographers ventured immediately into the production of composite photographic images. With the advent of photo-journalism, starting during the mid-nineteenth century but not fully established until the 1920s, photographs were required to capture history in the making and the pictures would be widely seen through exhibition or distribution in journals and magazines. With luck, the images would be all that was expected of them, but if they were not, ways and means could be found to "improve" them. For all of these reasons, manipulating photographic images was well-established practice by the late nineteenth century. When the airbrush was invented in 1893, it became in a short time the natural tool of photo-retouchers, because of its speed, precision and delicacy of application.

In later years, as photographic reproduction has become standard for editorial and graphic purposes, using both black-and-white and colour images, methods of retouching have become more efficient, and the reasons for adjusting pictures more complicated. Some photographs are retouched for purely technical reasons – to add colour where none exists or to enhance the actual colours; and to cover spotting, scratching or fading of a photograph, caused in development or through ageing of a print. There are many reasons for adjusting an image pictorially – in advertising, for example, to clean up and perfect the image of a particular product; in fashion and glamour photography, to heighten colour effects, remove blemishes and smooth out the overall appearance of the image; in photomontage, to remove all traces which show how the picture has been made from a combination of several sources, so the final effect is of a single, cohesive surface. It is also possible to change radically the character or content of a photograph by eliminating whole sections of the image and reintegrating the remaining elements. Some of this work is too delicate even for the airbrush and must be done by hand, using

RIGHT This photomontage was produced by Herbert Bayer in 1931. Bayer was one of the leading teachers at the Bauhaus. This school promoted creative experiment with all the media and techniques of the arts, and set out to train students as both artists and craftsmen, rejecting the traditional division between the two approaches. The airbrush played an important part in the composition of these images, disguising the method of construction – either montage of photographic prints or superimposition of negatives before the final print is created.

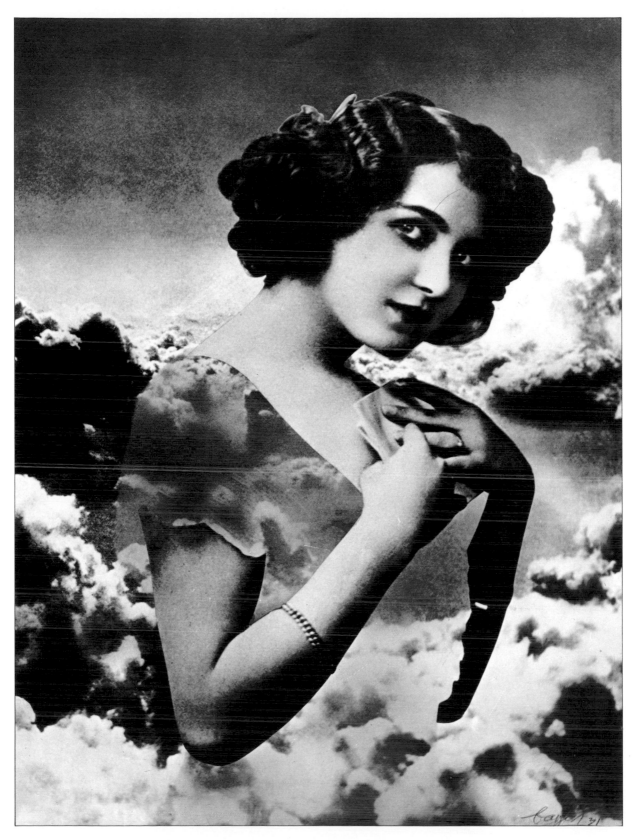

fine, good quality paint brushes. Airbrushing itself has been widely used for many years in retouching and still is, to some extent. But techniques of photography are now so sophisticated that a good deal can be done to manipulate the image in the staging of a photographic session, in the camera itself and certainly in the developing processes. Airbrushing is now a smaller percentage of professional retouching work, but where it is used, is no less vital than it has ever been.

There is no limit to the amount of creative experiment which can be made in the realm of manipulating photographic images. Retouching is a subtle art, however, and should not be used simply to cover the effects of bad photographic technique or to reconstitute a picture completely – if this type of work is called for it would be better to acquire more expertise in photography or to take up painting. Old photographs should be treated carefully – their ageing is a part of their charm and clumsy retouching will certainly look worse than the blemishes of the original, while damage such as tears or scratches cannot be fully concealed. A good method of approach is to rephotograph the original and retouch on the new print. Retouching is high-

ly skilled, professional work and the ability to estimate the work needed is part of that skill.

Retouching
Basic skills

While photography, painting and graphic arts have acquired a certain academic status, retouching has remained firmly within a tradition of technical craft, a skill learned in apprenticeship to a working studio. Like the arts which it services, however, it requires not only a high degree of dexterity and technical skill, but also the development of extremely keen perceptual faculties and a capacity for disciplined visual analysis. Yet it is largely an invisible art form, designed to retain the viewer's absolute faith in the "reality" of the photographic image. At the furthest extreme, retouching is capable of presenting in apparently objective form a record of events which is totally untrue or even physically impossible. More often, it functions to clean, mend and decorate visual presentation. In this less deceptive capacity, the work of the retoucher should still remain unobtrusive. He or she must have a clear understanding of colour, tone, light and form to match every aspect of what is changed in

ABOVE Airbrushing is used in retouching work to remove blemishes, heighten contrast or add detail. Working directly on a colour print in this example, the retoucher has added highlights to the windows of the jet, re-established the shadow areas under the engine and added insignia.

When retouching directly on a print, take care not to damage the photograph when cutting masking film. As gouache does not adhere well to a glossy surface, keep spraying light. Detach film before applying it to a sprayed area to prevent the paint lifting when the masking is removed.

Colour retouching
Retouching is often
required to help in the
production of an image
which cannot be
achieved by more
conventional means. In
this example, the
retoucher was
commissioned to adjust a
photograph to specific
requirements. The
intention was to remove
all detail from the
model's face so that her
features loomed from the
page. Although the model
had been heavily painted
with white make-up, the
studio photograph fell
short of the desired result
(1). Working on a colour
print taken from the
original transparency, the
retoucher used
airbrushing and
brushwork to remove all
detail from the face (2).
The hair was darkened,
so that type could be
reversed out of this area
in the final design. The
result had a luminosity
and precision which could
not have been produced
by photography alone (3).

MONEY CAN'T BUY LOVE ... IT *CAN* BUY PLEASURE

Her elderly husband's death leaves Jenny Townsend
grief-stricken – but rich. And Jenny soon finds that a
multi-million dollar fortune can buy almost everything.

To keep the money she has to obey her husband's dying
wish: she must marry again, but only after she has tried
many lovers.

Wildly rich, desperately alone and hungry for passion,
Jenny has six months in which to experience every
pleasure money can buy. Then – and only then – can she
marry for love.

Don't miss Francesca Greer's other sensational novels:
FIRST FIRE
BRIGHT DAWN
also available in Sphere Books.

0 7221 4080 0 CONTEMPORARY ROMANCE

Francesca Greer

Second Sunrise

Francesca Greer

Second Sunrise

the image with the precise information which remains.

The basic techniques used for airbrush retouching are little different from those required for airbrush painting. The capabilities of the airbrush must be mastered – the smooth grading of tone, fine linear effects and overall control of the spray texture. In addition, it is vital to use masking methods with extreme accuracy as the shapes may be small or extremely complex. Since the airbrushing must be fully integrated with sections of the original picture, careful attention must be paid to surface qualities and matching of colour and tone. If parts of the image are to be completely changed, an opaque medium, gouache or retouching colours, can be used, while to tint or modify the tones more subtly, a transparent medium, such as liquid watercolour or film colour, is needed since it will allow the underlying image to show through clearly.

When masking film is used it is again the general rule to keep cutting on the surface to a minimum. A score mark in the photograph cannot be successfully disguised. Liquid masking is often preferred for this reason, and also because it can be painted quite accurately into small shapes and intricate outlines. A loose mask for a photograph can be made by producing two or three extra prints from the negative, if one exists, and cutting them to take out the silhouette of a particular form. Weighted down on top of the full print, a silhouette functions very effectively as an accurate mask and has the added advantage of enabling the retoucher to see the whole image while a section of it is being reworked. A spare print is always useful for reference, even if not used in the masking. The precise form of the image must be clear to the retoucher – the work will be less convincing if important elements must be surmised or reinvented because the image is obscured by masking.

There are several different applications of retouching techniques. One is to remove completely any part of the image which is distracting from the central subject. In technical work, this may mean cleaning out signs of wear on a machine photographed *in situ*, or covering the background entirely so the machine is seen against an area of flat colour or tone. Ghosting has a slightly different meaning in retouching than in technical illustration. It refers to a light spray which reduces the clarity of a background without actually obliterating it, increasing the viewer's ability to define and focus upon the main subject. The dimensions of a photographic image can also be extended verti-

cally or horizontally, to alter the balance of the whole shape. A single element in a photograph may be retouched to increase clarity in contrasts: for example, the tonal value of sky in a landscape, or the clothing of a figure against a cluttered background.

It should be emphasized that retouching is a subtle and gradual process, however radical the alterations in the final version. Retouching is usually undertaken with the intention of rephotographing the picture or otherwise reproducing it – the camera will pick up and even exaggerate any clumsiness or inaccuracy. Even when the technical skill of airbrushing has been acquired, the skill in manipulating the pictorial aspects of retouching is only learned by experience.

Colour retouching

Colour tinting monochrome images was a traditional aspect of photographic work and an area where airbrushing has played an important role. Today, colour photography is standard in books, magazines and in advertising art and even appears in newspapers, where speed and cost control have always been key considerations. Airbrush work is not always required in the adjustment of colour photographs as a great deal can be done in the original creation and development of the image.

Colour photographs are made by the registration of three basic colours on the negative, the light primary colours red, green and blue. These are combined in varying degrees to make all the colours that exist in a particular view. By the use of various colour filters, these combinations can be adjusted to correct a loss of balance or to produce a colour bias. In photographs printed on lightsensitive paper, the image exists in the sensitized layer and cannot be lost completely once developed. It can therefore be bleached out and colours dyed back in, with adjustment in the dyeing to colour up the image to a particular specification. In the dye transfer process, an expensive, specialized, but extremely durable technique, the image is composed from separate gelatinous matrices soaked in dye solutions, which are combined on a surface to dye in the correct combination of colours. By altering the intensity of colour in the original matrices the colour balance can be manipulated to adjust the overall effect.

Occasionally it is simpler to retouch a colour image with airbrushing; although dye processes can change the hues in an image it is more difficult to alter the basic shapes and forms recorded by the camera. Even when care has been taken to set up a studio

arrangement, the final print may show an object with an unwanted area of reflected colour, a detail sometimes hard to spot through the camera viewfinder. The tonal structure of the print may not display sufficient contrast to create the impression of three dimensions. In these cases, common problems in fashion or advertising photography, it is simpler to retouch than to use complicated and expensive photographic techniques of adjustment, or in the final extreme, to arrange a new photography session. In fashion and glamour photography, retouching is used to take out tiny wrinkles or skin blemishes: the whole shape and texture of a body can even be altered to fit a desirable ideal. "Cosmetic surgery" by retouching can transform photographs of actors, actresses or models into perfect images by "improving" features.

In advertising, one of the main uses of retouching is to display the product in the best possible light, with an absolutely flawless finish and no single superfluous mark to detract from the whole presentation. Reflection is a considerable problem here. Products in glass packaging are obviously difficult to photograph because they will reflect actual objects from their surroundings, and may pick up a flashback from the lighting which will diffuse part of the image. But any surface which is slightly reflective, a car body, anything pure white in colour, or even a cigarette packet with a slight sheen, can pick up reflected colour to a degree which cannot always be anticipated by the photographer. Since the same advertisement may appear at half-page size in a magazine or 20 feet (6m) long on an advertising hoarding it is imperative that there is no blemish or wrong emphasis which might be exaggerated in reproduction. The opposite can also apply. If for any reason the product loses some essential or appealing quality in the photography, this can be restored and even made the focus of attention through retouching.

Journalism and documentation

In the news media, the aura of truth with which the photograph is invested is all-important. In editorial photography it is usually not the retoucher's business to alter the story told by the image in any way, merely to clarify the presentation so the personalities or action in the photograph are clear and recognizable. In magazines using good quality reproductions, the retouching should be quite invisible; in newspapers a different technical approach to retouching is needed because the black-and-white reproduction used is relatively crude and bold. Similar tones in background and foreground tend to merge and extra definition may be needed to make a particular figure stand out, for example. It is the nature of photojournalism that there is often little time or the opportunity to create good conditions for taking pictures and retouching is relied upon to make adjustments in composition.

Since the advent of photojournalism, a far more comprehensive record of historical events and personalities has been possible, although at first the distribution of such documentation was relatively limited. Despite the objective eye of the camera, there are many ways of manipulating news photographs, both with and without retouching. Even in the most open societies, and with international news agencies distributing the same pictures around the world within hours, a political slant can be added suitable to local ideologies and preoccupations. The picture can be cropped, that is, cut down to exclude a figure or the background locality to obscure the full circumstances of the action. The photograph can equally be slanted by the addition of a misleading caption which directs the reader towards a particular interpretation of the subject.

Retouching is also known to have been used in documentary photographs to twist or "rewrite" history. In societies where the authorities have strict control of the press, pictures can be manipulated so that those present at the scene might be persuaded to believe that their own memories were faulty. The examples usually quoted, whether true or apocryphal, concern politicians fallen from grace, who mysteriously disappear from all photographs taken during the period of their power.

Combining images

The original attempts to combine photographic images took place early in the history of photography. In 1857, O.G. Rejlander produced an ambitious photographic composition called *Two Ways of Life*. Rejlander was a painter and was working during the period when the debate over the comparative values of photography and painting was at its height. Intending to prove the creative potential of photography, he constructed the composition in the style of the grandiose moralist paintings popular in the Victorian era, using 30 negatives.

Photomontage as it is now known, the technique of producing a composite image by assembling sections of photographs and rephotographing the result, was pioneered by the Berlin Dadaists, notably Raoul Hausmann (b. 1886), Hannah Hoch (1889-1978),

George Grosz (1893-1959) and John Heart-field (1891-1968). The German term *montage* was chosen because of its mechanical associations; it refers to assembly in the sense of engineering or fitting. The Dadaists made a deliberate attempt to disassociate their work from what they saw as the pretensions of fine art traditions. Unlike the method used by Rejlander, the photomontages were composed of printed matter, not assembled in the process of printing, so the transpositions from one section of the image to another required the type of concealment which could be achieved with retouching techniques.

The montages which the Dadaists produced combined scraps from newspapers and magazines, including photographs,

ABOVE This striking image, illustrating "Austria" for Polygram's *World Atlas of Music,* was designed by Hipgnosis, a studio well known for innovative work in album cover illustration. Hipgnosis were commissioned to devise a series of images representing the music of different countries for Polygram's campaign. For the music of Austria, it was felt that the design should indicate modern experiment within the context of a classical heritage. The original photography was shot on location in Austria, using a Hasselblad camera fitted with a filter. No special lighting was required. The photograph was then processed using the dye transfer technique, a method of colour development which allows careful adjustment of colour balance. Hipgnosis' retoucher, Richard Manning, worked on the print, first bleaching out strips to provide a white background for subsequent airbrushing. To create the impression of neon light, he used photo-retouching dyes.

RIGHT Another Hipgnosis design, this image was produced to illustrate *Difficult to Cure,* an album by the rock group Rainbow. The original photograph was taken in a studio and then retouched by Richard Manning. Airbrushing was used to distance the background figures slightly, thus bringing forward the surgeon in the centre of the picture. Although a similar effect could well have been achieved by subtle use of studio lighting, airbrushing is more reliable and controllable.

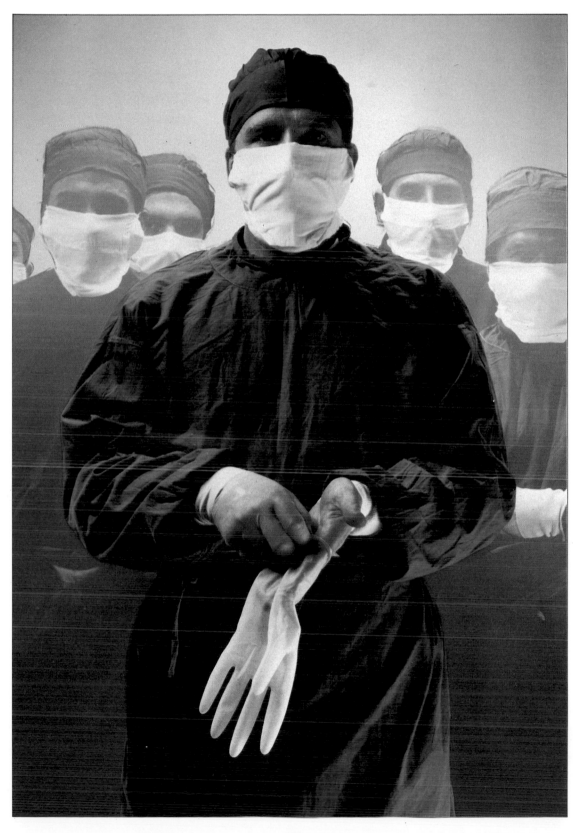

drawings and typography, as well as photographs specially produced to direct the image towards a specific theme or subject. The purpose of Dada was to mock and challenge accepted concepts in the arts. Photomontage offered the perfect opportunity to combine images in an apparently random form, or to pass comments in a "visual dialogue", or to render ridiculous images which were originally notable for their formal and conventional character. But it became recognized as a new art form and one which linked graphic art with the traditions of painting. As an area in which style could be reinvented, it was later taken up by many other artists, among them Herbert Bayer and László Moholy-Nagy of the Bauhaus.

John Heartfield was the member of the original group who became best known for his use of the technique, which featured savage attacks on the Nazi regime in Germany. Photomontage is a particularly effective medium for political comment since familiar and immediately topical images can

be used, but given a new slant by the different elements with which they are combined. Heartfield took pictures of Hitler and his henchmen, photographs which were originally intended to be imposing and politically effective, and used them to show the Nazis as bullies and butchers, obsessed with money, power and cruelty rather than the high ideals they themselves tried to impress upon the German nation.

Heartfield recognized the value of expert technical skill. He worked closely with a photographer and retoucher, directing their work in minute detail, but not participating practically. Airbrushing conceals the divisions in composite images and can subtly alter the texture and tonal values where necessary, so that when reproduced, the montage strikes the eye as a whole visual thesis, not as a disturbing jigsaw. These technical refinements took place after the early days of Dada, when the montages had revealed more about the disparate sources of their extraordinary imagery.

ABOVE Some retouching work amounts to full-scale restoration. The original photograph in this example was an old sepia-toned print. The left-hand portion of the photograph had completely fragmented. The retoucher was commissioned by a firm who wished to present the restored print to an employee who was retiring – the subject of the photograph. The retouching was carried out on a black-and-white copy taken from the sepia original. Aside from the necessity of carefully matching the tones of grey used in the airbrush and brushwork retouching to those in the print, the retoucher had to replace the missing detail.

Photomontage became standard practice for graphic and fine artists and is often used as the basis for silkscreen and lithographic printing of posters and edition prints. There are two basic methods of dealing with airbrush retouching in montage. The image can be fully assembled first and then airbrushed to provide a coherent surface, but it is also possible to treat the cut edges of each section of the image before they are stuck in place, a process known as edge painting. Because of the thickness of paper, a white line will remain visible around the form in the assembled montage which must be blended into the tonal structure. If much work is to be done to adjust surface qualities: for example, when different kinds of printed matter are combined, airbrushing is better done after the image has been assembled.

Illustrations for advertising and editorial purposes are often made by techniques similar to montage, but depending upon the size and expense of the project, the images may be combined in the photographic de-velopment processes rather than manually. Airbrushing is not necessarily involved. One growing area where airbrush retouching still finds an important use in montage is in the production of record album covers. The original artwork may be assembled from specially commissioned photographs or from stock agency pictures – airbrushing may be applied to integrate the elements or to introduce a new motif. The extraordinary creativity which has occurred in the realms of this graphic art form has put the airbrush to its fullest use.

Airbrushing is also used to create combination images on a single photographic base. A detailed illustration can be integrated with a photograph or a background of artwork can be laid in to surround a central subject. Architectural proposals are sometimes visualized in this way. First a photograph is taken of the site and then the building or construction, based on the architect's plans and elevation drawings, is painted in over the top.

RIGHT Photographs which will be reproduced in brochures are often retouched to clarify detail and remove unwanted background. This photograph of a rock drill was retouched to take out the stand and background. The rubber silencer, painted white in the original model, was retouched in black. A new tip was drawn from reference and added by airbrushing.

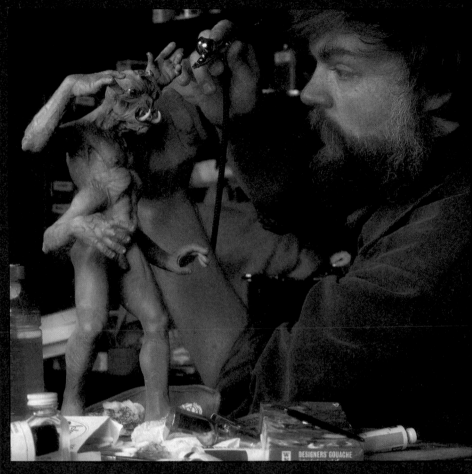

ABOVE Lyle Conway, a freelance special effects designer who has recently worked on *Dark Crystal*, used the airbrush to build up and blend layers of colour quickly so giving the foam rubber creature a realistic, translucent 'skin'. The airbrush technique saved time and created evenly blended tones. A paintbrush was used for the fine detailing.
RIGHT The finished four-armed creature – Tara Tarkas – was to be used in Edgar Rice Burroughs' film *John Carter On Mars*.
LEFT Car bodies, which are themselves spray-painted, are particularly suited to the application of designs with an airbrush. Use paint manufactured for the automobile market; clean the airbrush thoroughly after use.

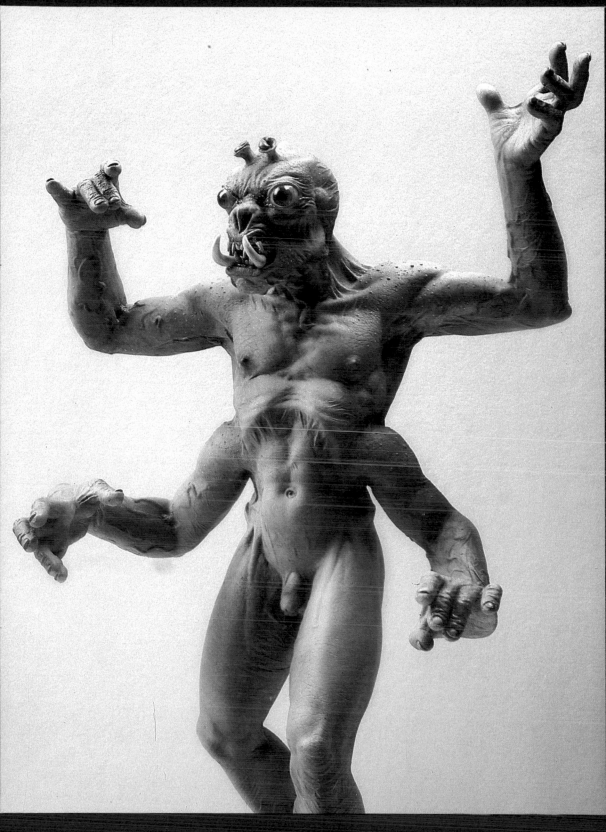

Other uses of the airbrush

Airbrushing is used in a number of disciplines aside from illustration and design, also playing an important role in the production of three-dimensional work of various kinds.

An extension of the graphic use is found in artists' printing techniques. This does not refer to work which is commercially reproduced in large quantities, but to limited edition printing, such as lithography and silkscreen. Lithographic ink, used for drawing an image directly onto a zinc plate, can be thinned and passed through an airbrush, while much work in silkscreen and lithography is based on photographic techniques where the airbrush is used in preparation of the image. In an edition, each print can be slightly altered by the use of airbrushing through stencils, laid over the print surface.

The airbrush is used in textile design to produce particular patterns and decorative effects, and also to decorate finished textile products, with thinned fabric-painting inks or other suitable paint or dye products. Individual designs are applied to items of clothing, such as scarves and T-shirts, or to soft furnishings such as curtains, lampshades and even hand-made quilts. An interesting sideline was the use of airbrushing for the decoration of blackout curtains during World War II. Since the regulation fabric was so depressing in a situation which was already grim enough, designs were used to enliven blacked-out rooms.

Walls, interiors and even shop fronts and windows can all be painted and decorated by airbrushing. A new development under consideration – an extension of industrial spray painting – is the use of the airbrush as a simple decorator's tool, for painting window frames, for example. The glass can be masked and the frame coloured in seconds. This is a feasible application now that propellant devices are small and portable.

A major application of airbrushing occurs in car customizing. This has been extraordinarily popular since the late 1960s and represents a large portion of the market for airbrushes, other than for graphic art. Designs applied to cars and trucks vary from simple colour gradations and lettering to colourful and detailed figurative or narrative scenes. The use of the airbrush is particularly appropriate in this context since the car bodies themselves are spray-painted by factory techniques. For successful work, the surface must be well prepared and painted with a suitable lacquer or enamel paint manufactured for the automobile market. Afterwards, the design should be protected with a transparent lacquer varnish. The use of such media requires careful attention: the airbrush must be thoroughly cleaned of these durable media.

Modelling covers a range of productions, from plastic kits to hand-crafted resin or ceramic objects. The simpler types of airbrushes are specially designed for model makers who wish to apply overall colour, muted tonal effects or colour details. Enamel paints are often the medium for this type of work. The particular airbrush and medium

chosen obviously depends upon the character of the modelling work being undertaken. In a related field, airbrushing can be applied to ceramic objects, to paint delicate designs on the surface of pots, plates and figurines with ceramic glazes or slips. Masking on small three-dimensional objects is tricky and the colouring often needs to be painted freehand, but the typical effects of airbrushing are distinctive and the final finish would be quite different if applied by brush painting.

The airbrush is more unusually used in cake and artificial flower decoration, and even taxidermy. Taxidermists use airbrush to enhance, for example, the delicate colouring of the scales of a stuffed fish, or to touch up the black patches of a badger. Another highly specialized application of airbrushing is in brain surgery, for spraying protective latex covering on exposed human tissues. Precision and control of the spray pressure is clearly important here, as is the fact that the airbrush can be made sterile.

Provided nothing is used which damages either the airbrush itself or the operator, it can be put to any decorative purpose: the potential is enormous. The future of airbrushing depends ultimately upon the inventiveness of both manufacturers and users. One factor which continues to be crucial is the propellant system; in this area much research still goes on. Another technical development being researched is computer-controlled operation of the airbrush. Robot spraying of car bodies is now standard practice; the same principles could be applied to more delicate spraying, devices for the decoration of china and ceramic models – programming a computer to direct the airbrush to repeat a particular pattern or design. At the same time, it is up to the artists who use airbrushing, to push the potential of their techniques to the limit, to discover new and more inventive applications.

LEFT Airbrushing on fine fabric produces a range of interesting effects, which can be further embellished by embroidery or simple quilting. The ability of the airbrush to create subtle shading or bands of soft colour is well suited to this application.
ABOVE The airbrush can be used to apply colour or tonal effects to three-dimensional objects. These models, made from resin, have been sprayed freehand to bring out contours. The technique is fairly simple, but adds a liveliness which could not be produced by other colouring methods.

GLOSSARY

Acetate A transparent film available in a variety of thicknesses which can be used as a surface in animation; for overlays; or cut into different shapes for stencils.

Airbrush Invented by the watercolour artist Charles Burdick in 1893, the airbrush is a mechanical colouring tool which mixes air and paint together and propels the combination at a surface in the form of a fine spray. The airbrush consists of a fine internal needle, a nozzle where air and paint are mixed, a colour receptacle and a pen-shaped body. It is connected by a hose to a propelling device and operated by a lever or push-button control. *(See Double-action independent; Double-action fixed; External atomization; Internal atomization; Single-action fixed.)*

Air eraser A device operating on the same principle as an airbrush, the air eraser is used to propel fine particles of an abrasive, thus removing unwanted areas or mistakes from artwork. It is more subtle in its effect than ordinary methods of erasing.

Air pump A component of a compressor which compresses air and forces it into the hose and thence to the airbrush.

Air trap *See Moisture trap.*

Bleed Certain pigments stain; when these are covered by another colour, no matter how opaque, they will show or "bleed" through. Pigments with this characteristic are clearly labelled by the manufacturer; care should be taken when selecting and using colours that will subsequently be overlaid.

Bromide A smooth, coated photographic paper sometimes used as a surface for airbrushing. It can be wiped clean easily.

Brushwork Many airbrushed illustrations include a fair proportion of brushwork, hand-painted work with a hair paintbrush. Brushwork is usually the final stage of an airbrush painting and is often restricted to fine detail or special textured effects, such as stippling.

Cel Individual acetate sheet used in animation. Airbrushing is done directly on the cels, one for each small change in a sequence of movement.

Colour cup Receptacle for holding a quantity of medium which is either mounted on the side, recessed into the top or attached to the underside of the airbrush. In the latter case, the receptacle is often in the form of a detachable jar.

Compressor The usual propellant used to power airbrushes, the compressor has a motor which maintains an air supply at a certain pressure. There are two main types: tank and direct compressors.

Cutaway A style of technical illustration in which the internal components of a complicated mechanism, for example, a car engine, are revealed by cutting away a portion of the outer casing. This usually involves careful study of existing technical drawings; in some cases, the mechanism may actually be cut to provide reference. As is the convention, the cut sections are shown in red in the finished illustration.

Direct compressor A small compressor which does not have a reservoir tank for the air. The air supply is created by a motor fitted with a diaphragm system and pumped directly to the hose connected with the airbrush.

Double-action fixed A type of airbrush design in which the lever controls the supply of paint and air. The paint-air ratio cannot be varied.

Double-action independent The most versatile airbrush design, in which the lever controls the proportion of paint to air and the artist can regulate the density of the spray.

External atomization The simplest type of airbrush design, in which the air and paint are combined outside the body of the airbrush. Most spray guns are of this type.

Freehand Freehand spraying is using the airbrush without masking of any kind.

Frisket A early variation of masking film, where rubber adhesive was applied to a thin translucent paper.

Frisk film A proprietary brand of masking film.

Ghosting A highly skilled technique of representing the internal workings of a mechanism in technical illustration. The ghosted image – or phantom view – is produced by making the surface layer seem transparent, as if looking through the outside.

Gravity feed A method of supplying the medium in which the fluid reservoir is mounted above or to one side of the air channel and gravity draws the paint into the brush.

Hard-edged The type of airbrushing which displays clean, sharp edges and is produced by masking film – or hard masking.

Hard masking In general, masking which adheres to the surface, giving sharp outlines.

Highlights The lightest areas of an illustration. They can be created by spraying white, if an opaque medium is used, or by leaving areas masked until the last stage if a transparent medium is used. Highlights can also be scratched back or rubbed back with a hard rubber.

Hose Connects the airbrush to the air supply.

Internal atomization Most airbrushes are designed so that the air and paint are combined within the nozzle to give a fine, even spray.

Knifing Method of creating highlights by using a scalpel to remove areas of paint. Also known as scratching back.

Knock back To reduce overall tonal contrast by spraying white gouache, for example, over finished work. This is often used to create a distancing effect.

Liquid mask A rubber compound solution which can be painted onto a surface and dries to act as a mask. It can be peeled or rubbed away when the airbrushing is finished.

Loose masking Any mask which is not stuck down to the surface.

Mask A mask is simply anything which prevents the spray from reaching the surface. *(See Frisket; Frisk film; Hard masking; Liquid mask; Loose masking; Soft masking; Stencil.)*

Medium In theory, almost anything which can be made to a certain liquid consistency can be blown through an airbrush. In practice, the most useful media are watercolour, ink and gouache.

Modelling The way artists build up the representation of three-dimensional forms on a flat surface to give the impression of volume and depth.

Moisture trap A unit which fits between the compressor and the airbrush to remove water from the air. Without a moisture trap, condensation can build up and cause blotting or uneven paint flow.

Montage Method of combining parts of different images – often photographs – to make a new composition.

Mouth diffuser A very simple form of spraying tool. Two hollow tubes are hinged together at right-angles. Air is blown through the upper, horizontal tube and causes paint to be drawn in the vertical tube which is placed in a jar of paint. The paint mixes with the air, making a spray.

Needle One of the most important and delicate components of the airbrush, the adjustable fluid needle controls the flow of medium.

Nozzle The tapered casing which contains the needle and in which the air and paint supplies are combined.

O ring Tiny circular rubber washer at the base of the nozzle, present in many airbrush designs.

Perspective grid Printed grids which have two or three vanishing points and aid the construction of technical drawings.

Propellant Any mechanism used to power an airbrush. Aside from compressors, these include air cans, air cylinders and foot pumps.

Reamer needle Special needle with a flat plane on the taper used to clean out the nozzle of an airbrush.

Regulator Attachment fitted to a compressor to allow adjustment of air pressure. It also acts as a moisture trap.

Rendering The process of working up an illustration.

Reservoir Sealed steel chamber capable of withstanding high pressure which is present in some compressors. The reservoir is fed from the air pump and supplies the airbrush with air. 'Reservoir' is also a term for the colour cup or paint well of an airbrush.

Resist Any substance applied to a surface which acts to prevent medium reaching the surface. Wax crayon or textured dry transfers are often used as simple resists.

Retouching The adjustment of photographic images. The chief aims of retouching are to clean, mend, tint or edit the existing image and the airbrush is an important tool in such work.

Scratching back Method of removing unwanted areas of paint on a surface by gently scratching with a razor blade or scalpel.

Screenprint Method of printing in which ink is forced through a fine screen to which a stencil has been applied. The airbrush can be used in the preparation of photographic stencils used in such printing.

Single-action fixed Airbrush design in which the speed or texture of the paint flow cannot be varied.

Soft-edged The type of airbrushed effect associated with the use of loose masking, where spray is allowed to drift and outlines are not clearly defined.

Soft masking Generally, masking which is not applied directly to the surface.

Spatter Granular textured effect caused by increasing the amount of paint and decreasing the amount of air.

Spatter cap Device fitted to the airbrush, replacing the nozzle cap, which gives a spattered spray.

Spray The fine mist of paint and air propelled from the airbrush at a surface. Blown-under spray can occur at the edge of a mask and may be exploited to diffuse contours. Overspray is where fine particles of paint drift over other sprayed areas.

Spray gun Heavy-duty spraying tool, capable of holding large quantities of paint.

Starburst highlight Star-shaped highlight useful for suggesting a high sheen.

Stencil Ready-made cut-out shape or template which can be used as a mask.

Stipple Series of small dots to give tone and texture, often applied by hand with a paintbrush.

Stipple cap A type of spatter cap which produces spattering in fine, controllable lines.

Suction feed In this method of supplying medium, the colour cup or receptacle is fitted underneath the fluid channel and liquid is drawn up into the path of the air. High pressure above forces a drop in pressure below, pulling the liquid up.

Tank compressor Large mechanism for supplying air, usually fitted with a moisture trap and containing a reservoir to maintain air pressure.

Technical illustration Highly finished illustration, usually of mechanical objects or systems, in which the purpose is to faithfully describe internal components, surface appearance, or both.

Torn paper mask Any piece of paper which is torn rather than cut and used as a mask. The uneven nature of such tears gives an effect which is useful for suggesting reflections.

Trammel method Method of constructing an ellipse. The major and minor axes of the ellipse are marked on a strip of paper and this is moved in such a way about an axis as to establish a series of points which, when connected, form an ellipse.

Vignette An area of graduated tone, either within a shape or extended to create a background.

INDEX

Page numbers in *italic*
refer to the
illustrations and their
captions.

ACKNOWLEDGEMENTS

The illustrations were reproduced by kind courtesy of the following:

4 Willardson & White, Los Angeles; **6** Collection TBWA, Zurich; **8** Mrs I Sneddon; **9** Jantzen Inc; **10** Imperial War Museum, London (t), Hipgnosis (b); **11** Fisher Fine Art; **12** Ronald Sheridan Photo-library; **13** Aspect Picture Library (Lief Ericksenn); **14** Bauhaus-Archiv, Berlin; **15** Tate Gallery, London; **17** The Mayor Gallery; **18** Tate Gallery, London (t), Courtesy Mme Klein (b); **19** Collection, The Museum of Modern Art, New York: gift of A. Conger Goodyear; **22** Collection, Joan and Barrie Damson, courtesy Louis K. Meisel Gallery, New York (t); Peter Sedgley (b); **23** The Pace Gallery, New York; **24** John Salt; **25** Francis Kyle Gallery; **26** Andrew Holmes (l), Fisher Fine Art (r); **27** Collection, The Duke of Bedford; **28** Paul Wunderlich, The Redfern Gallery (t), Angela Flowers Gallery (b); **30-1** Clive Boden; **38** Folio; **39** Mick Haggerty; **42** Imperial War Museum, London; **43** Bob Zoell (t), Conny Jude (bl), Ian Fleming and Associates (br); **50, 51** Clive Boden; **53** Ian Fleming and Associates; **57, 58** Clive Boden; **59** Folio; **63, 68** Clive Boden; **69** Bauhaus-Archiv, Berlin; **71** Adrian Chesterman; **79** Chris Moore; **80-3** Stephen Knuckley; **85** Ian Fleming and Associates; **86** Chris Moore (t), Doug Johnson (b); **87** Richard Manning; **88** Mick Haggerty; **89** Pictures; **90** Phil Dobson; **91** Ian Fleming and Associates; **92** London Transport (tl), Ian Fleming (tr), David Bull (b); **94** Pictures; **95** Hipgnosis; **96, 97, 98** Graham Poulter and Associates; **99** Grandfield, Rork and Collins; **100** Conny Jude; **101** John Harwood; **102** Imperial War Museum, London (t), Jantzen Inc (b); **103** Imperial War Museum, London; RAF Museum, Hendon; **105** Bauhaus-Archiv, Berlin; **106** William Wrigley Jr Co (t), London Transport (b); **107** *Esquire*, November 1944; **108** Willardson & White, Los Angeles; **109** *Fortune*, February 1932 (l), *The Butterfly Ball and the Grasshopper's Feast,* Jonathan Cape Ltd (r); **110** *The Lion's Cavalcade,* Jonathan Cape Ltd; **111** Willardson & White, Los Angeles (tl, tr), Francis Kyle Gallery (b); **112** Ian Fleming and Associates (tl, b), World Wide Posters Ltd (tr); **113** David Bull; **114** Ian Fleming (t), Mick Brownfield (b); **115** Doug Johnson; **116** Robert Grossmann; **117, 118** Folio; **119** NTA Studios; **120** Graham Poulter and Associates (t), Pictures (b); **121** Ian Fleming and Associates; **122, 123** (t) QED Publishing Ltd; **123** (b) Diagram Visual Information Ltd; **124-5, 126** Terry Gilliam for Monty Python's Flying Circus; **127** Ian Eames Films; **128-9** Richard Williams Animations; **131** Folio; **133** Rolls-Royce Ltd; **134** Folio (t); **135** David Draper; **137** John Crump; **138-9** Paul Davie; **141** Herbert Bayer Photomontage, from *The Language of Letters* (1931) © Herbert Bayer; **142, 143** Gordon Cramp Studios; **146, 147** Hipgnosis; **148** Gordon Cramp Studios; **149** Cornwall Technical College; **150** Henson Associates Inc (t), Colour Library International (b); **151** Henson Associates Inc; **152** Vicki Lugg; **153** Terry Webster.

Key: Top (t); bottom (b); left (l); right (r).

CONSULTANTS

Ken Warner trained in industrial graphic arts and went on to work as a technical airbrush illustrator for Aston Martin Lagonda, BAC, and Vauxhall Motors, among others. He worked on classified drawings for the sale of defence systems and still produces high quality illustrations for the motor industry. He now teaches technical illustration and is currently course tutor at Cornwall Technical College.

Peter Owen studied at Coventry College of Art and Design and has earned his living with an airbrush ever since his graduation. He has worked as a photo-retoucher, freelance illustrator, and with the illustrator Alan Aldridge, whose work first inspired him to use an airbrush. Since then, he has illustrated album covers, film posters, book jackets and magazine articles for clients all over the world. His illustrations have been selected for the Association of Illustrators Annual and the European Illustration Annual and have also been exhibited in London, Paris and Amsterdam. He continues to work as an illustrator while running The Airbrush Company, a firm specializing in airbrush equipment.